Building Systems Integration
for Enhanced Environmental Performance

Shahin Vassigh
Jason Chandler

Copyright ©2011 by J. Ross Publishing

ISBN: 978-1-60427-015-0

Printed and bound in the U.S.A. Printed on acid-free paper

10 9 8 7 6 5 4 3 2 1

Library of Congress Cataloging-in-Publication Data

Vassigh, Shahin.
 Building systems integration for enhanced environmental performance / by Shahin Vassigh and Jason R. Chandler.
 p. cm.
 Includes bibliographical references and index.
 ISBN 978-1-60427-015-0 (hardcover : alk. paper)
 1. Sustainable architecture. 2. Buildings--Environmental engineering. I. Chandler, Jason R., 1968- II. Title.
 NA2542.36.V37 2011
 720'.47--dc22
 2011002861

DISCLAIMER The contents of this book were developed under a grant from the U.S. Department of Education. However, those contents do not necessarily represent the policy of the U.S. Department of Education, and you should not assume endorsement by the federal government.

All the drawings produced for this book were developed by the authors, research assistants and students. The information presented in the book was researched and developed in good faith. The authors and publisher have credited resources and references to the best of their abilities. The authors and publisher do not warrant or guarantee the information in this book. This book is presented solely for educational purposes and is not intended as a definitive source for professional use and judgment.

This publication contains information obtained from authentic and highly regarded sources. Reprinted material is used with permission, and sources are indicated. Reasonable effort has been made to publish reliable data and information, but the author and the publisher cannot assume responsibility for the validity of all materials or for the consequences of their use.

All rights reserved. Neither this publication nor any part thereof may be reproduced, stored in a retrieval system or transmitted in any form or by any means, electronic, me-chanical, photocopying, recording or otherwise, without the prior written permission of the publisher.

The copyright owner's consent does not extend to copying for general distribution for promotion, for creating new works, or for resale. Specific permission must be obtained from J. Ross Publishing for such purposes.

Direct all inquiries to J. Ross Publishing, Inc., 5765 N. Andrews Way, Fort Lauderdale, Florida 33309.

Phone: (954) 727-9333
Fax: (561) 892-0700
Web: www.jrosspub.com

Acknowledgements & Credits

ACKNOWLEDGEMENTS We are grateful for the talent and hard work of students who helped produce this book. Silvana Herrera, Fiorella Mavares, Paolo Arce, Amir Melloul, Adrian Heid, Julian Sandoval and Madeline Gannon have contributed with their diligent work, passion, careful thought and craft to produce this book. Without their hard work this publication would not exist.

We thank our colleagues in the Department of Architecture at Florida International University for their insight and support. Special thanks to the Chair, Adam Drisin, for fostering a collegial atmosphere of collaboration and productivity. We also thank the Dean, Brian Schriner, for providing needed administrative support.

Shahin Vasigh would like to thank her husband, Kevin, and her sons, Kian and Kasra. She would also like to thank her mother, sisters and brother. Jason Chandler would like to thank his wife Susan and his daughters, Ava and Eliza. He would also like to thank his parents and sisters.

We dedicate this book to our children.

CREDITS The contents of this book were developed under a grant from the U.S. Department of Education, Fund for Improvement of Postsecondary Education, Comprehensive Program.

Initial drawings for this book were generated by the following students in Jason Chandler's, Materials and Methods class of Fall 2009:

Helena Hung, Maria Yepes, Natalia Escobar, Sybille Calixte, Claudia Garcia, Mayra Tellez, Christna Smith, Josanne O'Neil, Dalila Serrao, Carlos Fernandez, Emanuel Rousseau, Christopher Coule, Carly Gallo, Katrina Fumagali, Michael Bermudez, Omar Maach, Josefina Mercedes, Rosi Cutrone, Monica Mejia, David Miranda, Idabeth Rojas, Dafene Cristaldo, Ana Zapata, Diana Kagerl, Jorge San Martin, David Delgado, Ulises Reyes

Final drawings, layout and design were produced by the following group of research assistants:

Silvana Herrera, Fiorella Mavares, Paolo Arce, Amir Melloul, Adrian Heid, Julian Sandoval and Madeline Gannon

Symbol Legend

Context

 Urban

 Suburban

Climate

 Hot and Humid

 Hot and Arid

 Temperate

 Cool

Elevation

 Low: < 700 feet above Sea Level

Medium: 700-3000 feet above Sea Level

High: > 3000 feet above Sea Level

Temperature

 Average High/Low

Cold Air

Hot Air

Precipitation

 Dry

Dry/Wet

Wet

Lighting

 Winter Sun

Summer Sun

Solar Radiation

Daylighting

Climate Control

 Fan

 Natural Ventilation

 Air Circulation

 Cold Air Circulation

 Hot Air Circulation

 Buffer Zone

 Mechanical System

 Cooling Mechanical System

 Heating Mechanical System

Author Biographies

SHAHIN VASSIGH is an associate professor in the Department of Architecture at Florida International University and teaches courses in structures and building technologies. Vassigh has built a nationally recognized body of research work focused on improving building technology and sustainable building design education by developing alternative teaching pedagogies. She is a recipient of two major federal grants for "A Comprehensive Approach to Teaching Structures" and "Building Literacy: The Integration of Building Technology and Design in Architectural Education." Both projects developed interactive learning environments using state of the art computing technology. She is the author of Interactive Structures: Visualizing Structural Behavior (2005). She received a Master of Architecture, a Master in Urban Planning and a Bachelor of Science in Civil Engineering from University at Buffalo, the State University of New York.

JASON R. CHANDLER is an associate professor in the Department of Architecture at Florida International University and teaches courses in architectural design and building technologies. He is a registered architect in the State of Florida and is the principal of Chandler and Associates in South Miami. His academic and professional activities focus on building construction and its influence on architectural and urban design. Professor Chandler's research has been supported by grants and fellowships from The National Institute for Architectural Education, The International Hurricane Center, The National Renewable Energy Laboratory and The United States Department of Education. His design work has received several awards and has been exhibited nationally and internationally. He received his Bachelor of Architecture from Cornell University and his Master of Architecture from Harvard University.

Acknowledgements & Credits	iii
Symbol Legend	iv
Author Biographies	v
Introduction	1

1 Structure + Envelope

1.1 Singapore National Library — 8
T.R. Hamzah & Ken Yeang
Singapore
2005

1.2 William J. Clinton Presidential Center — 14
Polshek Partners
Little Rock, Arkansas, United States
2004

1.3 Heifer International Headquarters — 20
Polk Stanley Rowland Curzon Porter Architects
Little Rock, Arkansas, United States
2006

1.4 Paul L. Cejas School of Architecture — 26
Bernard Tschumi
Miami, Florida, United States
2003

1.5 Agbar Tower — 32
Jean Nouvel
Barcelona, Spain
2005

1.6 Rehab Basel — 38
Herzog & deMeuron
Basel, Switzerland
2001

1.7 Thermal Baths — 44
Peter Zumthor
Vals, Switzerland
1996

1.8 Arup Campus — 48
Arup Associates
Solihull, England
2001

1.9 Manchester Civil Justice Centre — 54
Denton Corker Marshall
Greater Manchester, England
2007

2 Envelope + Mechanical

2.1 Caltrans District 7 Headquarters Building — 62
Tom Mayne, Morphosis
Los Angeles, California, United States
2004

Table of Contents

2.2 Bregenz Art Museum
Peter Zumthor
Bregenz, Austria
1997
— 68

2.3 Debis Headquarters Building
Renzo Piano
Berlin, Germany
1998
— 74

2.4 Housing Estate in Kolding
3XNeilsen, Århus
Kolding, Denmark
1998
— 80

2.5 Helicon Building
Mick Pearce + Design, Inc.
London, England
1996
— 86

3 Structural + Envelope + Mechanical

3.1 Council House 2 (CH2)
Jean-Claude Bertoni + Design Inc
Melbourne, Australia
2006
— 94

3.2 San Francisco Federal Building
Tom Mayne, Morphosis
San Francisco, California, United States
2007
— 106

3.3 Loblolly House
Kieran Timberlake
Taylors Island, Maryland, United States
2006
— 112

3.4 Yale Center for British Art
Louis I. Kahn, Pellecchia and Meyers
New Haven, Connecticut, United States
1969-74
— 118

3.5 Manitoba Hydro Place
KPMB Architects
Winnipeg, Manitoba, Canada
2009
— 124

3.6 Braun AG Headquarters
Schneider+Schumacher
Kronberg, Germany
1998-2000
— 136

3.7 BRE Environmental Building
Feilden Clegg Architects
Watford, England
1996
— 144

Bibliography — 153

Index — 155

Introduction

PREAMBLE: CLIMATE CHANGE AND THE BUILT ENVIRONMENT Among all human activities contributing to climate change, the built environment, particularly the construction and operation of buildings, impacts the environment most. This impact is significant, central, and affects the environment in multiple dimensions. Since buildings are the largest consumers of energy, they are the principal contributors to the greenhouse gas emissions that cause climate change.[1] The building sector consumes over 49 percent of all energy produced in the United States. Of all the electricity produced in the United States, 77 percent is used just to operate buildings. Globally, these percentages are even greater.[2] Building and construction activities consume three billion tons of raw materials each year.[3] Materials utilized in buildings tend to have a high-embodied energy, high levels of toxins and pollutants at the end of production, as well as higher levels of emissions.[4]

Given the size of its contribution to the problem, the building sector has considerable capacity to reduce greenhouse gases and diminish global warming. This problem presents architects, as the primary designers of the built environment, an immense opportunity and a central role in solving the challenges of climate change and environmental sustainability.

INTEGRATED PRACTICE AS A KEY TO SUSTAINABLE BUILDING DESIGN Historically, architecture has evolved from an integrative practice that synthesized art and technology. This was often achieved by inventing solutions to solve engineering problems while enhancing human experience through architectural expression. Through the Renaissance, great architects were master builders, artists, sculptors, and engineers who practiced architecture holistically.

However, since the industrial revolution, the rapid growth of technical and scientific knowledge applied to building design and construction created the growing need for specialized professions to master, utilize, and advance applied science and engineering. The industrial application of technology drastically transformed society, introducing fundamental changes in our approach to architecture and the design of the built environment, thus creating a significant rift between artistic and scientific disciplines.

These resulting professional boundaries have defined architecture increasingly as a "design profession" and engineering as "applied sciences." This has split building design and construction into fragmented disciplines handled by architects, structural, mechanical and electrical engineers, computer scientists, and construction managers. Each of these fields has been institutionalized with widely divergent educational practices, cultural mindsets, and professional approaches to building design and construction.

The architectural practices of much of the latter half of the twentieth century are, therefore, radically different from the past and have revealed the limitation of specialized fragmented disciplines. This book aims to document a recent trend in architectural practice that integrates design and engineering disciplines to create responsible and sustainable buildings. The benefits of integrated practice have created substantial shifts in the professional role of the architect, the education of architects, the innovations of building design, and the accountability of design decisions.

Integrated practice reaffirms the role of architects as multitaskers by providing an overview of the relationship of design, engineering, and construction. In many cases, large-scale practices are led by architects who work with a wide range of in-house professionals from many disciplines that include engineers, construction managers, landscape architects, and interior designers. This holistic approach eliminates substantial inefficiencies from the design and construction process. The synergy between building systems limits the possibility of unintended redundancies and misinterpretation of intensions of the engaged parties.

In architectural education, formally based curriculums have begun to weave technologies into their pedagogy. The new criterions of accreditation, building information modeling (BIM), and the best practices of the profession are mandating the integration of technology into the pedagogy. In the past, building technology curriculums including structural, mechanical, electrical, and other building systems were considered support to design courses and were rarely integrated into the broader architectural curriculum. Today, accredited architectural programs are required to have a "comprehensive design" studio that integrates sustainability, structural, life safety, and

environmental systems in one design project.⁵ This new emphasis in architectural education means students are applying technology principles in building design and are learning the pivotal importance of integration as a means to drive innovation and creativity. This educational model contributes to producing architects that understand how the integration of design and technology can lead to the building of an efficient and sustainable built environment.

As architects integrate their design practices, they will again be a part of the innovations of buildings systems, materials, and construction process. In an integrated practice, all disciplines including architects, engineers, and contractors – will be part of earliest phases of a project. In integrated practice, initial design decisions are informed by the ramifications of building energy performance. Initial decisions have the greatest impact on the construction, building performance, and systems efficiencies of buildings. This will not only prevent costly reconsiderations of design decisions, it will also allow for synergistic collaborations that rethink old techniques.

Integrated practice and sustainable design ultimately expands the formal ambitions of architectural design by providing accountability to the environment. The metrics of sustainable design allow architects and other building professionals to measure the outcome of their decisions. Within integrated practice, these quantifiable criteria create a lens through which practitioners can remediate a design decision. In the end, architecture is the reconciliation of an expansive set of influences, not all of which are motivated by purely sustainable aims. These conflicts require analysis from all parties invested in the project development and lead to innovations that satisfy many ambitions.

THE BOOK APPROACH This book is a compendium of works of architecture that demonstrate the best practices and principles of designing and constructing buildings that are both environmentally responsible and architecturally expressive. The buildings selected for inclusion in this book exhibit a high level of sustainability and environmental performance and at the same time are complex architectural proposals that go far beyond simplistic instrumentalized notions of design.

The objective of this book is to demonstrate, clearly and unambiguously, three fundamental principles:

First, high performing, highly sustainable buildings can be architecturally significant – achieving high performance and efficiency does not have to sacrifice design and architectural expression. To the contrary, high-performing buildings can embody the unquantifiable concern for beauty and the traditions of the metier of architecture.

Second, improving building performance, efficiency, and environmental sustainability are not always the product of radical, exotic, or even new design ambitions but can be achieved with established architectural design languages that engage with climate, site, orientation, custom, use, and history.

Third, there is an irrefutable and undeniable connection between sustainability, quality design, and the use of integrated practice. Most high-performance and sustainable buildings are the outcome of close collaboration between architects, engineers, construction managers, and building owners who work together to make decisions from the start to the end of the development, design, and construction process.⁶ This collaborative process insures better understanding and coordination of building systems operation and their interaction and their synergetic benefits, improving building efficiency and minimizing negative environmental impact.

This book examines the work of a growing stream of architectural practice that produces exemplary models of integrated design that engage climate and context. All the examined buildings are introduced within their context indicating location, climate, and use. The book utilizes two distinct drawing types describing each building: the wall section and the axonometric. The wall section is a partial cut through the perimeter of a building. While it is an isolated moment in the building, it is one of great consequence and has become the site of much attention and innovation in building construction. It describes in a simple and direct fashion a building's enclosure – the locale of the interaction of the interior and exterior. As a drawing, it records the interactions, adjacencies, and connections of a building's enclosure, mechanical, and structural systems. While the wall section serves to present the information about a building's enclosure in a focused way, it does so without providing a complete picture of the system's interactions.

Introduction

As a complement, axonometric drawings serve to illustrate the spatial configuration of the wall section. There are two types of axonometrics in this book: those that show the complete assembly of a wall section and those that show the assembly exploded. The ambition of these drawings is to represent details within the context of a complete building assembly. The use of both axonometric types allows for the study of interactions of building components and the study of components in isolation.

These drawings attempt to expose the complex layers of the building components, revealing the interworking and the beauty of building systems integration typically hidden in glossy photographs. While the outward expression of a building may remain a sought-after effect, it can now be engaged with energy efficient performance. These drawings examine a myriad of construction issues: the selection and use of materials, the integration of structural and mechanical systems, the use of enclosure and cladding systems, the use of glazing systems and sun control, the detailing of waterproofing, and the weathering of materials. These drawings highlight and celebrate innovations in the development of integrated building.

ORGANIZATION OF THE BOOK The book organizes the selected buildings into three sections based on integration of paired building systems including structure, envelope, and mechanical systems. The content aims to demonstrate the performance of each systems pair in terms of interaction and contribution of each individual system and the synergetic benefits resulting from the unique pairing. The last section of the book is devoted to buildings that have a higher degree of integration and cannot be studied as paired systems.

The first section is entitled "Structure + Envelope." Structure and envelope systems are the principal elements in materializing architectural form; therefore, their integration has a significant impact on the environmental performance of buildings. Each of the selected buildings in this section demonstrates how complementary pairing of these systems has contributed to the admission of natural light, improved energy performance, and reduced embodied energy.

The second section, "Envelope + Mechanical," demonstrates how the integration of envelope and mechanical systems can become an efficient vehicle to mediate between the exterior environment and the demands of the interior space. The selected buildings for this section show how the appropriate pairing of these systems contributes to thermal comfort, natural ventilation, natural lighting, and affords the architect highly expressive and energy efficient façades.

The final section of this book, "Structure + Envelope + Mechanical," includes buildings that represent a significant degree of integration in structure, envelope, and mechanical systems. These buildings demonstrate how comprehensive integration can inform building orientation, configuration, fenestration, mechanical systems, and natural lighting. These buildings are models of interdisciplinary collaboration that solve significant design problems, achieve energy efficiency, reduce impact on the environment, and are beautifully crafted buildings.

REFERENCES

1. Pew Center on Global Climate Change, "Innovative Policy Solutions to Global Climate Change," In Brief, November 2006.

2. "Architecture 2030 Will Change the Way You Look at Buildings," Architecture 2030, http://architecture2030.org/the_problem/buildings_problem_why.

3. D. M. Roodman and N. Lenssen, Worldwatch Paper 124, A Building Revolution: How Ecology and Health Concerns are Transforming Construction, (Washington, D.C.: Worldwatch Institute, 1995), 5.

4. Pekka Huovila, Buildings and Climate Change, Status Challenges and Opportunities, United Nations, Environment Programme, Sustainable Consumption and Reduction Branch, illustrated edition, (UNEP/Earthprint, 2007).

5. National Architectural Accrediting Board, Inc., "2009 Conditions for Accreditation," Public Comment edition, (2009).

6. "Whole Building Design Guide, National Institute of Building Sciences (NIBS)," Don Prowler, August 7, 2008, http://www.wbdg.org/wbdg_approach.php.

1
[S+E]

Structure + Envelope

Structure has always been a significant determinant of the outward expression of a building. Yet, in spite of its profound formal presence, it often is not considered as a significant contributor to the environmental performance of a building. The buildings selected in this section demonstrate how the integration of structural systems with the exterior envelope can contribute to energy efficiency. The interaction between the structure and envelope can be identified as one of the following pairings: structure and envelope are fused together as an infill frame, structure serves to support a hung enclosing system or it becomes a monolithic enclosing load bearing wall. Alternatively, a self-supporting independent enclosure can wrap the building's structure. In each pairing structure acts as a critical partner in the definition of how light and air is either prevented or allowed to enter the interior space.

1.1 [S+E]
Singapore National Library

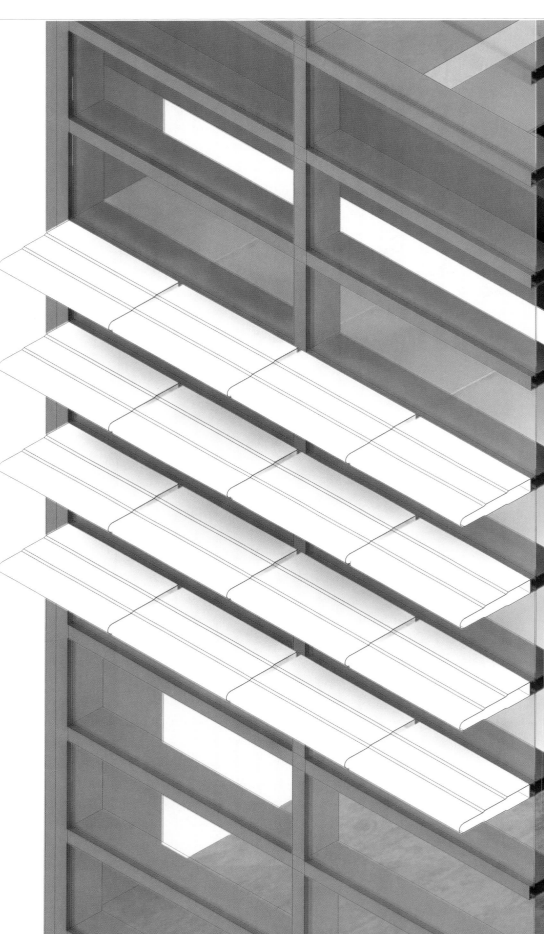

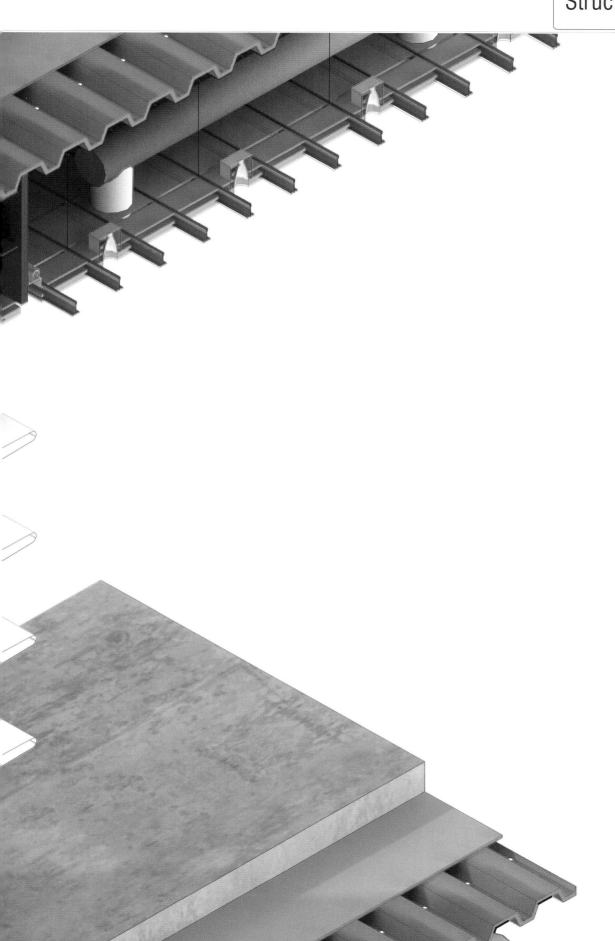

Structure + Envelope

1.1 [S+E] Singapore National Library

ARCHITECT	T.R. Hamzah & Ken Yeang
LOCATION	Singapore 1.2°N 103.5°E
DATE	2005

LOCATION CONDITIONS

BACKGROUND Located in the downtown district of Singapore, the new National Library building is an urban civic icon exemplifying innovative sustainable architecture for the tropics. The building complex consists of a sixteen-storey rectangular block and a fifteen-storey curved structure separated at ground level by a semi-enclosed pedestrian street. The two buildings are linked by a series of bridges at the upper levels. The rectangular block houses the library collections, storage, and study areas, while the curved block accommodates exhibitions, lecture rooms, conference rooms, and a space for other cultural events. The internal street or atrium serves as a communal space for outdoor events and is surrounded by cafés and other retail spaces.

PLANTED TERRACES The Singapore National Library building incorporates extensive landscaping within the building to improve the working environment. It has a series of garden terraces and sky courts that insulate the building's interior and lower the ambient temperature for energy efficiency. They consist of fourteen gardens spread between the two blocks dedicated to outdoor activities and green space. These civic plazas are also located in the basement to allow light and natural ventilation underground.

NORTH In the north façade, the entry of diffused sunlight is controlled throughout the day by giant metal blades that reflect light off their surface onto the interior space.

EAST In summer, large amounts of solar radiation enter the east façade at a shallow angle. This façade is protected from the morning sun by projecting metal blades.

SOUTH The south façade receives light at a steep angle during the summer. Shading is provided by giant metal blades that block direct sunrays.

WEST In summer, the west façade receives large amounts of solar radiation at a shallow angle during 75 percent of the period of use. Solar screening is provided by the metal blades, which also serve as light shelves that allow light to penetrate into the library.

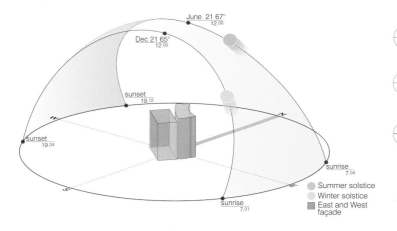

PERFORMANCE The Singapore National Library building employs a number of strategies to reduce energy consumption and the building's impact on the environment. The design responds to climatic conditions through its configuration and orientation, the use of sun shading devices, natural ventilation, green terraces, and façade treatment. During the design process, several thermal, daylighting, and wind simulations were conducted to forecast, evaluate, and modify the building's performance. The simulation results have led to reducing electric energy consumption of the building to 31 percent below the country's national average.[1]

The design also integrates landscape elements to further decrease the energy demand. Landscaped areas and gardens located throughout the building reduce the roof temperature and minimize heat transfer into the interior spaces. Thoughtful selection of sustainable local timber, recycled and reused materials, and materials with lower embodied energy for wall fabrics and wooden fixtures all contribute to reducing the building's adverse impact on the environment. The building has received a number of sustainability awards including the ASEAN Energy Efficiency award and Singapore, Silver Award in the Universal Design Award in 2007.

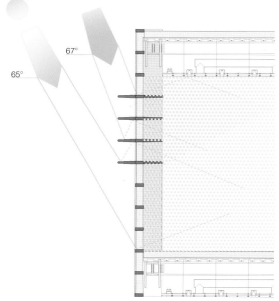

DAYLIGHTING AND SCREENING

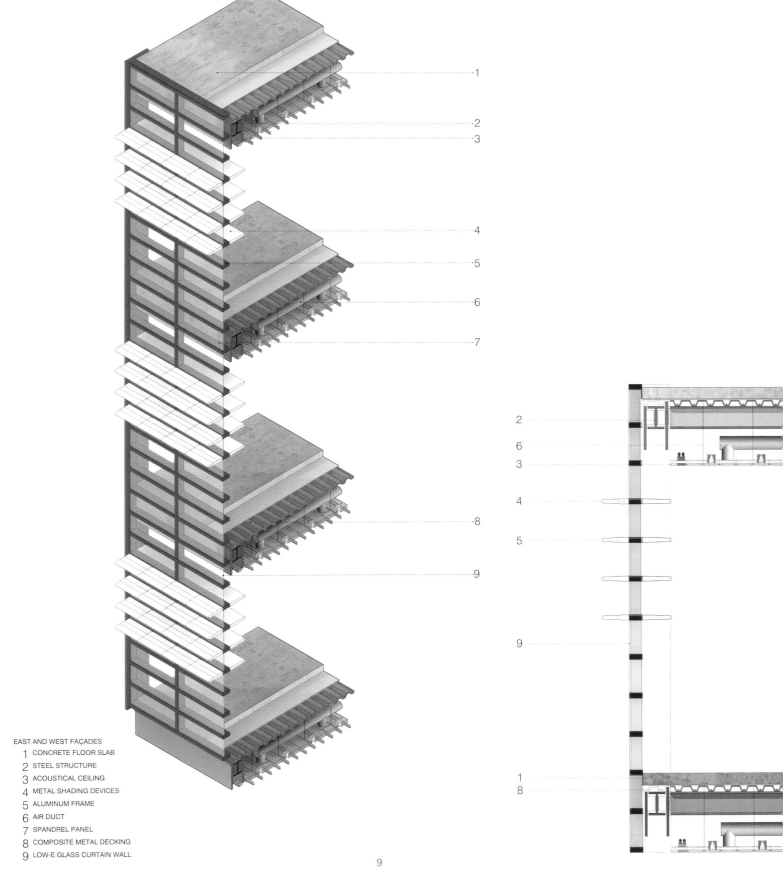

Structure + Envelope

EAST AND WEST FAÇADES
1. CONCRETE FLOOR SLAB
2. STEEL STRUCTURE
3. ACOUSTICAL CEILING
4. METAL SHADING DEVICES
5. ALUMINUM FRAME
6. AIR DUCT
7. SPANDREL PANEL
8. COMPOSITE METAL DECKING
9. LOW-E GLASS CURTAIN WALL

1.1 [S+E] Singapore National Library

BUILDING FAÇADES In addition to proper building orientation, selecting an environmentally responsive enclosure system is crucial in mitigating the impact of a tropical climate. Both the rectangular block and the curved structure of the Singapore National Library are aligned to face north, the ideal orientation to minimize solar heat gain. The north and south façades of the atrium utilize large metal blades to block direct sunrays while reflecting diffused light off their surface onto the interior space. These shading devices project out from the face of the building about 6 feet (1.8 meters) and are supported by crossing steel cables. On the east façade, the building utilizes a low-E glass curtain wall with a series of protruding shading blades that wrap around the building. The blades protect the east façade from direct solar exposure while allowing ample daylight and views from the interior. The west façade also incorporates the metal blades for shading. These blades extend to the interior of the building to serve as light shelves allowing light to filter into the library area.

The west side of the building accommodates the support and service areas. This area serves as a climate buffer for the reading rooms and book stacks reducing the impact of the late afternoon sun. The building envelope prevents solar heat gain, humidity, and glare to provide a comfortable environment while allowing the use of natural light to minimize the library's dependence on artificial light.

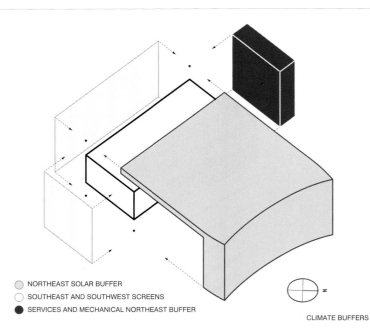

○ NORTHEAST SOLAR BUFFER
○ SOUTHEAST AND SOUTHWEST SCREENS
● SERVICES AND MECHANICAL NORTHEAST BUFFER

CLIMATE BUFFERS

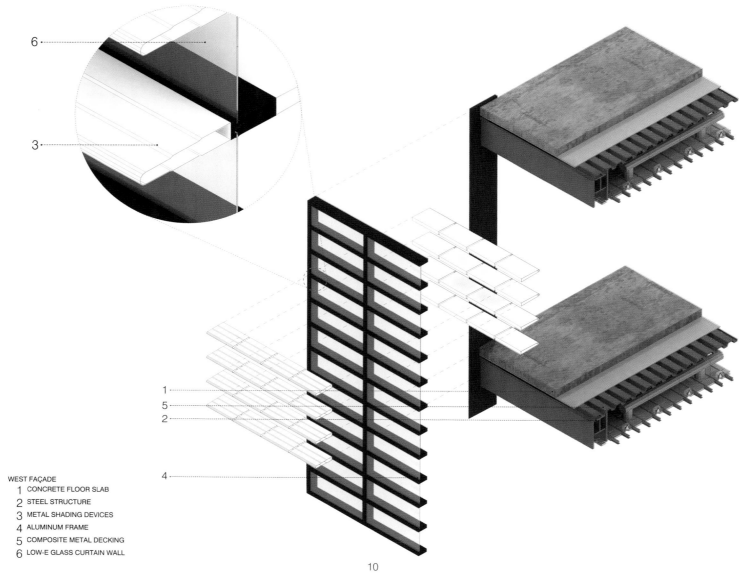

WEST FAÇADE
1. CONCRETE FLOOR SLAB
2. STEEL STRUCTURE
3. METAL SHADING DEVICES
4. ALUMINUM FRAME
5. COMPOSITE METAL DECKING
6. LOW-E GLASS CURTAIN WALL

Structure + Envelope

VENTILATION STRATEGY The Singapore National Library building utilizes a zoned climate control system to control interior temperature. This system customizes the interior environment in different areas within the building according to their use. The library collections, study areas, and theater operate under the "full mode." They are fully air-conditioned and lit with artificial lighting. Transitional spaces run under the "mixed mode." They use a combination of natural ventilation and mechanical systems to achieve a comfortable temperature. The semi-enclosed atrium operates under the "passive mode" throughout the year.[2] It is naturally ventilated and mostly daylit. The atrium is oriented to capture the prevailing breezes and allows fresh air to circulate and cool the space. Glass louvers in the atrium's roof open and close to create a stack effect to pull hot air up and out of the space.

REFERENCES
1. "National Library Building," Asia Business Council, http://www.asiabusinesscouncil.org/docs/BEE/GBCS/GBCS_Library.pdf.
2. "Assessing the Assessor Breeam vs Leed," Sustain Magazine 9, no. 6: 31-33, http://www.breeam.org/filelibrary/BREEAM_v_LEED_Sustain_Magazine.pdf.

SOURCES
Russell Cole, Andre Lovatt, and Mani Manivannan, "Singapore's New National Library," Arup Journal (2006), http://www.arup.com/_assets/_download/download626.pdf.
Tony McLaughlin and Buro Happold, "Engineering the Library Environment," September 2007, http://library-architecture.upol.cz/2007/prezentace/Laughlin.pdf.
"TR Hamzah & Yeang International," http://www.trhamzahyeang.com/project/large-buildings/nlb01.html.

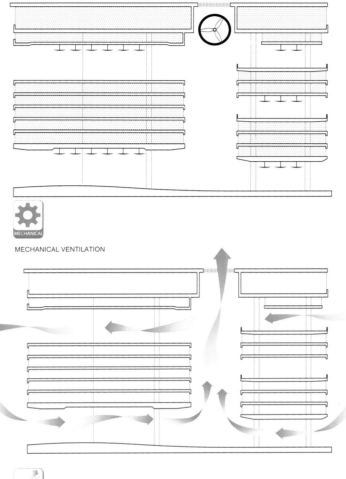

MECHANICAL VENTILATION

ATRIUM STACK EFFECT The semi-enclosed atrium and the transitional spaces are carefully oriented to capture the prevailing winds and allow natural ventilation within the space.

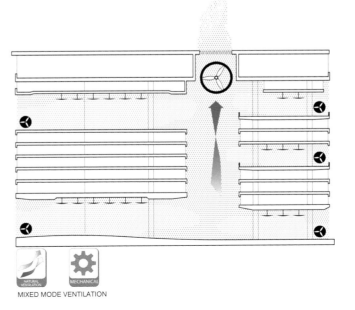

MIXED MODE VENTILATION

1.2 [S+E] William J. Clinton Presidential Center

Structure + Envelope

1.2 [S+E] William J. Clinton Presidential Center

ARCHITECT	Polshek Partners
LOCATION	Little Rock, Arkansas, USA
	34.4°N 92.2°W
DATE	2004

LOCATION CONDITIONS

BACKGROUND The William J. Clinton Presidential Center is located on the edge of the Arkansas River next to the Rock Island Railroad Bridge. The center houses a variety of programs including the presidential library, exhibition spaces, archives, the Clinton Public Policy Institute, a small theater, a café, and an apartment for President Clinton. The four-storey building is conceived as a "bridge to the 21st century" that is elevated from the ground with a long cantilever truss. The structure appropriates the typology of the six existing bridges that cross the Arkansas River. The grounds of the building, once a deserted brown field, has been transformed to a green park landscaped with trees, an amphitheater, and a playground. The new park utilizes an energy efficient system of irrigation and connects to a series of existing parks.

PERFORMANCE The integration of the structure and envelope systems is the most effective green strategy used for providing natural ventilation, daylighting, and solar protection in the Clinton Presidential Center. The principal gallery of the library is lifted off the ground to allow prevailing winds to pass around the structure and cool the building. To minimize solar heat gain, the west façade of the building has a double storey veranda with a glass wall. The vegetated roof above the gallery spaces is composed of grass, earth, and insulation. This roof minimizes the heat island effect of this structure and contributes to the insulation of the space below. The building has a Leadership in Environmental Design (LEED) certification from the U.S. Green Building Council and two Green Globes from the Green Building Initiative (GBI).

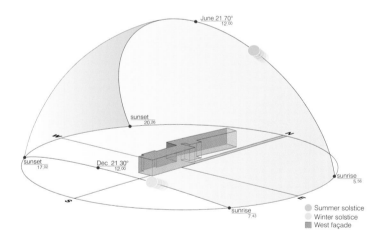

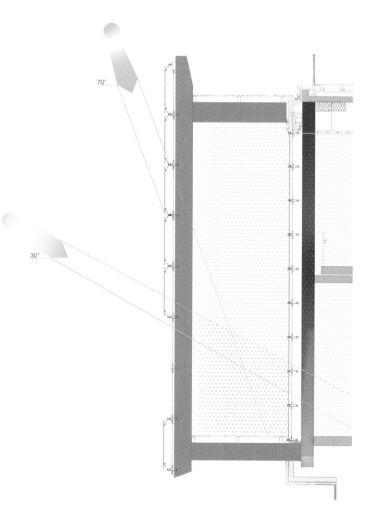

EAST In summer, large amounts of solar radiation hit the east façade. This façade has little glazing and an insulated wall.

WEST In summer, the west façade receives large amounts of solar radiation in the afternoon. Solar screening is provided by a screen of patterned glass.

WEST FAÇADE: DAYLIGHTING AND SCREENING

Structure + Envelope

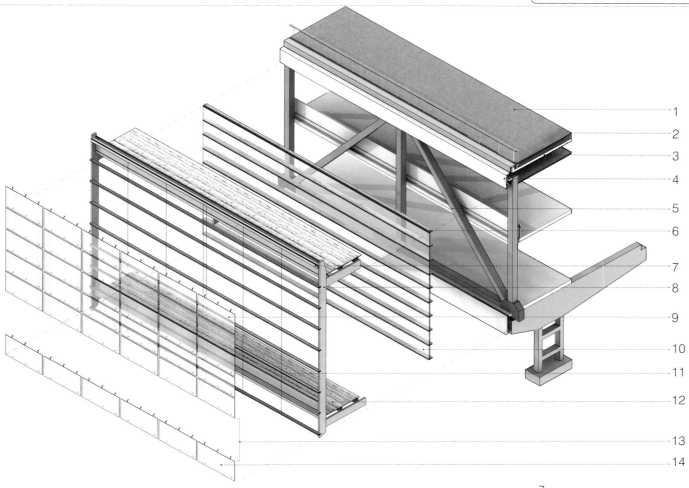

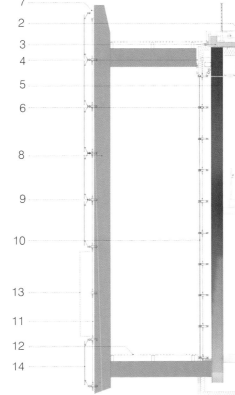

WEST FAÇADE
1. GREEN ROOF
2. RAISED WOOD DECK
3. CAST-IN-PLACE CONCRETE SLAB
4. ALUMINUM COMPOSITE PANEL
5. STEEL TRUSS
6. HORIZONTAL STEEL TUBE
7. PAINTED HORIZONTAL STEEL TUBE
8. BUILT-UP VERTICAL STEEL PLATE
9. CUSTOM STAINLESS STEEL BRACKET
10. LAMINATED LOW-IRON INSULATED GLASS WITH LOW-E COATING
11. 3" X 8" X 3/8" STEEL TUBE
12. OPEN ALUMINUM GRATING SUPPORTED BY STEEL TUBES
13. OPENING OF THE SCREEN WALL
14. LAMINATED LOW-IRON TEMPERATE GLASS WITH PRINTED INTERLAYER

1.2 [S+E] William J. Clinton Presidential Center

BUILDING FAÇADES The building is a long structure that extends north to south with its east and west façades exposed to direct sunlight. The west façade is a fully glazed gallery wall with views of the bridges on the Arkansas River. To control heat gain on this façade, the design incorporates a double-height 10-feet-wide (3 meters) veranda set on a cantilevered structure. The veranda has a patterned glass screen wall composed of individual laminated panels with printed dots. These patterns function as a shading device reducing the demand on the mechanical climate control systems. The glass panels are open in the lower portion to allow air movement on the veranda, cooling the space.

The overall depth of this façade allows ambient light to enter the gallery but eliminates direct sunlight, which can harm the exhibitions. The interior glass skin is a fixed system composed of low-E coated insulating glass that seals the envelope of the presidential center. The east façade is primarily clad with insulated aluminum panels with a few windows to reduce heat gain. The main view out of the building is westward toward the bridges crossing the Arkansas River.

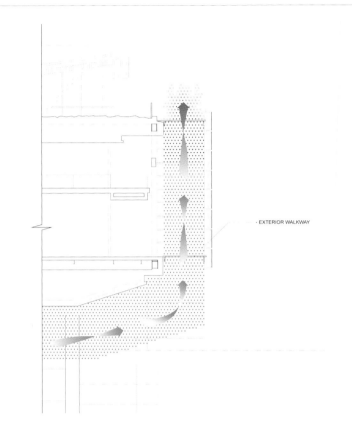

WEST FAÇADE: PASSIVE AIR FLOW

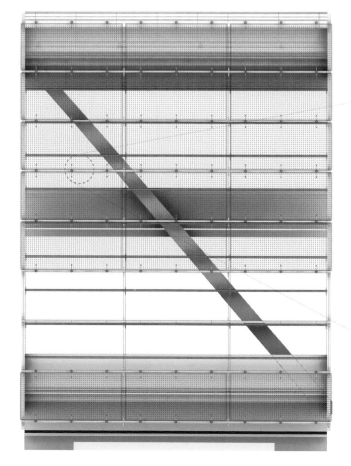

WEST FAÇADE ELEVATION

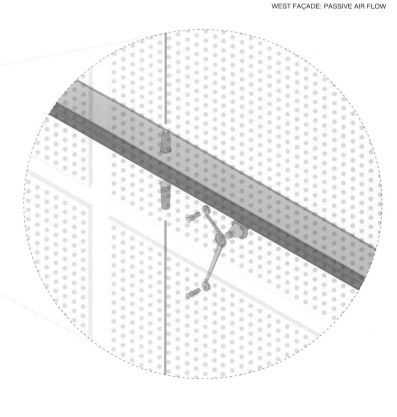

LAMINATED GLASS PANELS WITH PRINTED DOTS

Structure + Envelope

STRUCTURE The principal structure of the building is an innovative 14-bay steel truss, which cantilevers 90 feet (27.5meters) towards the Arkansas River. The 37-feet-deep (11 meter) steel truss is a moment frame that supports the cantilevered sections extending from the north and south ends of the structure[1]. The entire truss frame is supported at three locations by two sets of columns and a large steel pier at the north end. This pier has a large transfer beam on the top that cantilevers on both sides to accommodate the entire width of the building.

The structure is exposed on the building's interior and fire protected with intumescent paint. Materials used in the building include cast-in-place concrete, precast concrete, and structural steel. These materials were selected for their availability locally, recycled and renewable content, and low chemical emissions.

REFERENCES
1. Polshek Partnership Architects, William J. Clinton Presidential Library and Park, 9908 (New York: Polshek Partnership LLP, 2006).

SOURCES
James Polshek, Susan Strauss, and Polshek Partnership, Polshek Partnership Architects, 1988-2004 (New York: Princeton Architectural Press, 2004).

Scott Murray, Contemporary Curtain Wall Architect, illustrated ed. (New York: Princeton Architectural Press, 2009).

William J. Clinton Presidential Library and Museum, "Clinton Presidential Library Receives Highest Green Building Rating," http://www.clintonlibrary.gov/being-green.html.

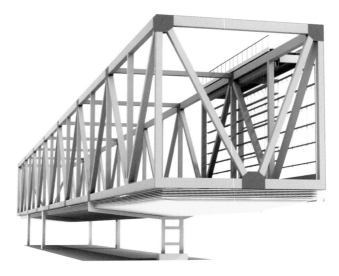

STEEL PIER AND TRANSFER BEAM

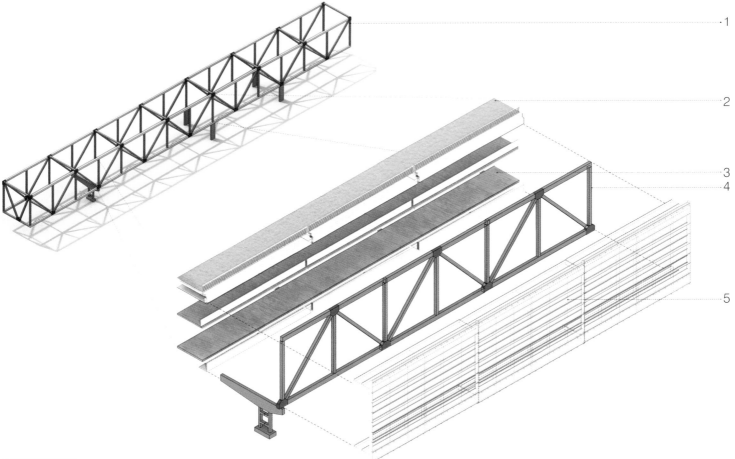

STEEL TRUSS FRAME
1 14-BAY STEEL TRUSS
2 GREEN ROOF
3 CAST-IN-PLACE CONCRETE SLAB
4 STEEL TRUSS
5 LAMINATED LOW-IRON TEMPERATE GLASS WITH PRINTED INTERLAYER

1.3 [S+E] Heifer International Headquarters

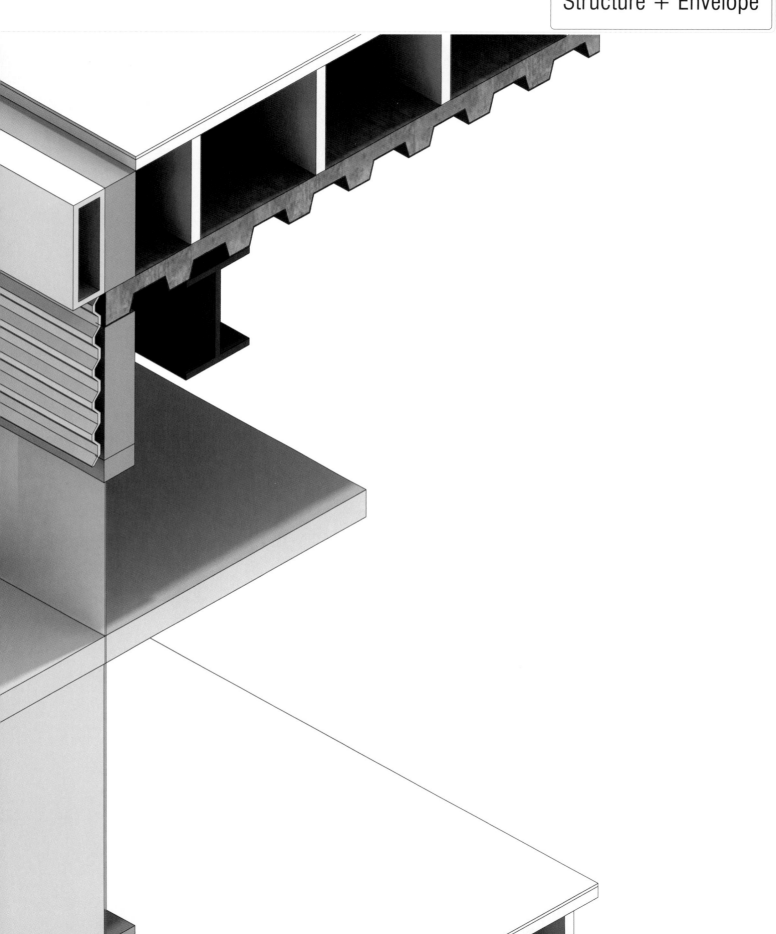

Structure + Envelope

1.3 [S+E] Heifer International Headquarters

ARCHITECT Polk Stanley Rowland Curzon Porter Architects
LOCATION Little Rock, Arkansas, USA
34.4°N 92.2°W
DATE 2006

LOCATION CONDITIONS

BACKGROUND The Heifer International Headquarters is located near the Arkansas River next to the William J. Clinton Presidential Center. The building program incorporates administrative offices, lounges, conference rooms, a library, and a café. Since Heifer International is an organization committed to fighting hunger through sustainable initiatives, the building design was set to reflect this mission by incorporating sustainable strategies throughout the project beginning with the site selection. Rather than planning a building on a pristine site along the river, Heifer International sought to reclaim an existing riverfront brownfield site. The completed building has re-established wetlands along the Arkansas River. In addition, material salvaged from the demolition of a series of existing dilapidated warehouses was recycled for this project. This building was awarded LEED Platinum certification by the U.S. Green Building Council in 2007.

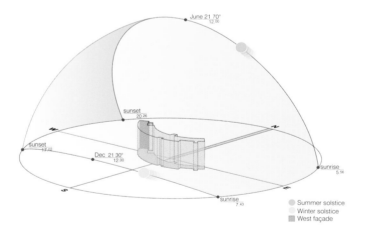

NORTH The north façade features large windows that span to the ceiling, allowing ambient light to enter the building.

SOUTH The south façade features a glass curtain wall with aluminum frame and corrugated aluminum panels. It contains light shelves that reflect light into the structure's interior while blocking direct sunlight from entering the spaces. Vertical shades located between each bay of windows help block direct sunlight from the east and west.

PERFORMANCE Among the many strategies developed to create a sustainable building, providing access to natural light has the most significant impact in the building performance. The overall plan configuration and orientation along the east-west direction diminishes the need for artificial lighting by creating a shallow floor plate that locates workers near natural light. The demand for artificial lighting is monitored by integrated sensors that activate electric lights to augment natural lighting. The large amount of glazing required to provide this light is protected by shading fins on the building façades. The design of the façades contributes to the energy savings of the building by mitigating solar heat gain during the summer and allowing light in during the winter. As a result, the energy consumption of the building is 55 percent less than other comparable buildings.[1]

The building provides outdoor porches at each level, a long covered veranda on the top floor, and open, naturally ventilated staircases. In addition, the break rooms are outfitted with doors that can be opened to collect cool river breezes. The natural ventilation of both the staircases and the break rooms provide cool outdoor spaces during the hot summer months. This strategy reduces the interior area that requires powered climate controlled systems.

The planning of the mechanical system also contributes to energy savings. The mechanical system separates the supply and return air to create an efficient system of climate control. Supply air is distributed through a ceiling-hung duct. Return air is collected in a raised floor plenum. In the summer, cool air is dropped into the workspace from above and is collected from below providing an even distribution of air.

STRUCTURE The structure of the Heifer International Headquarters is composed of a steel frame with high-recycled content. On the interior, the frame is exposed. On the exterior, it is principally clad with aluminum panels and an aluminum and glass glazing. The floor plate forms a shallow crescent shape with columns on its perimeter and down its central axis allowing for open office planning. The crescent shape creates two long glazed north and south façades. The roof is angled to provide abundant north daylight to the top floor and collect rainwater, which is reused for gray water purposes.

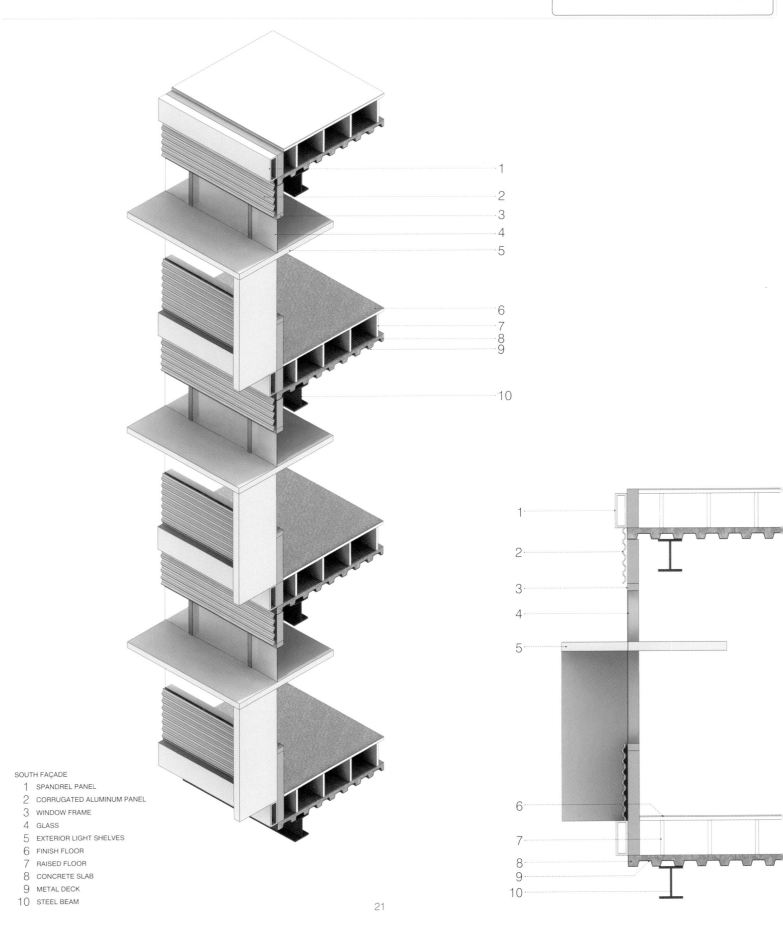

Structure + Envelope

SOUTH FAÇADE
1 SPANDREL PANEL
2 CORRUGATED ALUMINUM PANEL
3 WINDOW FRAME
4 GLASS
5 EXTERIOR LIGHT SHELVES
6 FINISH FLOOR
7 RAISED FLOOR
8 CONCRETE SLAB
9 METAL DECK
10 STEEL BEAM

1.3 [S+E] Heifer International Headquarters

SOUTH FAÇADE The crescent shape of the building creates a long convex south façade that requires protection to mitigate heat gain during the summer and allows low sunlight in during the winter. As a result, this façade utilizes a series of horizontal and vertical projecting fins and light shelves. In the summer, the horizontal fins protect from solar heat gain when the sun is high in the sky. The convex surface of this façade requires protection from intense western sunlight. Vertical fins protect the façade when the sun is setting as the horizontal fins do not provide protection from low sun angles. In the winter, these sunshades have been calibrated to provide little shade when the sun is low in the sky. Windows are placed above and below the horizontal fins that project into the interior of the building. As a result, these fins act as light shelves that reflect daylight off their surfaces deep into the interior.

DAYLIGHTING

SUMMER:
In the summertime, exterior light shelves and roof overhangs prevent direct sunlight from entering the building during the peak hours of operations.

WINTER:
In the winter, the lower angle of the sun penetrates past these shades to provide a level of passive heating to spaces on the south portion of the building. Highly insulated walls combine with high performance glass in an effort to prevent excess heat loss.

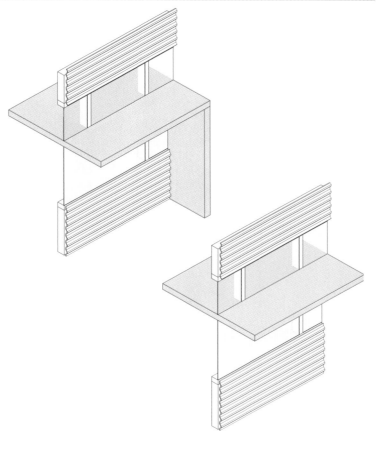

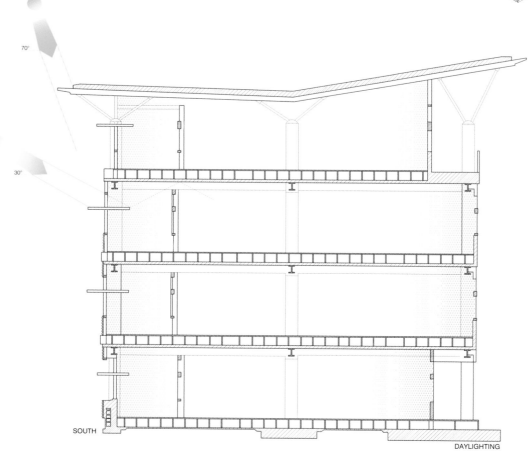

SOUTH

DAYLIGHTING

Structure + Envelope

FLOOR SYSTEM The floor construction of Heifer International Headquarters both integrates and separates building systems. Building system integration occurs through the utilization of a raised floor system that integrates the building structure with the mechanical system. The raised floor creates an air space that is used as the return air plenum for the climate control of the interior. This air space also provides room to accommodate electrical and telecommunication lines. The raised floor system rests on concrete set in corrugated metal decking. Below the decking, building systems are separated and are exhibited as components to be viewed in the work area. The structural steel frame supporting the decking is exposed. Air supply ducting, lighting, and fire sprinklers are suspended from the corrugated metal decking.

NORTH FAÇADE The window wall of the north façade is open and does not have any solar protection on its windows. Indirect ambient north light is desirable and does not create unwanted heat gain during the summer. As a result, this façade is a taut surface of corrugated aluminum panels and glass. The concave shape of this surface protects this open façade from low morning and evening solar glare.

REFERENCES

1. "Buildings Database. Heifer International Headquarters," U.S. Department of Energy, Energy Efficiency and Renewable Energy, 2009, http://eere.buildinggreen.com/energy.cfm?ProjectID=781.

SOURCES

Michael Cockram, "Big Ripples," Architecture Week (April 2007) http://www.architectureweek.com/2007/0404/environment_1-1.html.

"Green Parking Lot Case Study: Heifer International, Inc." Industrial Economics, Incorporated (IEC), (May 2007) http://www.epa.gov/region6/6sf/pdffiles/heiferparkingstudy.pdf

Tristan Korthals Altes, "Case Study: Heifer International Center," GreenSource: The Magazine of Sustainable Design (January 2007) http://greensource.construction.com/projects/0701_COL.asp

Charles Linn, Emerald Architecture: Case Studies in Green Building (McGraw-Hill Professional, New York, 2008).

Stephen Luoni, "Little Rock's Emerging Nonprofit Corridor," Places (2008).

William Sarni, Greening Brownfields, Remediation through Sustainable Development, illustrated ed. (New York: McGraw-Hill Professional, 2009).

Martin L. Smith, "Green Parking Lots" (presentation, Sustainable Communities Conference, Dallas, TX, March 2009). }

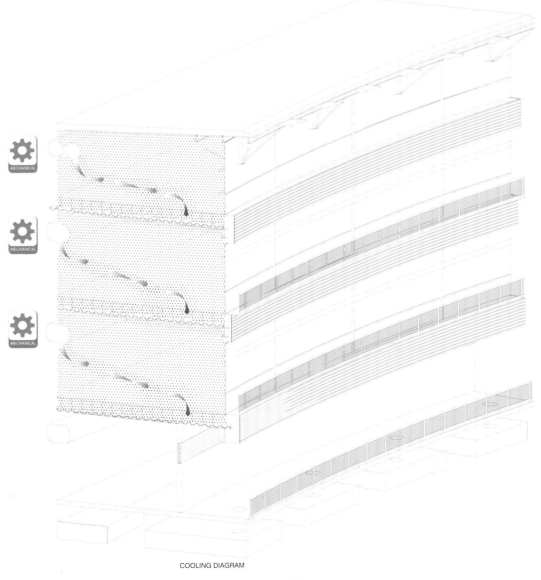

COOLING DIAGRAM

1.4 [S+E]
Paul L. Cejas School of Architecture

Structure + Envelope

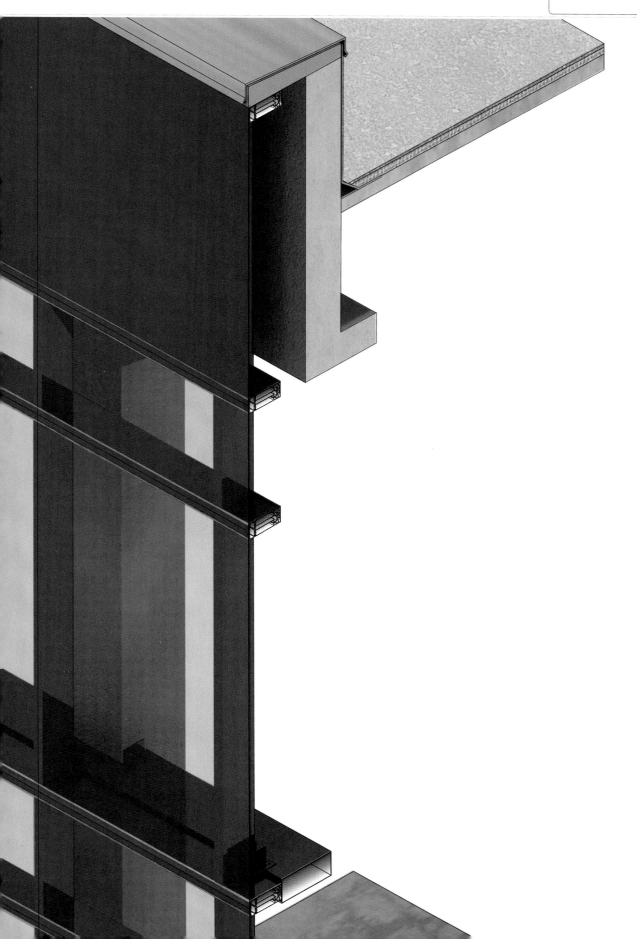

| 1.4 [S+E] | Paul L. Cejas School of Architecture | ARCHITECT: Bernard Tschumi
LOCATION: Miami, Florida, USA
25.5°N 80.2°W
DATE: 2003 | LOCATION CONDITIONS |

BACKGROUND The design for the School of Architecture building at Florida International University (FIU) is the outcome of an invited competition. Since FIU did not have a devoted building for the study of architecture, the building provides the School of Architecture with an identity and presence on campus of over 42,000 students. The building is conceived as a mini-campus unto itself with five distinct structures: a three-storey studio, an office wing, a gallery hall, a lecture hall, and a wood shop. Tschumi envisioned this project as a collection of buildings that would inspire discourse and interaction. His design centers around three generators: a "red generator" that contains communal meeting spaces such as a lecture hall and roof terrace, a "yellow generator" that contains a gallery and reading room, and a "green generator" that is a cluster of palm trees. The building is located in Miami, a tropical city that is distinguished by hot, humid, and rainy summers and dry winters.

PERFORMANCE The challenge of creating a sustainable building in the hot and humid climatic conditions of South Florida is the reduction in utilization of air-conditioning, the dominant solution for cooling and removing humidity. Although the building is connected to a university-wide chiller system that provides cooling for the entire campus, the spatial planning of the building minimizes the interior building volume that requires cooling. This is achieved by placing most stairs, circulation spaces, and many of the school's assembly spaces outdoors.

To further improve the performance, the building configuration limits solar heat gain. The four main structures of the school are three stories tall and grouped closely together. This organization provides many shaded outdoor spaces and allows the buildings to shade each other. The south and west sides of the building are the most shielded from solar heat gain. The most southern building in this complex is the office wing. This white structure is a long rectangular volume with a south face composed of punched window openings with projecting windowsills and heads. These projections shade the windows from the high summer sun. On the west face of this complex, three walls are exposed to sun: a side of the office wing, the back of the "red generator" and a side of the studio. These west-facing walls receive the most intense solar heat gain and as a result, all of them are windowless.

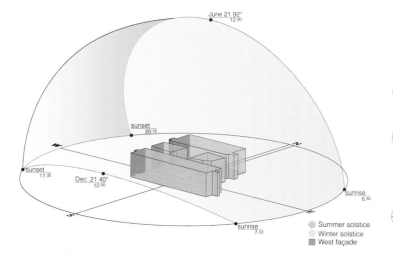

NORTH The north façade consists of a glass curtain wall. This façade allows diffused sunlight into the studio space providing ample natural light without heat gain.

EAST The east façade receives large amounts of solar radiation during the morning. This façade blocks solar radiation through the use of windowless white precast concrete walls.

SOUTH The south façades receive light at a steep angle during the summer. Punched windows on the south façade of the office wing are shaded by projecting windowsills and heads, while the studio's south façade is protected by a three-storey veranda that shades the exterior walls.

WEST The west façade is exposed to afternoon to evening sunlight during the hottest part of the day. This façade is composed of windowless precast concrete walls that mitigate solar heat gain.

Structure + Envelope

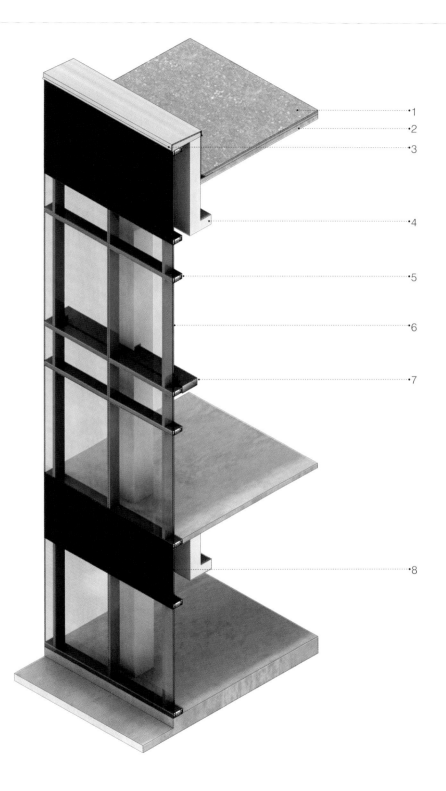
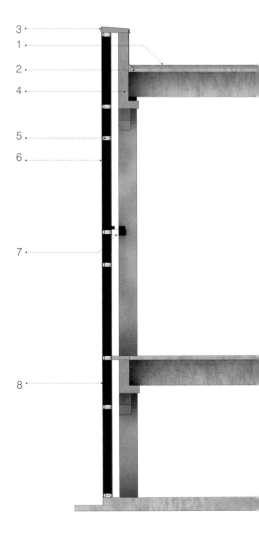

NORTH FAÇADE

1 ROOFING
2 CONCRETE DOUBLE TEE
3 FLASHING
4 PRECAST "L" BEAM
5 ALUMINUM PROFILE
6 GLASS
7 STEEL RECTANGULAR TUBE
8 SPANDREL PANEL

1.4 [S+E] Paul L. Cejas School of Architecture

STRUCTURE The project's tight budget dictated an efficient and inexpensive structure. A precast concrete system integrates the structure and enclosure into a single system. This system is composed of twin tee beams held up in place on tall load bearing wall panels. The bearing walls widths are limited to 12½-foot (3.8 meter) panels due to transportation constraints. The maximum design loads these wall panels will typically incur are those associated with the lifting and moving during assembly. The large shear forces produced during transportation require the panels to resist significant lateral loads.

As this structural system is prefabricated, the time for onsite assembly was shortened. Once in place, this structure was in-filled with mechanical, electrical, plumbing, glazing, and interior finish systems. With a construction cost of $130 per square foot, the selection of a precast concrete system proved to be a cost effective choice. Concrete is the prevalent building material in Florida with several concrete plants located in Miami. The selection of this local material reduces the building's embodied energy by minimizing the energy required for shipping the material to the site.

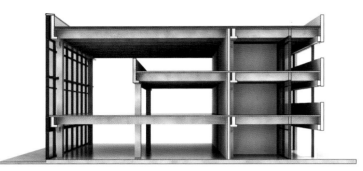

SECTION THROUGH STUDIO WING

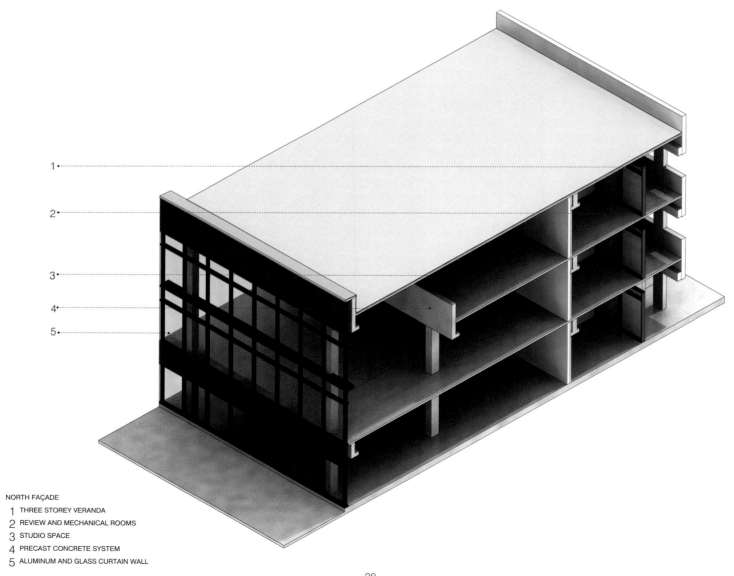

NORTH FAÇADE
1 THREE STOREY VERANDA
2 REVIEW AND MECHANICAL ROOMS
3 STUDIO SPACE
4 PRECAST CONCRETE SYSTEM
5 ALUMINUM AND GLASS CURTAIN WALL

Structure + Envelope

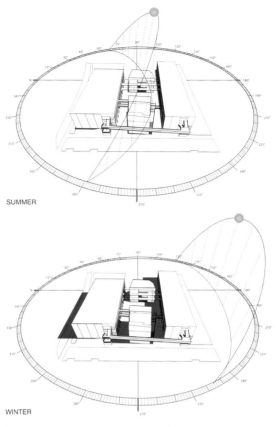

SUMMER

WINTER

SHADOW ANALYSIS DURING WINTER AND SUMMER

BUILDING FAÇADES The studio wing at the School of Architecture building can be conceived as a simple diagram of how proper positioning of façades can mitigate solar heat gain and provide natural illumination. There are three distinct façades: the first façade type is composed of windowless white, precast concrete walls that are found at the east and west sides of the studio wing. These solid walls block solar heat gain. The west wall receives the harshest afternoon to evening sunlight during the hottest part of the day. The second façade type is a three-storey veranda. The veranda's outer face is made of precast wall panels covering a 7-foot-wide (2 meters) exterior walkway. The veranda is located on the south wall of the studio creating a deep surface that shades the exterior walls of the review and mechanical rooms. The third façade type, an aluminum and glass curtain wall, constitutes the north wall of the studio. It receives little solar exposure and provides the studio with abundant natural light without heat gain.

SOURCES

Bernard Tschumi, Event-Cities 2 (Cambridge: The MIT Press, 2000).

Bernard Tschumi and Enrique Walker, Tschumi on Architecture: Conversations with Enrique Walker (New York: The Monacelli Press, 2006).

Yoshio Futagawa ed., GA Document 75 (Tokyo: GA International A.D.A Edita, 2003).

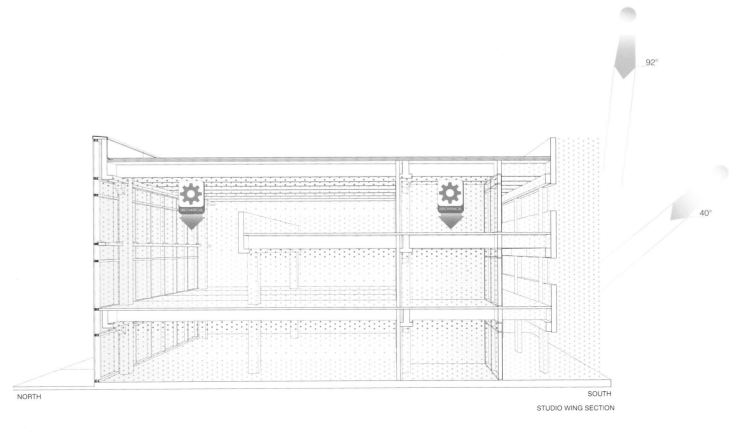

NORTH

SOUTH

STUDIO WING SECTION

1.5 [S+E] Agbar Tower

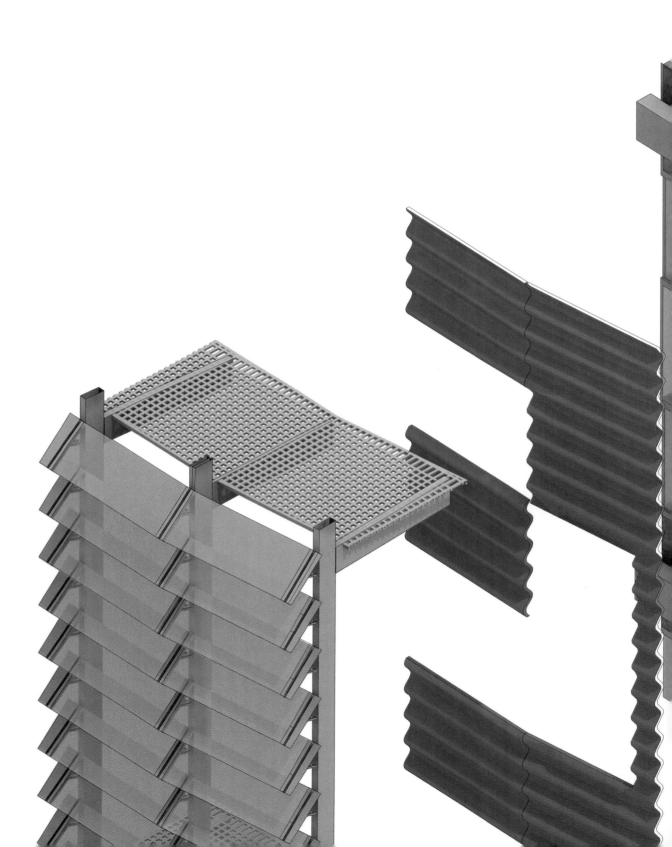

Structure + Envelope

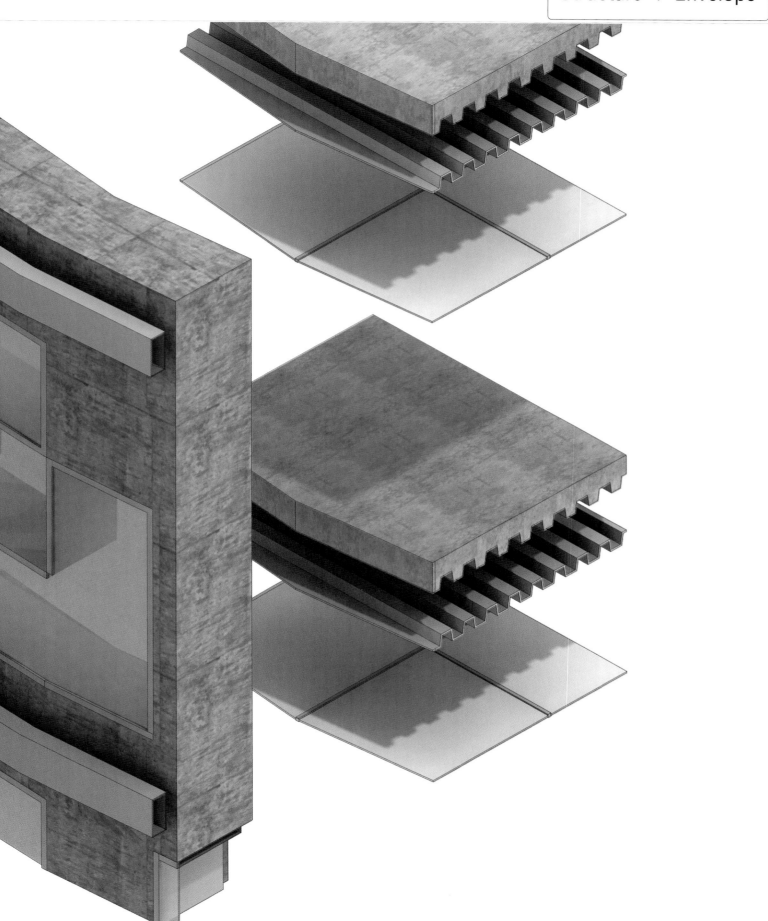

1.5 [S+E] Agbar Tower

ARCHITECT	Jean Nouvel
LOCATION	Barcelona, Spain
	41.2°N 2.1°E
DATE	2005

LOCATION CONDITIONS

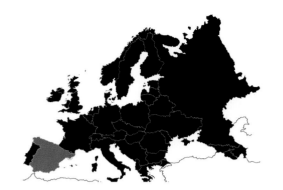

BACKGROUND Agbar Tower is the headquarter building for Barcelona's water utility. The building is a freestanding bullet-shaped tower built in a new commercial development in Glories Square. The tower is principally an office building that contains open office floors, executive office floors, multi-purpose rooms, a cafeteria, an auditorium, and parking. As the only tower in the area, without any adjacent tall building to shield it from solar heat gain, Agbar Tower is cloaked with a protecting aluminum and glass buffer skin. This impressive multicolor façade has become an icon and a landmark for the city. Its façade moves to reveal colored panels during the day and at night, lit by LED lights, the tower becomes a colorful beacon.

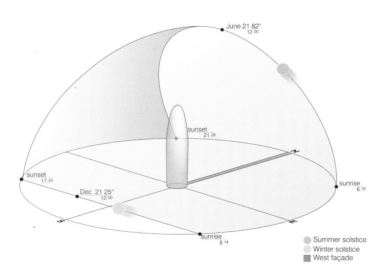

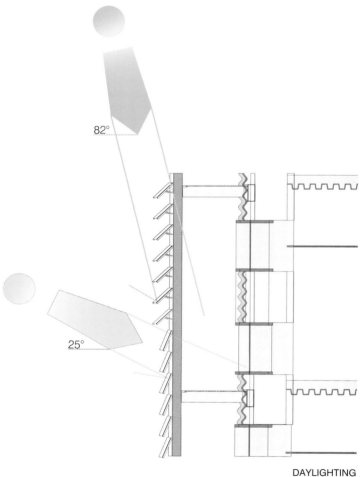

DAYLIGHTING

PERFORMANCE In this building, the structure and skin work together to create a double-skin façade that provides a thermal buffer, natural ventilation, and diffused natural illumination for the interior space. The integration of structure and envelope creates the most sustainable aspect of this design. The outer peripheral concrete structural wall has an average thickness of 1.6 feet (50 cm) with a layer of insulation, covered by aluminum panels to increase its thermal resistance. All window openings on the outer concrete wall are oriented to balance daylight and heat gain. The oval-shaped plan of the tower minimizes the distance of the occupants to windows, affording them great views of the city and access to natural daylight.

SUMMER SUN The angle of the louvers is adjusted to reflect the high rays of summer sun to prevent solar heat gain and provide diffused lighting.

WINTER SUN The angles of the louvers are adjusted to admit the low rays of winter sun.

Structure + Envelope

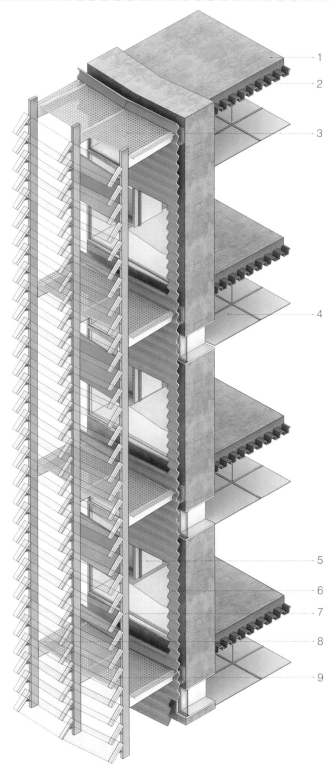
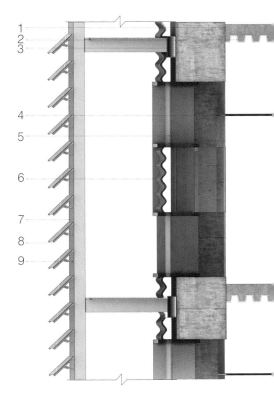

1. REINFORCED CONCRETE
2. GALVANIZED STEEL SHEET
3. MAINTENANCE CATWALK
4. CEILING FINISH (PERFORATED STEEL PANELS)
5. DOUBLE GLAZING
6. INSULATION/AIR LAYER/CORRUGATED ALUMINUM SHEET
7. ALUMINUM PROFILE
8. GLASS LOUVERS
9. ADJUSTABLE ANGLE GLASS LOUVER MECHANISM

1.5 [S+E] Agbar Tower

STRUCTURE Agbar Tower is composed of two distinct structural systems: a thirty-three-storey cast-in-place rigid concrete structure and a perimeter façade composed of aluminum and glass. The concrete structure is composed of a central core and an outer tube. The inner solid core contains elevators and stairs while the outer tube is perforated with square window openings. The outer tube is insulated on its exterior and clad with corrugated aluminum panels. The two tubes are connected by steel beams, which support the floors.

ENVELOPE The tower's façade is composed of adjustable glass louvers mounted on an aluminum frame. The aluminum frame is held away from the outer concrete wall to create a thermal buffer and provide room for maintenance catwalks. The thermal buffer helps to reduce the temperature of the building by producing air space between the structure and the skin.

The façade's glass louvers are equipped with temperature sensors and adjust in angle to protect the building from solar heat gain. These louvers shade the outer concrete tube and form the exterior surface of the buffering air space. In this space, hot air is not trapped, rather it moves upwards and out at the top of the tower. The glass louvers are also textured to create varying opacities.

In addition to this thermal buffer, insulation protects the mass of the outer concrete tube. Within the concrete tube, 4,500 double-glazed windows control thermal gain. The overall depth of this façade allows ambient light to filter the building mitigating direct sunlight exposures. The outer skin of this structure provides access for controlled daylighting of the open office plates within. In addition to protecting the structure from heat gain, the louvers contain photovoltaic cells that can be adjusted to capture the sun's energy.

SOURCES
"2006 Sustainability Report," Agbar Group, http://www.agbar.es/eng/docs/pdfs/2007_Informe_sostenibilidad_eng.pdf.

Jean Nouvel, Architecture and Urbanism: Jean Nouvel 1987-2006, special ed., (Tokyo: A+U Publishing Co, 2006).

Philip Jodidio, Jean Nouvel by Jean Nouvel: Complete Works 1970-2008, limited ed., (Cologne: TASCHEN America Llc, 2008).

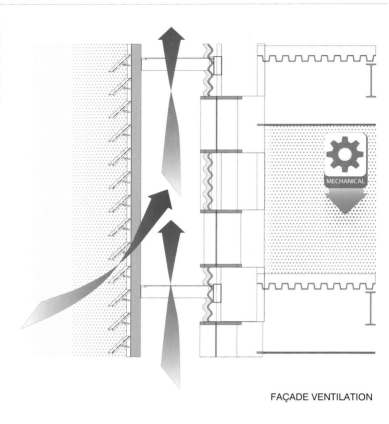

FAÇADE VENTILATION

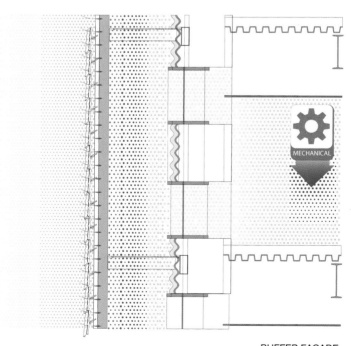

BUFFER FAÇADE

Structure + Envelope

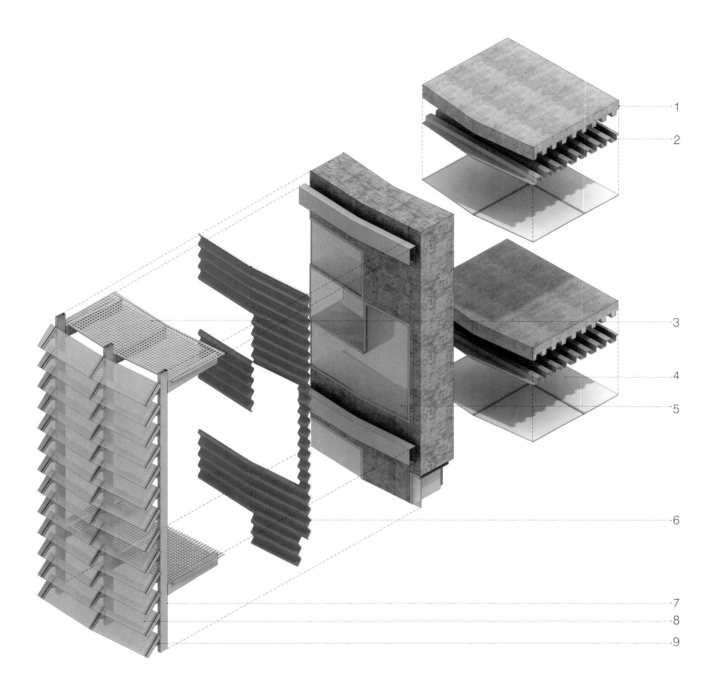

1 REINFORCED CONCRETE
2 GALVANIZED STEEL SHEET
3 MAINTENANCE CATWALK
4 CEILING FINISH (PERFORATED STEEL PANELS)
5 DOUBLE GLAZING
6 INSULATION/AIR LAYER/CORRUGATED ALUMINUM SHEET
7 ALUMINUM PROFILE
8 GLASS LOUVERS
9 ADJUSTABLE ANGLE GLASS LOUVER MECHANISM

1.6 [S+E] Rehab Basel

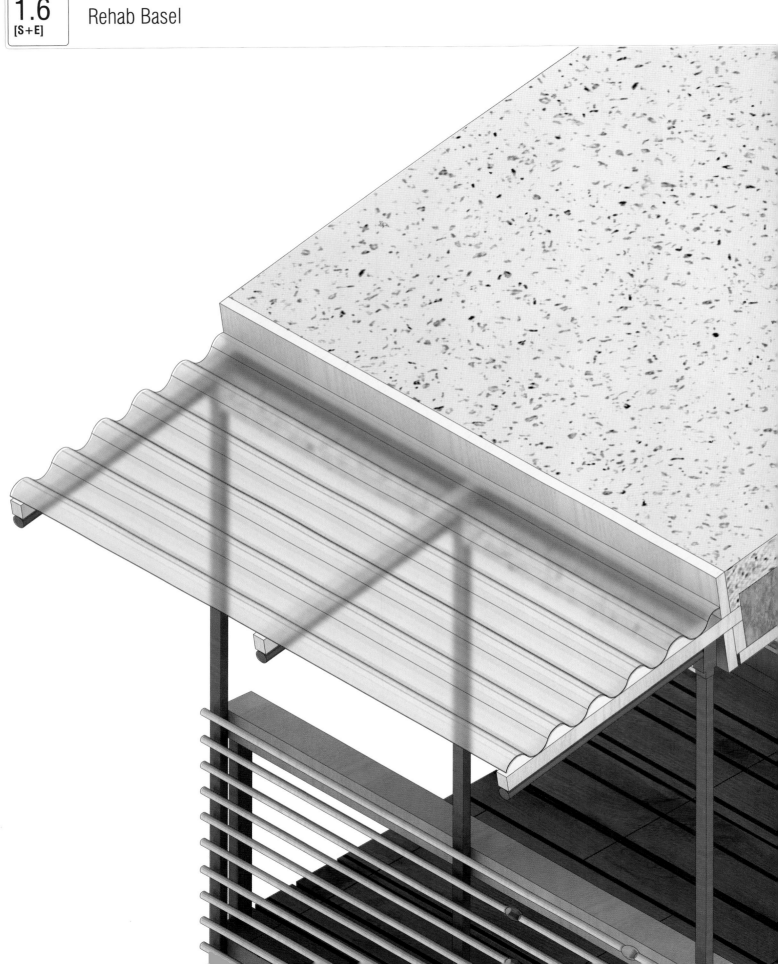

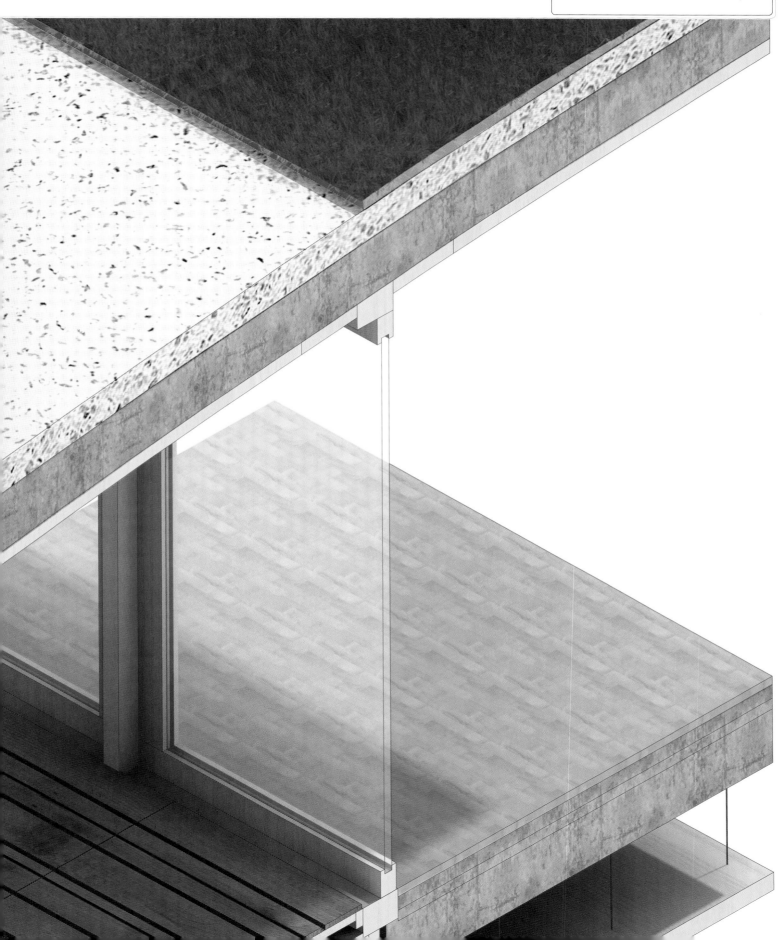

Structure + Envelope

1.6 [S+E] Rehab Basel

ARCHITECT	Herzog & deMeuron
LOCATION	Basel, Switzerland
	47.3°N 7.3°E
DATE	2001

LOCATION CONDITIONS

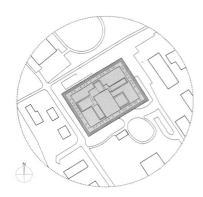

BACKGROUND Rehab Basel is a medical rehabilitation center for those suffering from spinal cord and brain injuries. The center is a two-storey multi-courtyard building incorporating patient bedrooms, lounges, therapy rooms, offices, a pool, a gymnasium, and a cafeteria. The center also has semi-private areas for family meetings and overnight accommodations for patients' relatives. The design challenges the conventional notion of a hospital by providing a variety of spatial experiences that create a place without a hermetic or a "hospital feel." There are five courtyards within the building serving the therapy areas by accessing daylight, providing balconies for rolling beds, and providing views. The Rehab Basel architects have created a building that connects the interior with the exterior of the building. The building is located in the suburbs and is exposed on all sides and surrounded by landscape.

PERFORMANCE The architects refer to this building as "garden architecture." Most of the courtyards are vegetated, and the indoor areas are covered with a green roof. This roof is composed of grass, earth, and insulation to minimize the heat island effect of the structure and contribute to the insulation of the space below. While the roof is composed of an effective insulating system, it is interrupted by sphere-shaped skylights that project through the grass. These skylights provide natural light for illumination and are double-glazed to minimize the thermal break. The building façade utilizes a solar screen for thermal control. The integration of envelope and structure is a key feature of sustainability in this design.

STRUCTURE The structure of the building is cast-in-place concrete slabs with steel columns. Round steel columns punctuate the public spaces in a discrete manner to create flowing interiors. The building is clad with oak, pine, and larch. The ceilings are composed of suspended wood in the patient rooms and suspend plaster in the public areas. The second floor verandas are framed in wood with a wood deck floor.

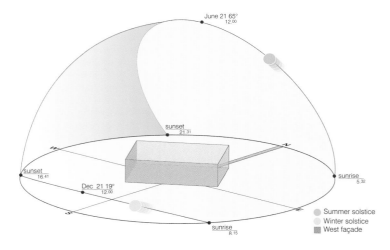

SKYLIGHTS The spherical skylights inside the patient rooms spread light outward, illuminating the rear of the room, a place typically dark in most hospitals. These spheres capture light throughout the year. In the summer, they function as typical skylights, bringing light into the room when the sun is at a high angle in the sky. In the winter, the spherical shape captures low angle sunlight and disperses it into the interior.

DAYLIGHTING AND SCREENING

Structure + Envelope

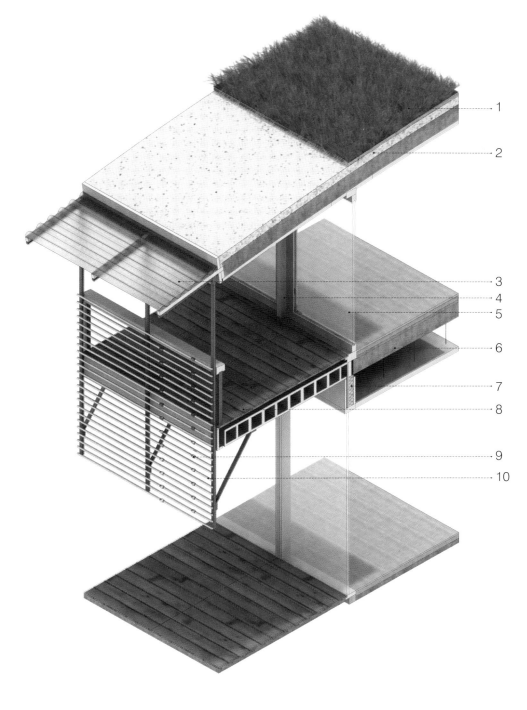
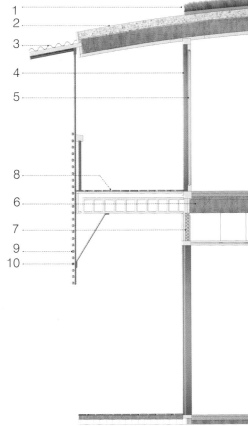

FAÇADE SECTIONAL MODEL
1. GREEN ROOF
2. INSULATION
3. CORRUGATED ACRYLIC SHEET
4. WOOD CLADDING
5. GLASS
6. CONCRETE SLAB
7. INSULATION
8. WOOD DECK
9. PLEXIGLASS DOWELS
10. WOODEN DOWELS

1.6 [S+E] Rehab Basel

BUILDING ENVELOPE The entire building is surrounded by a deep veranda. In addition to serving as a place for patients to lie in bed on nice days, the veranda allows each room to have an exterior glass wall without any heat gain. Complementing the depth of the veranda, a wood screen composed of horizontal wood rods and Plexiglas dowels helps screen from solar gain and glare. In the summer, the wood screen on the handrail and the corrugated translucent outrigger provide shade for the veranda itself. In spite of this shading, the rooms are well lit with natural daylight. Sphere-shaped skylights bring natural light deep into the rooms to mitigate the need for artificial lighting, a ubiquitous element of the typical hospital. In addition to the fixed screens, retractable canvases on both the ground and second floors provide additional solar protection when needed.

VERANDAS The patient room verandas are shaded by both vertical and horizontal screens. The screens allow for diffused light and solar protection. The vertical screen is composed of the handrails of the veranda, which extend down to the ground-floor covered walkway. This screen shades low light for the patient rooms on the second floor and shades the walkway from high light in the middle of the day. The corrugated translucent outrigger provides shade as a horizontal screen. This outrigger extends the covered veranda and protects the patient rooms from afternoon sun. As a supplement to these fixed screen systems, a retractable canvas is used for protection from intense solar exposures.

SOURCES
Cecilia Marquez and Fernando Levene, Herzog & DeMeuron, 1998-2002, 1st ed. (Madrid: El Croquis Editorial, 2004), 109-110.

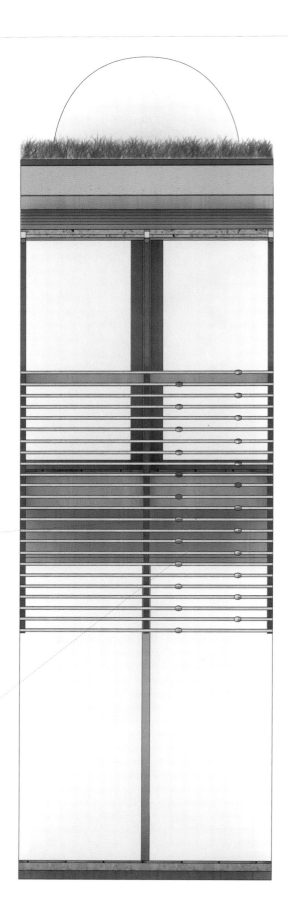

Structure + Envelope

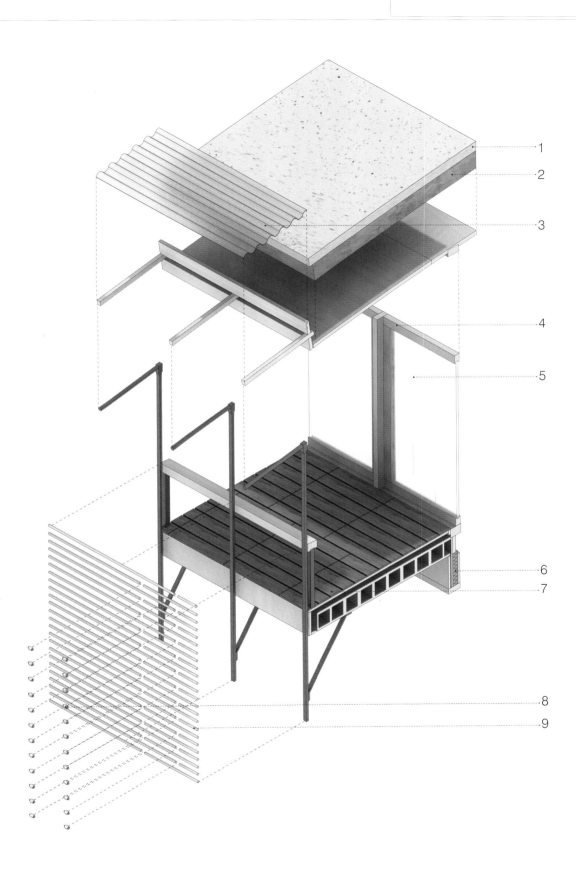

FAÇADE SECTIONAL MODEL
1 INSULATION
2 CONCRETE SLAB
3 CORRUGATED ACRYLIC SHEET
4 WOOD CLADDING
5 GLASS
6 INSULATION
7 WOODEN TERRACE
8 PLEXIGLASS DOWELS
9 WOODEN DOWELS

1.7 [S+E] Thermal Baths

Structure + Envelope

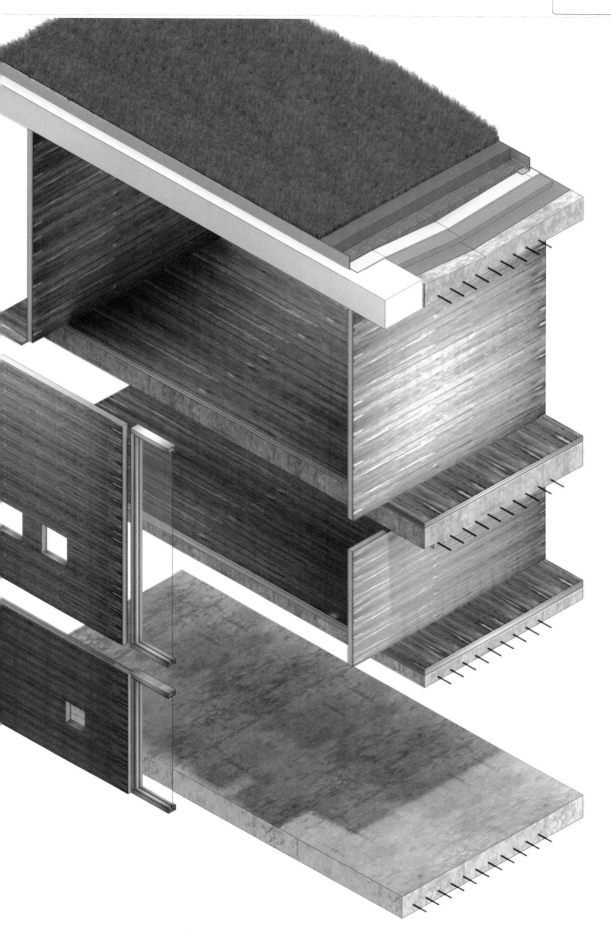

1.7 [S+E] Thermal Baths

ARCHITECT	Peter Zumthor
LOCATION	Vals, Switzerland 46.4°N 9.1°E
DATE	1996

LOCATION CONDITIONS

BACKGROUND The Thermal Baths building is located in a remote valley near the small village of Vals. The building was commissioned to create a new spa, replacing the bathing facilities of an existing hotel. The spa serves as a luxurious facility for visitors to experience the benefits of the thermal springs of Vals. The new building is connected to the existing hotel complex, which is accessed by an underground tunnel. Much of the building is either subterranean or engaged within the hill. The program for this building includes a series of pools of varying temperatures, changing rooms, restrooms, showers, massage rooms, rest spaces, and terraces. The building mass is organized around a central indoor pool and a rectangular outdoor pool.

STRUCTURE AND ENVELOPE The structure of the thermal baths is composed of concrete and stone load-bearing walls with cantilevered concrete roofs supported by tie beams. The walls are comprised of solid cast-in-place concrete covered with locally quarried Vals gneiss cladding. Zumthor refers to this structure as "large porous stones" as they give the impression that the building is excavated from the hill. This structure is a man-made cave with cavernous spaces punctuated with discrete light apertures.

GREEN ROOF A vegetated roof composed of grass, earth and insulation covers the concrete roof of the thermal baths.[1] The roof minimizes the heat island effect of the structure and contributes to the insulation of the space below. The roof has an effective insulating system that is interrupted by thin linear skylights that are flush to the top of the grass. These skylights are double-glazed to minimize this thermal break. In the winter, these skylights are heated to prevent freezing.

REFERENCES
1. Peter Zumthor, Architecture and Urbanism, extra ed. (Tokyo: A+U Publishing Co., Ltd., 1998), 172.

SOURCES
Peter Zumthor, Three Concepts, illustrated ed. (Boston: Birkhäuser Verlag, 1997).

Peter Zumthor and Hélène Binet, Peter Zumthor Works: Buildings and Projects 1979-1997 (Switzerland: Lars Müller, 1998).

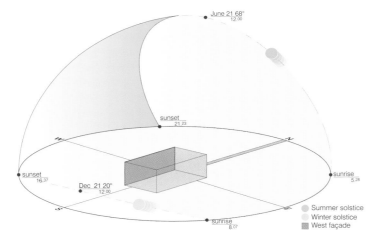

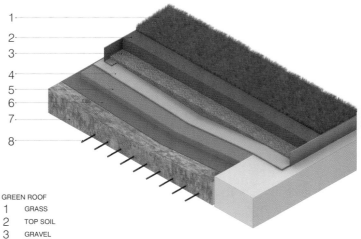

GREEN ROOF
1. GRASS
2. TOP SOIL
3. GRAVEL
4. DRAINAGE MAT
5. STYROFOAM INSULATION
6. WATERPROOFING BARRIER
7. REINFORCED CONCRETE ROOF SLAB
8. REINFORCING BAR

PERFORMANCE Geothermal insulation provides a stable thermal environment for this building. This is achieved by integrating the structure and the building envelope with the natural topography. The design utilizes the surrounding hill as a thermal insulator protecting the interior from extreme temperature fluctuations. The majority of the baths and pools are contained within the hill. These rooms benefit from this containment, as they do not need to mitigate the exterior weather conditions. The largest pool in the bath is outdoors. This pool is exposed to the elements and has eastern and southern exposure. The thermal mass of the structure also helps to insulate the Vals' spring water. The building also utilizes a green roof to provide insulation. While many program components are embedded in the natural slope, the stone and concrete walls outside of the hill support the rest of the building functions. These walls are substantial enough to act as significant thermal masses and absorb passive solar heat during the day and emit it at night.

Structure + Envelope

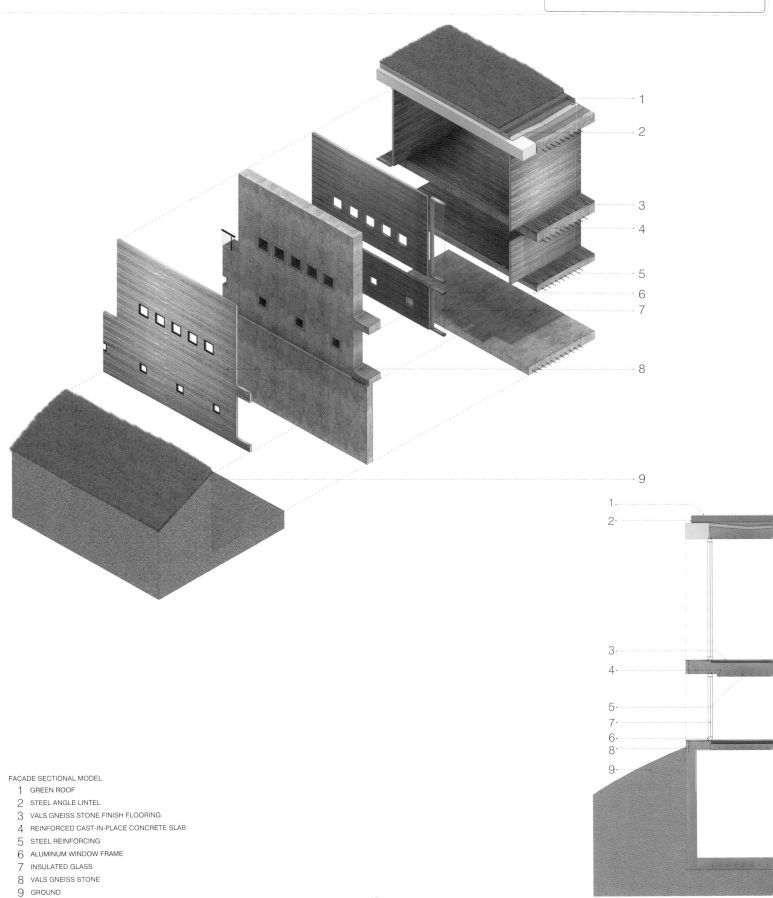

FAÇADE SECTIONAL MODEL
1. GREEN ROOF
2. STEEL ANGLE LINTEL
3. VALS GNEISS STONE FINISH FLOORING
4. REINFORCED CAST-IN-PLACE CONCRETE SLAB
5. STEEL REINFORCING
6. ALUMINUM WINDOW FRAME
7. INSULATED GLASS
8. VALS GNEISS STONE
9. GROUND

1.8 [S+E] Arup Campus

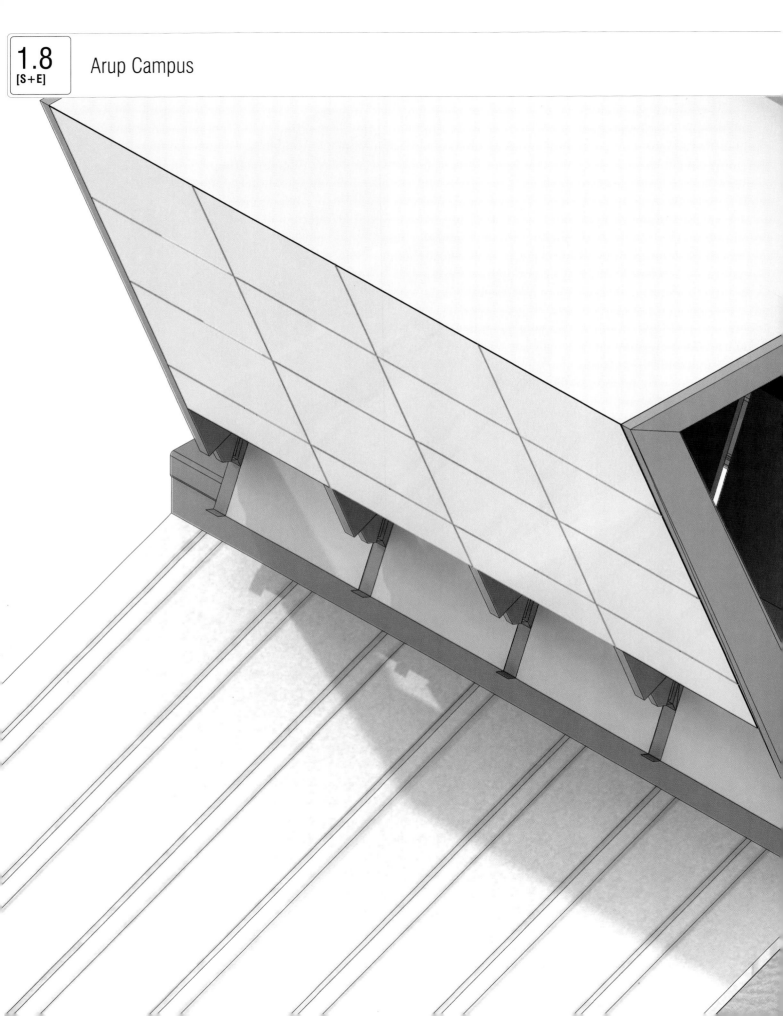

Structure + Envelope

1.8 [S+E] Arup Campus

ARCHITECT	Arup Associates
LOCATION	Solihull, England
	52.4°N 1.8°W
DATE	2001

LOCATION CONDITIONS

BACKGROUND Situated along a sloping site in a business park near Solihull, England, Arup Campus houses a new facility for seven hundred employees engaged in diverse disciplines of design, architecture, and engineering. The campus consists of two parallel pavilions joined by a central spine containing common facilities. The pavilions are two storeys tall, providing a deep open plan that is lit from above. The overall energy saving strategy for the building is to maximize the use of natural lighting and ventilation while minimizing heat loss through a thermally efficient envelope. This strategy combines important principles in modern office design, allowing occupants to control their own working conditions while reducing the building's impact on the environment.

PERFORMANCE The rectangular shaped building is oriented to the northwest and southeast to optimize daylighting and reduce glare. The short sides of the building face northeast and southwest to mitigate the hot morning and late afternoon sun. In addition, these façades utilize smaller window openings to limit heat gain while providing some light for general illumination.

The building's most successful aspect of systems integration is achieved by designing a structural system that facilitates daylighting. The design uses generous ceiling heights, clerestories, and light scoops supported by steel framing to bring significant amounts of light to the center of the building. The light scoops consist of aluminum enclosures with louvers at regular intervals along the roof. Underneath these light scoops, the second-floor slab opening allows light to pass through and reach the first-floor areas. This illumination strategy eliminates the need for permanent artificial lighting that is normally required by a deep-floor plan design.

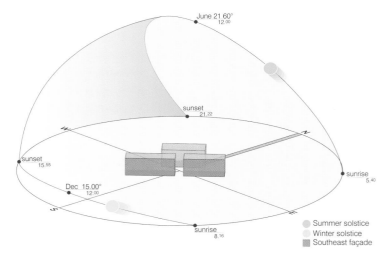

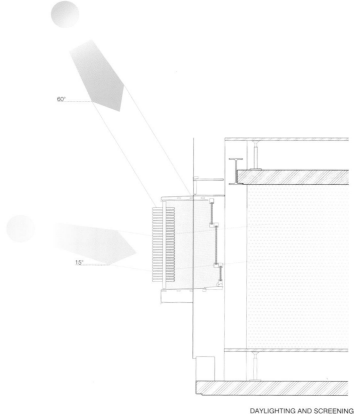

NORTHEAST Glazing in the northeast façade is minimized to reduce heat gain and achieve comfortable interior temperatures.

NORTHWEST The entry of diffused sunlight on the northwest façade is controlled throughout the day by manually operated internal blinds.

SOUTHEAST During summer, large amounts of solar radiation enter this façade. Solar screening is provided by the external timber louvers controlled by the building management system.

SOUTHWEST The southwest façade receives light at a steep angle during the summer. Glazing is minimized in this façade to reduce solar load while allowing daylight entry.

DAYLIGHTING AND SCREENING

Structure + Envelope

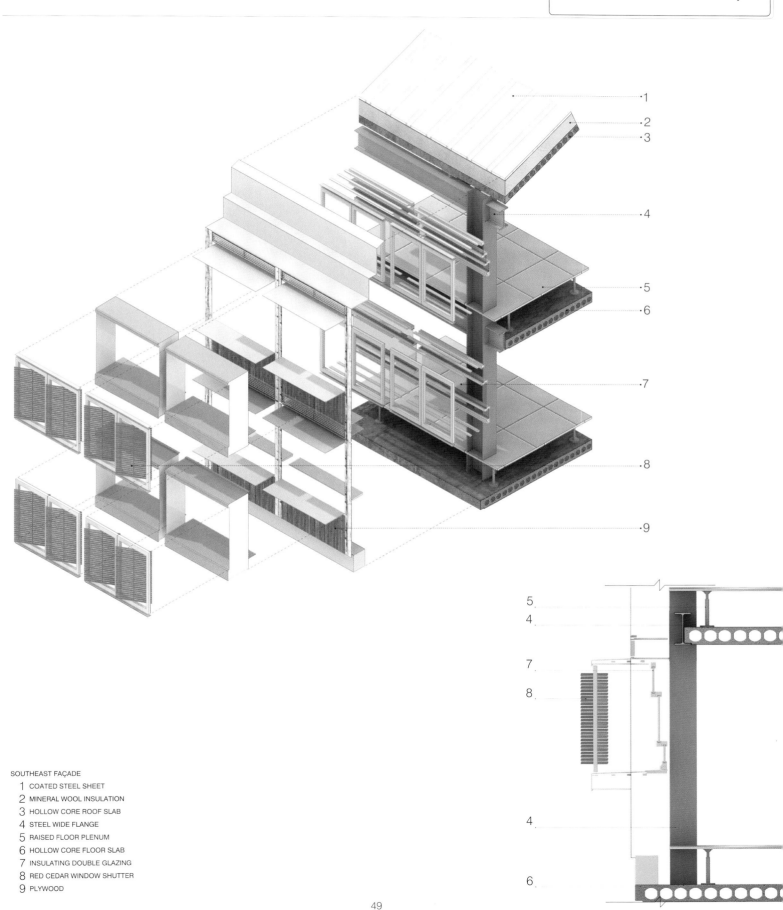

SOUTHEAST FAÇADE
1. COATED STEEL SHEET
2. MINERAL WOOL INSULATION
3. HOLLOW CORE ROOF SLAB
4. STEEL WIDE FLANGE
5. RAISED FLOOR PLENUM
6. HOLLOW CORE FLOOR SLAB
7. INSULATING DOUBLE GLAZING
8. RED CEDAR WINDOW SHUTTER
9. PLYWOOD

1.8 [S+E] Arup Campus

STRUCTURE The structural system of the two pavilions is designed to provide an economic structural solution to minimize embodied energy, and to be reused once the building is no longer needed. The structure of each pavilion is composed of a steel frame with hollow core floor and roof slabs. There are three parallel rows of columns composed of steel wide flange: two rows located on the periphery supporting the floors, and one central row of Y-shaped columns. The Y-shaped columns support the light scoops that project above the roof, allowing daylight penetration. The use of this structural system permits a continuous open space providing a high degree of flexibility and adaptability. The steel frame is left exposed and is bolted to allow disassembly and reuse at the end of the building's cycle.

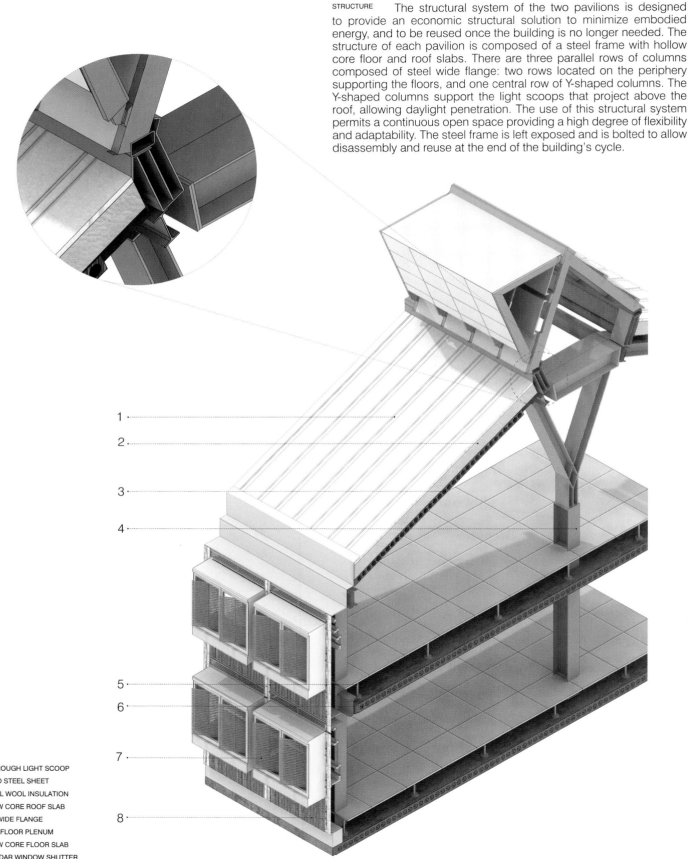

SECTION THROUGH LIGHT SCOOP
1. COATED STEEL SHEET
2. MINERAL WOOL INSULATION
3. HOLLOW CORE ROOF SLAB
4. STEEL WIDE FLANGE
5. RAISED FLOOR PLENUM
6. HOLLOW CORE FLOOR SLAB
7. RED CEDAR WINDOW SHUTTER
8. PLYWOOD

Structure + Envelope

ENVELOPE The building envelope is primarily clad with untreated western red cedar from certified environmentally managed sources. Each façade is carefully designed to respond to the building's orientation. The southeast two-storey façade is equipped with external shading to control solar heat gain. These shading devices consist of timber louvers that are electronically operated by a building management system with manual override. The northwest façade, where solar penetration is not as critical, incorporates manually operated interior blinds to allow individual control and glare reduction. The use of shading devices along the long façades enables highly adaptable control of natural daylighting.

VENTILATION The building envelope is designed to provide natural ventilation during most of the year. The exterior walls have windows with operable vents at high and low levels that admit fresh air from the outside. The light scoops, which are a critical component of the ventilation system, perform as chimneys to draw hot air out of the building. During the summer, windows are opened as necessary to allow fresh air to cool the interior and exit the building via the light scoops. The same strategy is utilized during the night to provide effective night cooling. In winter conditions, a low-pressure hot water system with perimeter radiators keeps the building warm. Temperature sensors located throughout the building activate the building management system to control ventilation rates.

SOURCES

Corus Group, Sustainable Steel Construction, The Design and Construction of Sustainable Buildings (UK: Corus, 2006), 16-17.

Dean Hawkes and Wayne Foster. Energy Efficient Buildings: Architecture, Engineering, and Environment, first American ed. (London: W.W. Norton & Company Ltd., 2002), 62.

Derek Phillips, Daylighting: Natural Light in Architecture, illustrated ed. (Oxford: Architectural Press, Elsevier, 2004).

Dr Joanne Wade, Jacky Pett, and Lotte Ramsay, Energy Efficiency in Offices: Motivating Action (ACE The Association for the Conservation of Energy, 2003), 30-31.

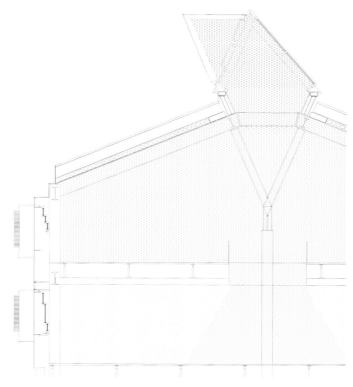

LIGHT SCOOP ILLUMINATION

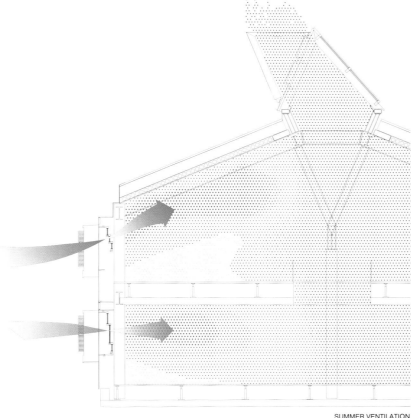

SUMMER VENTILATION

1.9 [S+E] Manchester Civil Justice Centre

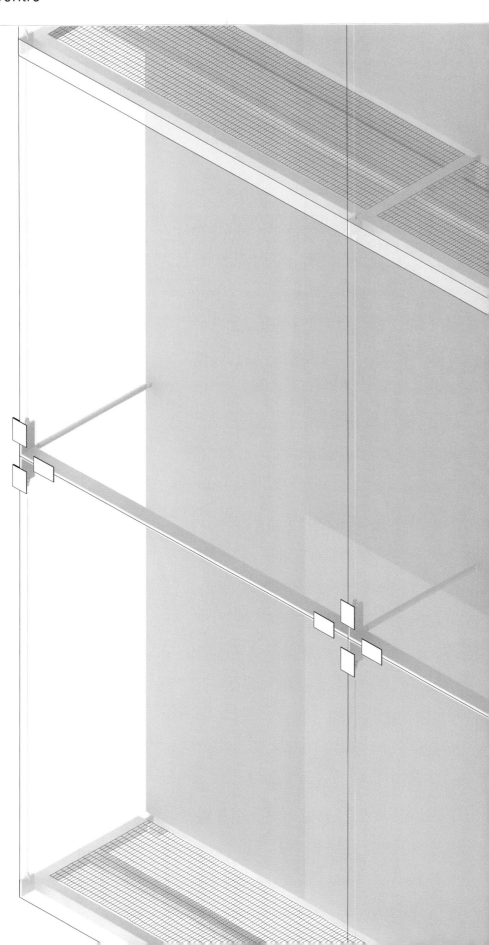

Structure + Envelope

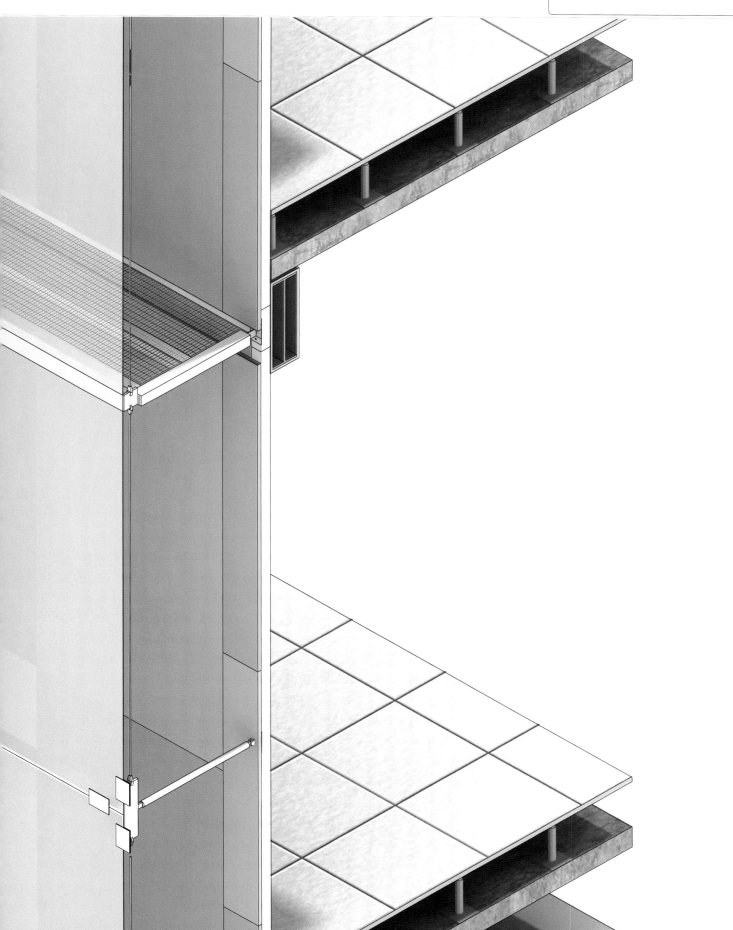

1.9 [S+E] Manchester Civil Justice Centre

ARCHITECT	Denton Corker Marshall
LOCATION	Greater Manchester, England 53.3°N 2.1° W
DATE	2007

LOCATION CONDITIONS

BACKGROUND The Civil Justice Centre for Manchester is one of the largest court complexes in England. The building design was the winner of an international competition for the Ministry of Justice headquarters. The competition brief called for environmental sustainability and energy saving strategies as critical design priorities. After a winner was selected, an integrated design process provided for close collaboration between the client, the future occupants, and the design team. The building can be identified with three primary volumes: an elongated volume on the west side consisting of an eleven-storey glazed atrium that provides public areas and concourses serving all court levels and publicly accessed office areas; a fifteen-storey vertical volume that encloses separate circulation routes for the public, defendants, and judges; and an east side volume housing courtrooms, tribunals, hearing rooms, and related offices. The east side volume projects out from the ends of the building, creating distinctive north and south façades with significant cantilevers.

NORTH The cantilevered volumes at the north end utilize a double skin façade system with an inner skin of aluminum sheets to admit diffused sunlight.

EAST In the summer, solar radiation enters the east façade at a shallow angle during the morning hours. The veil provides shading to the glazed façade while maximizing natural daylight.

SOUTH The south façade receives sunlight at a steep angle during the summer. The double skin façade on the cantilevered volumes at the south end allows natural light into the building without excessive heat gain.

WEST In the west façade the glazed atrium receives large amounts of solar radiation. This double skin façade functions as a buffer zone during the winter months.

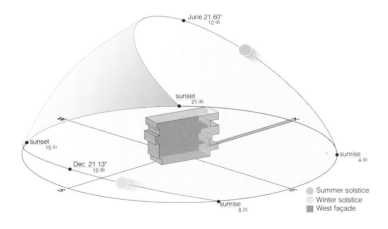

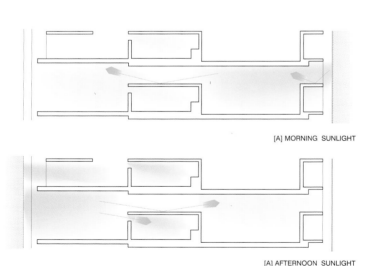

[A] MORNING SUNLIGHT

[A] AFTERNOON SUNLIGHT

PERFORMANCE The long and slender form of the building was selected to maximize natural lighting and natural ventilation. The building's orientation takes advantage of prevailing winds by placing wind scoops along the west façade to collect fresh air. The glass atrium on the south side admits ample light for the illumination of public spaces as well as channelling light into the courtrooms. This atrium has a double-glazed skin suspended from the roof structure to control solar heat gain. The integration of structure and envelope is one of the main features contributing to the sustainability of the building. In addition to reducing the cooling load, the building uses a ground water supply. These green strategies reduce energy consumption of the building by 15 percent to 20 percent.[1]

Structure + Envelope

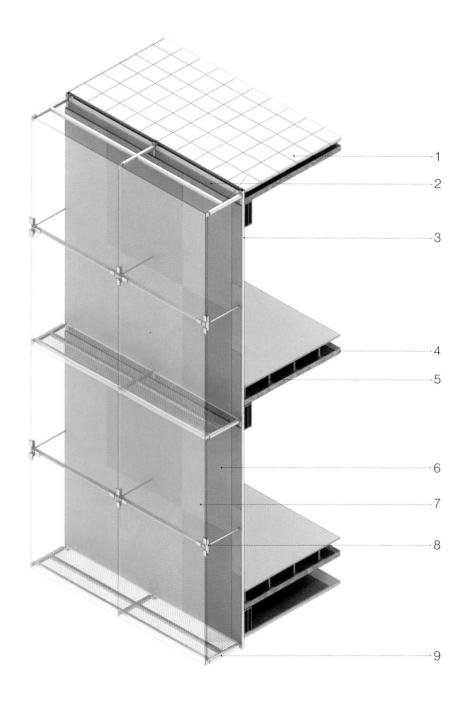
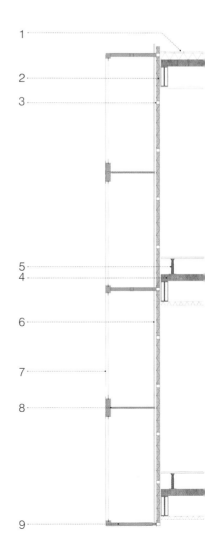

NORTH AND SOUTH FAÇADES
1. CONCRETE PAVERS
2. INTERIOR MINERAL WOOL INSULATION
3. ALUMINUM MULLION AND TRANSOM PROFILES BOLTED TO SECONDARY STRUCTURE
4. REINFORCED CONCRETE SLAB
5. RAISED ACCESS FLOOR SYSTEM
6. ALUMINUM PANELING
7. EXTERIOR GLAZING
8. CIRCULAR HOLLOW SECTION STRUT BOLTED TO ALUMINUM PANEL FRAMING
9. CANTILEVERED SUPPORT BEAM BOLTED TO SECONDARY STRUCTURE

1.9 [S+E] Manchester Civil Justice Centre

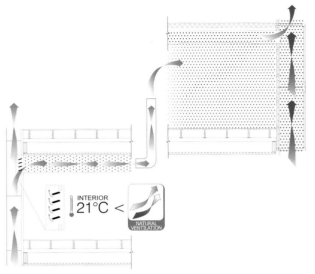

[A] SUMMER: NATURAL VENTILATION

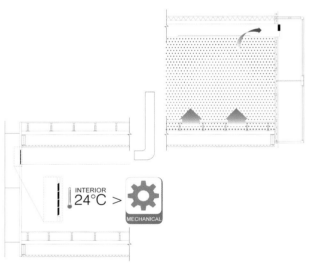

[B] SUMMER: MECHANICAL VENTILATION

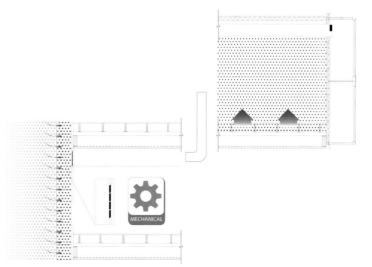

[C] WINTER: THERMAL BUFFER AND MECHANICAL VENTILATION

NATURAL VENTILATION The building's structural frame is designed to accommodate air paths that provide natural ventilation throughout the building. The court complex utilizes natural ventilation as part of a mixed-mode strategy. Natural ventilation is provided by directing outside air from the west to the east of the building. The air is taken in through long wind scoops integrated onto the west façade and is channelled to the top of each floor. Air is then discharged into the courtroom on the floor above through a diffuser located on the wall. Temperature sensors in each of the courtrooms monitor the interior climate. When temperature rises above 70°F (21°C), smoke and fire dampers in the ventilation ducts open to allow fresh air into the rooms. When the interior temperature reaches 75°F (24°C), the air-conditioning system is activated.[2] To admit natural light into the building, the court complex utilizes the air path that supplies natural ventilation. The light-air path admits ample sunlight from the west façade to illuminate the courtrooms without excessive heat gain.

MECHANICAL VENTILATION The court complex utilizes a mechanical cooling system to supplement natural ventilation. This consists of a centralized air-conditioning system that supplies air under the floor of the courts, the consultation rooms, and the meeting rooms. The air-handling units, located on the roof, are supplied by ground water cooled from an aquifer sitting underneath the building. Ground water is extracted at 54°F (12°C) from two deep boreholes.[3] This water passes through a series of heat exchangers to cool the building and the building's chillers. Groundwater is also used to cool the water in the atrium's floor system by radiant cooling.

VENTILATION

SUMMER:
[A] NATURAL VENTILATION Natural ventilation is used during mild or warm weather. Wind scoops on the west façade circulate air through the building to provide natural ventilation. When the wind speed is too low for the natural ventilation system to function, or when internal temperatures reach 75°F (24°C), mechanical cooling is activated.

[B] MECHANICAL COOLING A mechanical cooling system is used when internal temperatures rise above 75°F (24°C). The building utilizes chilled ground water to cool the interior space. Water extracted from the aquifer underneath the building runs through heat exchangers to cool the court complex and then it is returned back into the river to maintain the surrounding water table.

WINTER:
[C] MECHANICAL VENTILATION During the cold months, the west façade is closed by sensor-controlled dampers to create a buffer and minimize natural ventilation. Mechanical heating is provided for each courtroom and meeting room with individual thermal control. The atrium space is heated with underfloor heating.

Structure + Envelope

STRUCTURE The building utilizes steel framing to achieve large column-free interior spaces. However, the most complex aspect of the structure is the support of cantilevered volumes projecting from the north and south sides of the building. These cantilevers are structured with 39-feet-tall (12 meters) prefabricated trusses that rest on double columns at the ends of the main building's frame. The trusses are welded at the joints to create a rigid frame that provides adequate support for the cantilevered volumes. The tension forces on the top chords and the compression forces on the bottom chords are distributed through the truss and are transferred to the composite steel floors and then to the building's concrete core.

BUILDING ENVELOPE The volumes cantilevering from the north and south building faces utilize double-skin façades to provide light and acoustic control. These volumes are clad in laminated glass on the outer skin and aluminum sheets of a random pattern of colors on the inner skin. The inner skin is supported by a secondary structure of steel beams, which is bolted to the primary structure at each floor level. A central stainless steel strut located at mid-height braces the outer layer against wind loads. The long western façade is dominated by one of the largest glazed atriums in Europe. This façade consists of a ventilated double skin that functions as a buffer zone during the cold months of winter. The west façade integrates wind scoops to provide natural ventilation for the building during the summer months.

The eastern façade of the building is fully glazed with an exterior layer of shading devices. This layer consists of aluminum-perforated panels at strategic points to provide sun screening, maximize daylighting, and provide views. The perforations on the aluminum layer are arranged to coincide with clerestorey windows that admit daylight into the courtrooms.

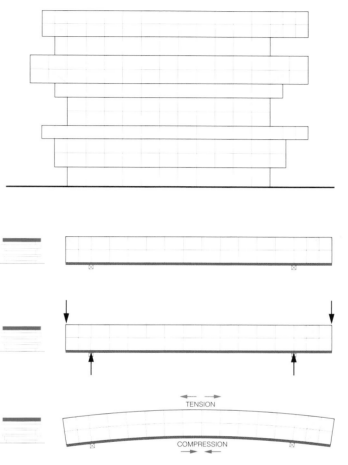

TENSION AND COMPRESSION FORCES ON THE STEEL TRUSS

REFERENCES
1. Bovis Lend Lease, "Manchester Civil Justice Centre," http://www.bovislendlease.com/llweb/bll/main.nsf/images/pdf_project_uk_manchester_cjc.pdf/$file/pdf_project_uk_manchester_cjc.pdf.
2. Logan, Stephen, "Low Energy Initiatives Manchester Civil Justice Centre" (EcoLibrium, 2008), 29.
3. Ibid., 28.

SOURCES
Bizley, Graham. "Civil Justice Centre, Manchester." In Detail.

"Courtroom Appeal," NSC, September, 2005.

"Doing Manchester Justice," NSC, February, 2008.

Kennett, Stephen, "Courtroom Drama," Building Services Journal: The Magazine of CIBSE, (2007), bsjonline.co.uk.

"Manchester Civil Justice Centre," Commission for Architecture and the Built Environment (CABE), http://www.cabe.org.uk/case-studies/manchester-civil-justice-centre.

2
[E+M]

Envelope + Mechanical

The integration of the building envelope with mechanical systems has enormous ramifications on the thermal performance and climate control of the interior environment. A building's mechanical system controls the heating, cooling, and air quality, which is greatly impacted by the infiltration of air and light through the envelope. Buildings surveyed in this section illustrate how the integration of the exterior envelope with mechanical systems translates into energy efficiency and thermal comfort. These buildings achieve higher performance by utilizing a number of strategies. Some of these strategies include utilizing shading devices to mitigate solar heat gain, extensive daylighting with mechanical controls, and providing passive heating and cooling. Responsive façades are also used to reduce energy consumption and provide the building occupants with comfortable, light-filled interiors.

2.1 [E+M] Caltrans District 7 Headquarters Building

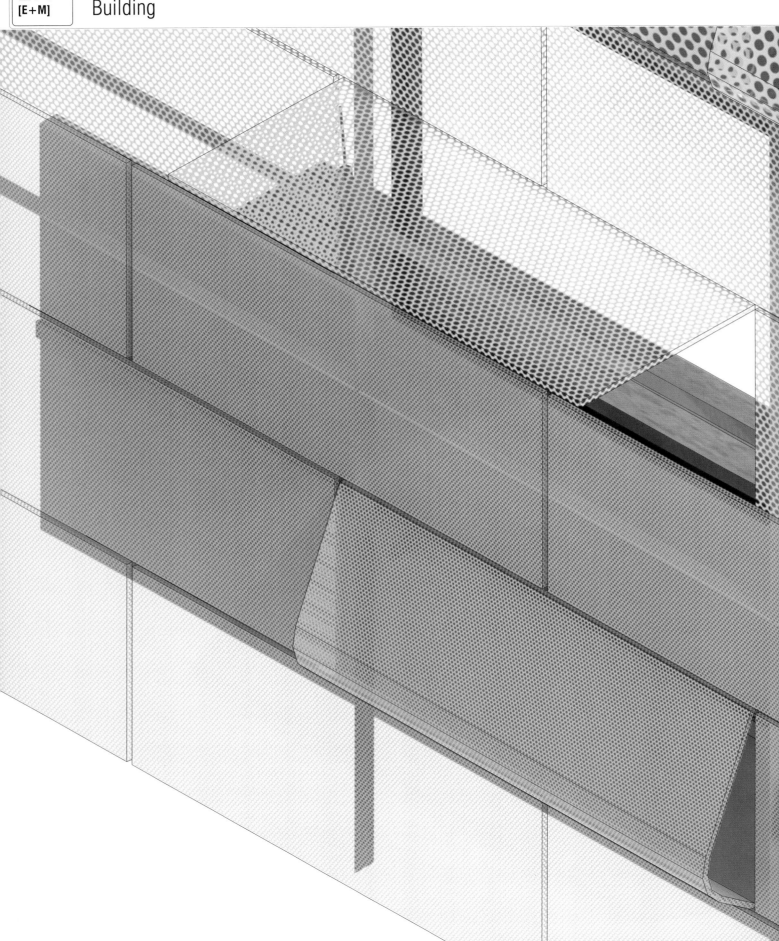

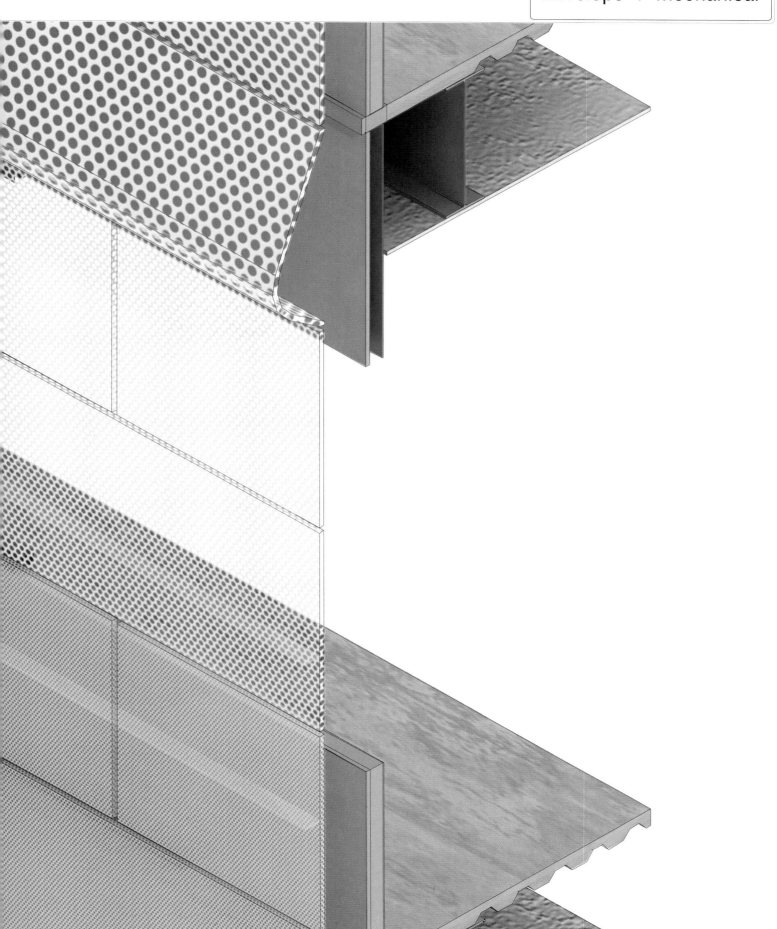

Envelope + Mechanical

2.1 [E+M] Caltrans District 7 Headquarters Building

ARCHITECT	Tom Mayne, Morphosis
LOCATION	Los Angeles, California, USA
	42.0°N 32.5°E
DATE	2004

LOCATION CONDITIONS

BACKGROUND The Caltrans District 7 Headquarters Building occupies an entire city block in downtown Los Angeles. The thirteen-storey building was built to exemplify the state's commitment to design, the environment, and civic life of Los Angeles. The building program is parking, retail space, offices, and public space and amenities. Two volumes compose this project: a large thirteen-storey volume that extends an entire block and a smaller four-storey volume. The volumes combine to form an L-shaped footprint that defines a public plaza.

The design of the building emphasizes open and large, naturally lit work areas. Almost all private enclosed offices are placed at the center of the floor plan, leaving the large perimeter open for workspaces. This layout enables the majority of employees to have access to windows with shading devices, thus enabling them to manually control natural light and ventilation. The building incorporates large centralized stairwell lobbies with the use of skip-stop elevators. The main elevators stop every three floors to reduce waiting time, promote social interaction, and encourage physical activity. The building has a constantly changing mechanical skin that responds to sunlight and exterior temperatures

NORTH The north façade, which consists of double-pane glazing, allows plenty of diffused sunlight to enter the building throughout the day.

EAST Large amounts of solar radiation enter the east façade in the early morning. The operable aluminum panels filter direct sunlight to achieve a comfortable environment.

SOUTH The south façade receives solar radiation at a steep angle throughout the day. This façade is entirely covered with photovoltaic cells that generate electricity and provide shading to prevent heat gain.

WEST In summer, the west façade receives great amounts of solar radiation. The double façade protects the building against summer heat gain by the exterior aluminum scrim that responds to the movement of the sun and weather conditions.

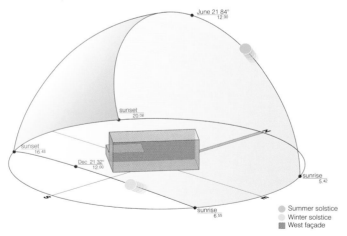

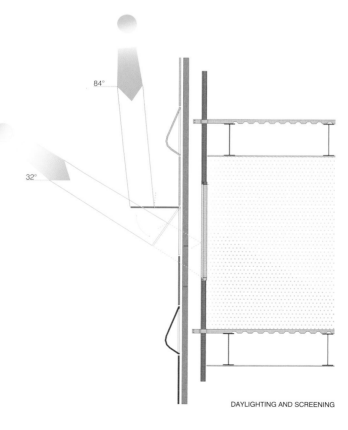

DAYLIGHTING AND SCREENING

PERFORMANCE The Caltrans Headquarters building features a remarkable double-skin façade system that minimizes energy consumption by a considerable amount. The east and west façades are comprised of intelligent features that monitor ambient conditions to adjust an exterior layer of metal panel shading devices. These façades respond to the position of the sun to provide ample natural light while reducing heat gain on the building. The innovative south façade also contributes to the sustainable design of the building. It utilizes an exterior layer of photovoltaic panels to generate electricity and minimize heat load on the building's façade.

Envelope + Mechanical

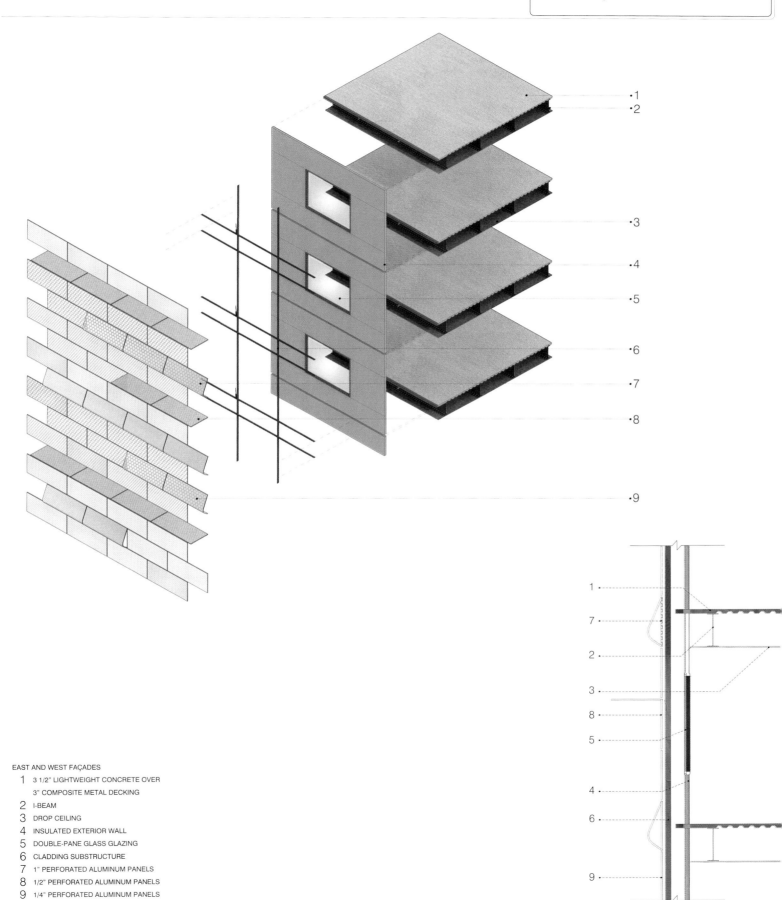

EAST AND WEST FAÇADES
1. 3 1/2" LIGHTWEIGHT CONCRETE OVER 3" COMPOSITE METAL DECKING
2. I-BEAM
3. DROP CEILING
4. INSULATED EXTERIOR WALL
5. DOUBLE-PANE GLASS GLAZING
6. CLADDING SUBSTRUCTURE
7. 1" PERFORATED ALUMINUM PANELS
8. 1/2" PERFORATED ALUMINUM PANELS
9. 1/4" PERFORATED ALUMINUM PANELS

2.1 [E+M] Caltrans District 7 Headquarters Building

BUILDING FAÇADES The east and west façades of the Caltrans Headquarters building, which are directly exposed to the hot California sun, utilize a double-skin façade system. These façades are composed of an interior layer of solid curtain wall with ribbon windows and an exterior layer of adjustable- and fixed-perforated aluminum panels. The aluminum scrim of perforated panels is positioned 10 inches (25 centimeters) away from the curtain wall to minimize solar load. These panels were engineered and fabricated with perforations of varying sizes to provide openness and admit natural light. They are sensor controlled and automatically close to respond to the position of the sun and outside temperatures. When direct sun is not hitting the side of the building, the panels automatically open, allowing for increased ambient light. The perforated scrim also reduces the temperature on the inner skin by creating a microclimate between the two layers. Hot air is channeled upwards, while cooler air rises from beneath. This double façade system significantly reduces heat gain and energy consumption.

The south façade incorporates one of the largest exterior photovoltaic walls in the western United States. It is composed of a double façade with an exterior layer of integrated photovoltaic (PV) panels that provide sunshade and absorb solar energy for electrical power. These panels harvest solar energy and convert it into electricity during hours when cooling demands are at their highest. The electrical power generated by the PV cells accounts for 5 percent of the building's energy requirement.[1] The south façade also reduces the heat load in the building by the shading from the opaque PV cells and by natural ventilation between the two layers of the façade.

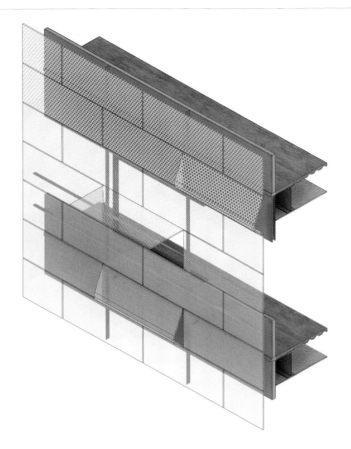

EAST AND WEST FAÇADES: PERFORATED ALUMINUM PANELS

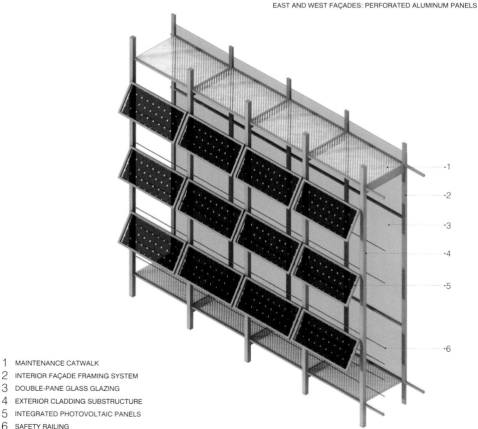

1 MAINTENANCE CATWALK
2 INTERIOR FAÇADE FRAMING SYSTEM
3 DOUBLE-PANE GLASS GLAZING
4 EXTERIOR CLADDING SUBSTRUCTURE
5 INTEGRATED PHOTOVOLTAIC PANELS
6 SAFETY RAILING

SOUTH FAÇADE: INTEGRATED PHOTOVOLTAIC PANELS

Envelope + Mechanical

LIGHTWELL A twelve-storey lightwell above the lobby area cuts through the center of the building to provide additional daylight and natural ventilation. The lightwell, which is in contrast to the opacity of the exterior metal panels, admits natural light to prevent dark spots at the center of the large floors areas. This central space also functions as a chimney, allowing hot air to rise and escape the building while cool air enters and ventilates the interior space.

REFERENCES
1. "Caltrans District 7 Headquarters," Morphosis Architects, Morphopedia, February, 2009, http://morphopedia.com/projects/caltrans-district-7-headquarters.

SOURCES
Eugene DeSouza, Andy Howard, and Teena Videriksen, "The Caltrans District 7, Los Angeles," The Arup Journal (February, 2005), http://goarup.com/docs/Caltrans%20District%207.pdf

Tiffany Lee-Youngren, "Glaziers Delight: Scrim Walls, Like Those on Caltrans Headquarters, Are Multifunctional," Glass, Your Online Industry Resource (2005), http://www.glassmagazine.com.

"Lighting Applications, Designing with Light in L.A.," Paramount Industries, http://www.paramount-lighting.com/caltrans-appl-sheet_3-05.pdf.

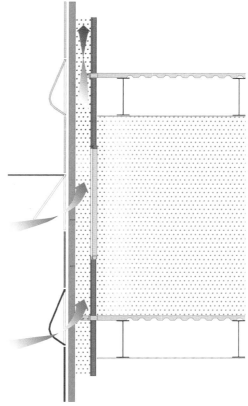

EAST AND WEST FAÇADE: NATURAL VENTILATION

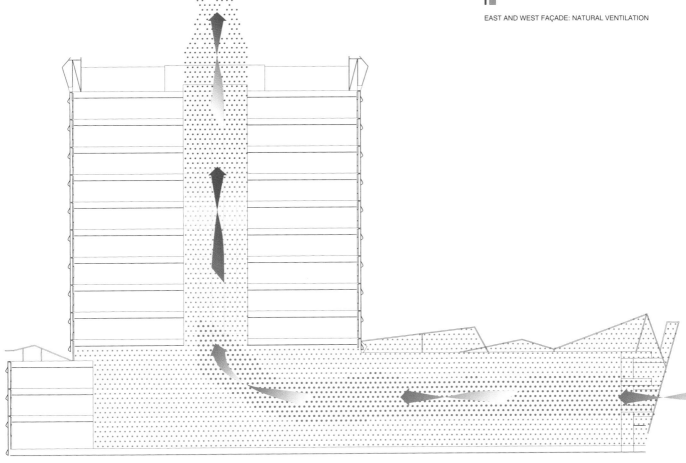

LIGHTWELL DIAGRAM

2.2 [E+M] Bregenz Art Museum

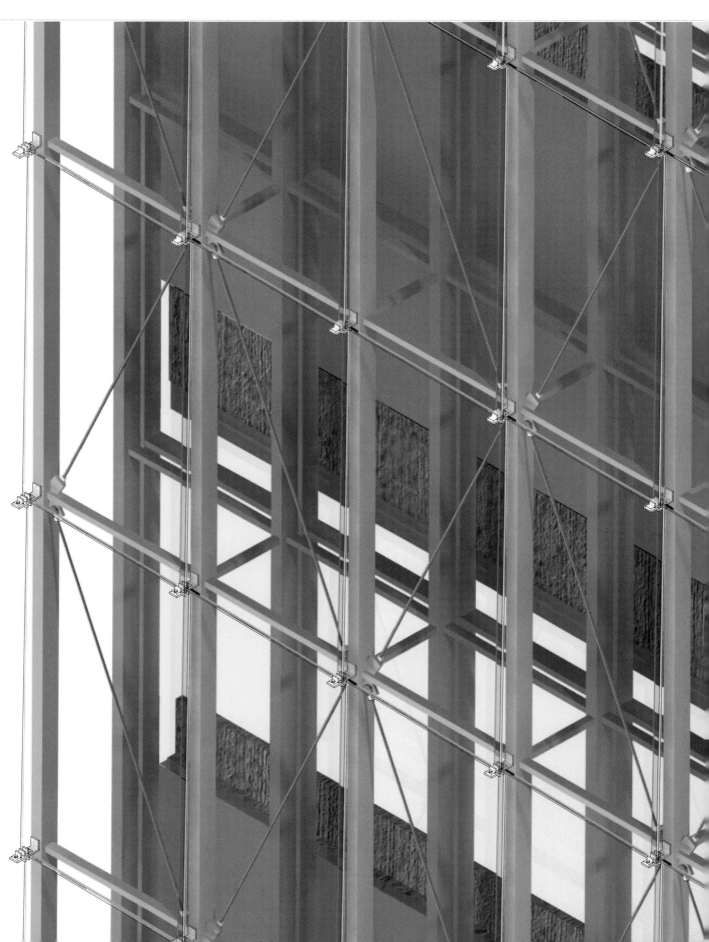

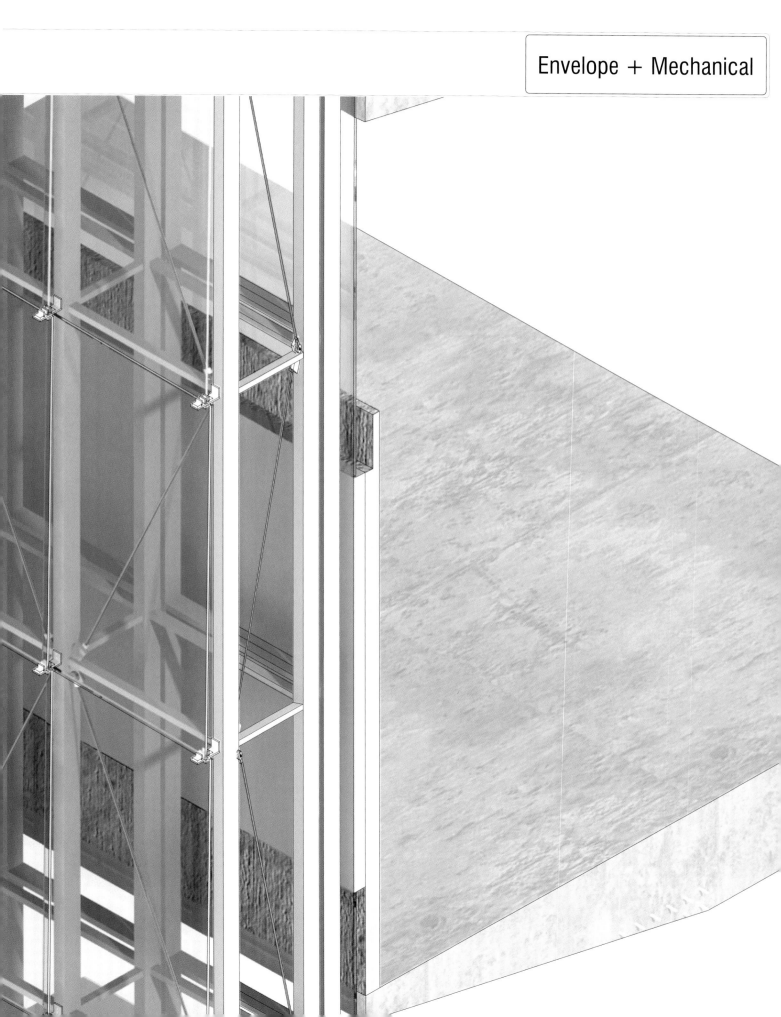

Envelope + Mechanical

2.2 [E+M] Bregenz Art Museum

ARCHITECT	Peter Zumthor
LOCATION	Bregenz, Austria
	47.3°N 9.4°E
DATE	1997

LOCATION CONDITIONS

BACKGROUND Located on the southern edge of Lake Constance, the Bregenz Art Museum is the result of an award-winning urban regeneration project. The main building is a four-storey concrete structure housing gallery spaces, reception areas, and storage spaces. All museum support spaces, including a library, administration offices, museum shop, and café, are located in a separate adjacent structure. This smaller support structure faces the city and acts as a mediator between the main museum building and the smaller scale buildings of the old town. This building allows the main museum space to be completely dedicated to the display of art. In the main building, each gallery is an open floor contained by perimeter display walls with a ceiling of glass illuminated by natural daylight.

PERFORMANCE The building uses a combination of active and passive strategies to reduce energy consumption. This is principally achieved by the integration of the envelope and mechanical systems. Both the cast-in-place concrete structure and the perimeter steel and glass façades are integral components of the environmental control systems that provide natural lighting, heating, and cooling. The building orientation of 30° off true north enables all the glass façades to receive ample natural daylight, while the double-skin façade surrounding the building on all four sides controls heat gain. The compact square shape selected for the museum encloses the largest volume with the least exterior exposed surface, thus reducing heat gain and heat loss through the envelope.

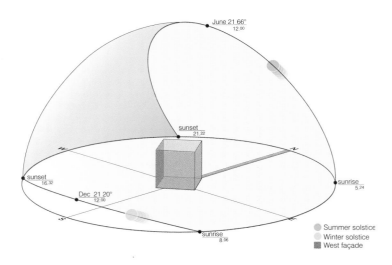
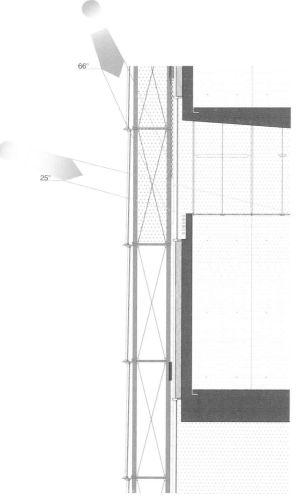

STRUCTURE The main museum building is composed of two distinct structural systems: a cast-in-place concrete structure and a perimeter steel frame. This perimeter steel frame surrounds the concrete structure and supports a glazed façade that performs as a partial insulator and a shading device for the building. The four-storey concrete structure contains the gallery spaces with four concrete boxes supported by concrete shear walls. Each box is held apart from the other boxes to allow natural light into the exhibition spaces.

DAYLIGHTING AND SCREENING

Envelope + Mechanical

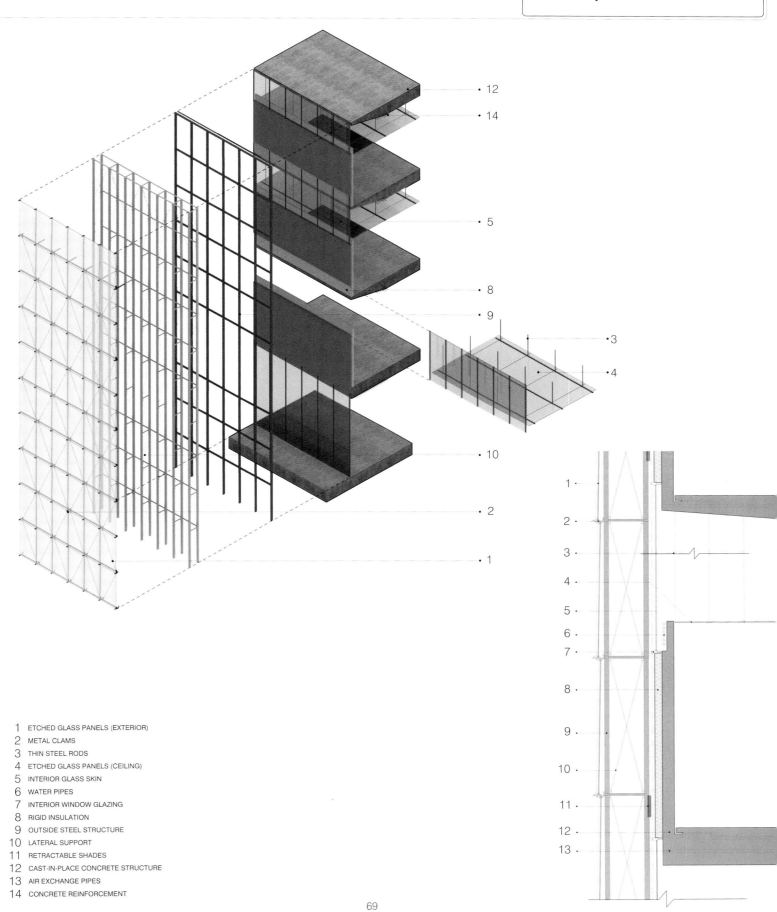

1. ETCHED GLASS PANELS (EXTERIOR)
2. METAL CLAMS
3. THIN STEEL RODS
4. ETCHED GLASS PANELS (CEILING)
5. INTERIOR GLASS SKIN
6. WATER PIPES
7. INTERIOR WINDOW GLAZING
8. RIGID INSULATION
9. OUTSIDE STEEL STRUCTURE
10. LATERAL SUPPORT
11. RETRACTABLE SHADES
12. CAST-IN-PLACE CONCRETE STRUCTURE
13. AIR EXCHANGE PIPES
14. CONCRETE REINFORCEMENT

2.2 [E+M] Bregenz Art Museum

BUILDING ENVELOPE A double-skin façade, composed of individually etched glass panels, which are connected by metal clips, forms a permeable, protecting surface for the museum. These glass panels are hung from a self-supporting steel frame independent of the concrete structure. The inner layer of the façade is composed of concrete walls and glass panels that seal the building. While these two layers cannot be considered a buffer façade with significant insulating capabilities, they do provide protection against the weather and serve as a shading device for the building, blocking harmful solar rays. The inner and outer layers of the façades are separated by a 3-foot (90 centimeters) vertical shaft that functions as a lightwell and illuminates a series of glass ceiling plenums. These plenums provide light to the galleries and reduce the need for artificial lighting.

During the summer, the outer-layer glass skin assists in the mitigation of solar heat gain. When hot air accumulates in the space between the inner- and the outer-façade layers, it will rise up and escape at the top openings. Further cooling is accomplished by air movement through the glass panels, reducing the temperature of the concrete structure. In winter, outer layer glass provides partial insulation against low temperatures.

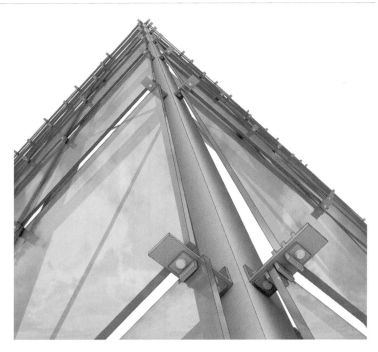

FAÇADE DIAGRAM

The Bregenz Art Museum is cloaked with a single all-encompassing skin. All façades have the same construction and provide natural lighting and shading to reduce unwanted heat gain. The air movement through the open glass panels contributes to cooling the building during the summertime.

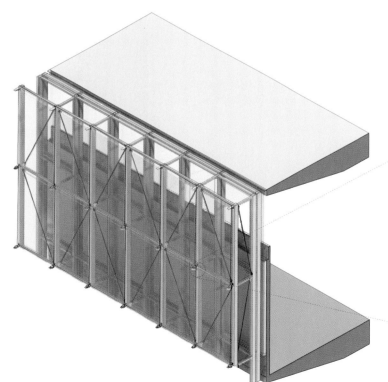

FAÇADE DETAIL

The building's exterior envelope is composed of individual glass panels suspended from each other with metal clips and thin steel rods. The metal clips allow the glass panels to overlap and create a rain screen similar to traditional shingles.

Envelope + Mechanical

SUMMER:

COOLING During the summer months, water pipes pump chilled water to cool the thermal mass of the concrete to achieve a comfortable interior temperature. Solar shading is provided by the building's envelope, which blocks direct solar rays reducing solar heat gain.

AIR EXCHANGE Pipes for air exchange embedded in the concrete walls and floors allow fresh air to enter the galleries, renewing the air in the rooms.

CLIMATE CONTROL The integration of a climate control system with the concrete structure provides the main heating and cooling source for the building and minimizes reliance on conventional mechanical systems. Both walls and floors of the concrete structure are equipped with two sets of plastic pipes. One set of pipes is utilized to pump cool or hot water through the concrete mass, and the second set supplies fresh air for air exchange. As the walls and floors of the concrete structure are cooled or heated, they become a thermal source for the gallery spaces. The air exchange system is used for replenishing fresh air in the galleries. The water pipes are supplied with water from a low-temperature reservoir.

SOURCES

Architecture and Urbanism, February 1998 Extra Edition, Peter Zumthor", A+U Publishing Co., Ltd. Tokyo, 1998.

"Kunsthaus Bregenz," EcoWikiArchitecture, February 2009, http://www.ecoarchwiki.net/pmwiki.php?n=Projects.KunsthausBregenz

"Cooling and Heating of Buildings by Activating their Thermal Mass with Embedded Hydronic Pipe Systems," Bjarne W. Olesen, http://www.cibse.org/pdfs/Embedded%20Hydronic%20Pipe%20Sys.pdf.

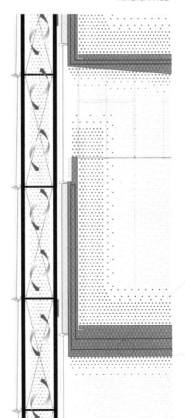

AIR EXCHANGE

SUMMER: COOLING

RADIANT FLOOR SYSTEM DIAGRAM

2.3 [E+M] Debis Headquarters Building

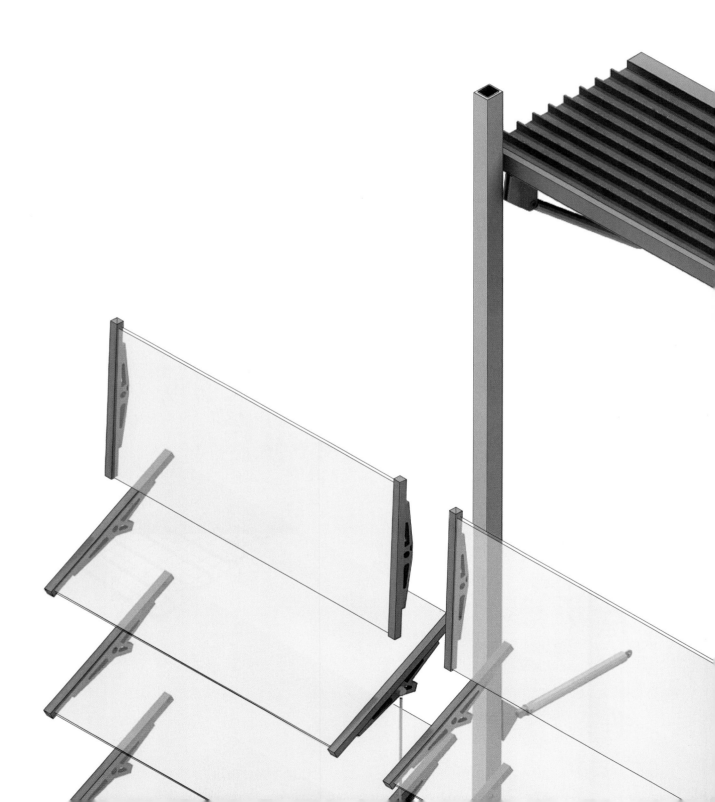

Envelope + Mechanical

2.3 [E+M] Debis Headquarters Building

ARCHITECT	Renzo Piano
LOCATION	Berlin, Germany
	52.3°N 13.3°E
DATE	1998

LOCATION CONDITIONS

BACKGROUND Located in historic Berlin, the Debis Headquarters is considered to be one of the most critical urban redevelopment projects and one of the largest commercial buildings in the recent history of Europe. The building is comprised of a low-rise, six-storey structure and a twenty-one-storey tower. The low-rise structure is divided by a wide atrium that serves as a public and exhibition space. The building complex is designed to accommodate office spaces as well as retail and food services in the lower levels. The interior organization of the building is designed to provide healthy working conditions through access to natural light and ventilation. The building utilizes double-skin façades with various degrees of transparency to respond to the solar orientation and provide occupant comfort.

NORTH The entry of sunlight is controlled throughout the day in order to achieve thermal comfort.

EAST In summer, large amounts of solar radiation enter at a shallow angle. Solar screening is provided by terra-cotta cladding elements.

SOUTH This façade receives light at a steep angle during the summer. Shading is provided by terra-cotta shading devices without reducing daylight entry. This façade is exposed to solar heat gain in winter.

WEST In summer, the west façade receives large amounts of solar radiation at a shallow angle. Retractable blinds provide solar screening. In winter, this façade is heated by the sun and functions as a thermal blanket to keep the building warm.

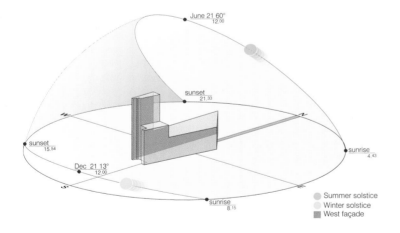

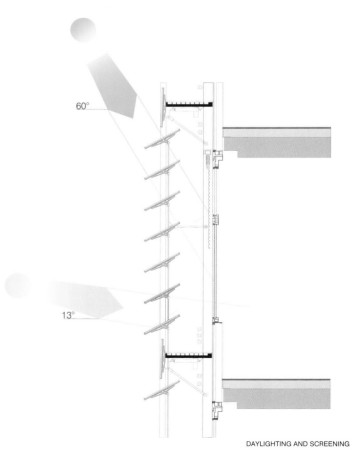

PERFORMANCE The most significant sustainable aspect of the Debis Headquarters building is the utilization of an innovative building envelope that reduces the building's energy demand. The building's envelope and double-skin façades serve as examples of energy efficient design achieved through the integration of envelope and mechanical systems. The building is comprised of intelligent features that monitor external conditions to initiate and adjust passive and active thermal controls. The double-skin façade is regulated by mechanical thermal controls when the ambient temperature is not adequate to provide the desired interior environment. The building envelope provides ample natural daylight and ventilation to achieve thermal comfort.

DAYLIGHTING AND SCREENING

Envelope + Mechanical

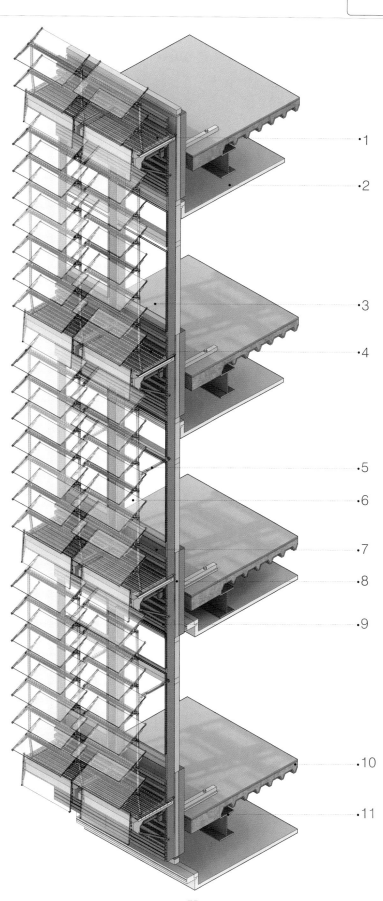

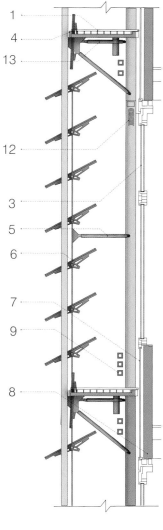

WEST FAÇADE
1. LAMINATED GLASS
2. DROP CEILING
3. OPERABLE WINDOW(S)
4. MAINTENANCE GRATING
5. TILT MECHANISM
6. LAMINATED GLASS BLADES
7. SAFETY GLASS-CLAD INSULATED PANELS
8. INSULATION
9. TERRA-COTTA CLADDING
10. CONCRETE FLOOR SLAB
11. STEEL BEAM
12. EXTERNAL BLIND
13. PIVOT MOTOR

2.3 [E+M] Debis Headquarters Building

BUILDING FAÇADES The west façade is the most transparent. The inner skin layer is composed of a conventional glazed curtain wall with two double-pane windows. This layer is the main weather barrier of the building and provides the occupants with control of natural ventilation. The outer skin of the façade is composed of louvered-glass blades on metal frames that pivot up to 70 degrees vertical to open.[1] These blades are controlled by sensors that respond to climatic conditions. This layer has several functions when it is closed: it reduces the wind impact on the inner wall, keeps the rain out, and provides thermal insulation during the winter months. When open, in conjunction with the inner layer it helps to remove the heat from the intermediate space and provides fresh air to the interior of the building.

The space between the two skins is separated by a maintenance walkway at each floor level. This space is equipped with retractable blinds that provide solar protection and glare control. The blinds are sensor controlled with a manual override. In addition to the retractable blinds, the intermediate space utilizes terra-cotta-cladding elements for additional shading and thermal insulation.

The east and south walls of the building also utilize double-skin façades. However, in order to protect the building from intense exposure to the sun, they use terra-cotta shading devices more extensively. As a result, these façades appear to be more opaque. The covered central atrium space is surrounded by an internal innovative façade as well. This façade is clad with angled blades to provide privacy for the offices while admitting daylight from the large glass roof of the atrium.

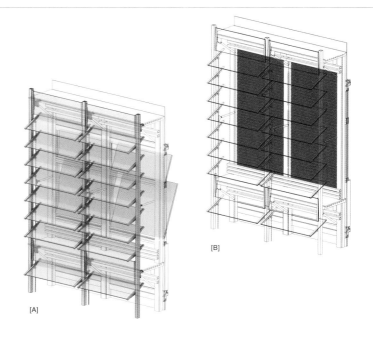

[A] OPEN LOUVERS When open in conjunction with the inner layer it helps to remove the heat in the intermediate space and provides fresh air to the interior of the building.

[B] CLOSED BLINDS The west façade is equiped with retractable blinds that provide solar protection and glare control. The blinds are sensor controlled with a manual override.

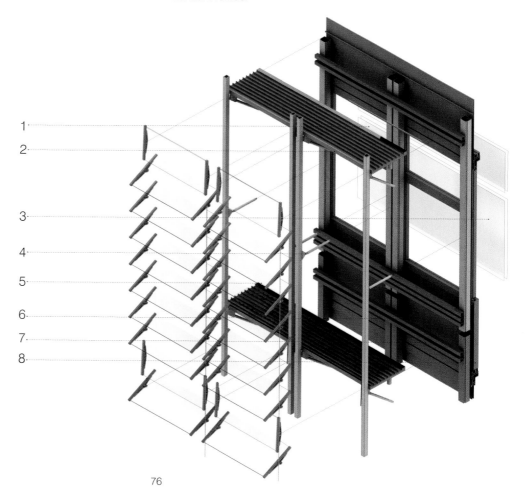

WEST FAÇADE
1. LAMINATED GLASS
2. MAINTENANCE GRATING
3. OPERABLE WINDOW(S)
4. TILT MECHANISM
5. LAMINATED GLASS BLADES
6. SAFETY GLASS-CLAD INSULATED PANELS
7. TERRA-COTTA CLADDING
8. INSULATION

Envelope + Mechanical

NATURAL VENTILATION

SUMMER: [No mechanical ventilation]

[A] DAY VENTILATION During the summer, natural ventilation is achieved by opening both skins: the louvered glass blades on the outer skin and the upper windows on the inner skin. The air movement between these two layers allows cool breezes to penetrate the space and enter the building. As the hot air inside the building rises, it is channeled up and away from the building. When ambient temperature rises above 68°F (20°C), mechanical ventilation is activated.[2]

[B] NIGHT COOLING In warm weather, night cooling is used to remove the accumulated heat during the day from the building. At night, the upper windows on the inside skin open automatically to ventilate the interior space. Cool air flows into the building, removing hot air. The concrete floor slab is left exposed at the outer edges to absorb and store cooling energy for the next day.

WINTER:

[C] THERMAL BUFFER During the winter, the building uses a mechanical heating system. In cold temperatures, both skin layers are closed to prevent heat loss. Warm air escaping from the interior of the building is stored between the two skins. This space, which is also heated by the sun, acts as a thermal blanket and protects the interior space from the cold weather.

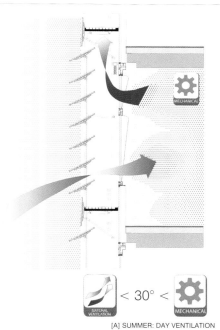

[A] SUMMER: DAY VENTILATION

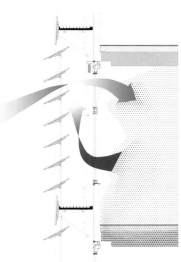

[B] SUMMER: NIGHT COOLING

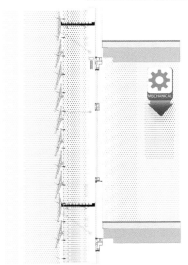

[C] WINTER: THERMAL BUFFER

REFERENCES

1. Debbie Lundberg, "The Debis Tower," Structure Innovations, 85.

2. Sandrina Dumitrascu, "Debis Headquarters Building, Berlin, Germany, Renzo Piano Building Workshop," http://www.architecture.uwaterloo.ca/faculty_projects/terri/pdf/Dumitras.pdf.

SOURCES

Gordon Graff, "Debis Headquarters. Berlin, Germany Renzo Piano Building Workshop," http://www.architecture.uwaterloo.ca/faculty_projects/terri/pdf/Graff.pdf

Vladyslav Kostyuk, "Debis Headquarters, Potsdamer Platz, Berlin. Renzo Piano Building Workshop," http://www.architecture.uwaterloo.ca/faculty_projects/terri/125_W03/kostyuk_debis.pdf

Matthew Wells, Skyscrapers: Structure and Design, illustrated ed. (Yale University Press, 2005).

Michael Wigginton and Jude Harris, Intelligent Skins, illustrated ed. (Burlington: Architectural Press, Elsevier, 2002).

2.4 [E+M] Housing Estate in Kolding

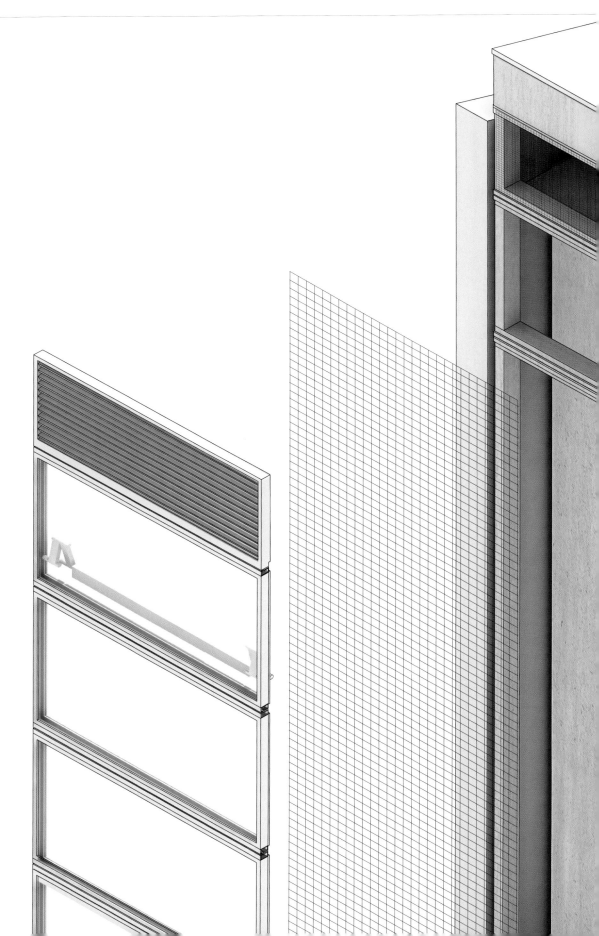

Envelope + Mechanical

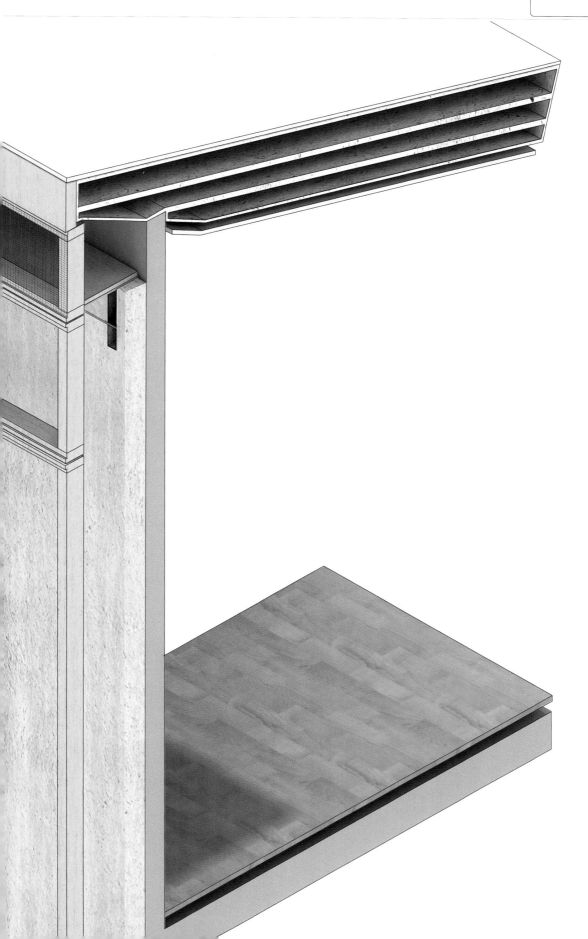

2.4 [E+M] Housing Estate in Kolding

ARCHITECT	3XNeilsen, Århus
LOCATION	Kolding, Denmark
	55.5°N 9.5°E
DATE	1998

LOCATION CONDITIONS

BACKGROUND Located in a densely populated area of Denmark, Kolding's Housing Estate consists of fifty-nine terraced houses, developed in blocks of two to five units, and a building with communal facilities. This development was the winning entry of a sustainable environmental design competition. The innovative design of the housing estate utilizes solar-thermal energy, multifunctional façades, and passive ventilation techniques.

PERFORMANCE The overall design strategy of the housing units relies on optimizing building orientation to harvest solar energy. The housing units are composed of rectangular blocks with their long sides oriented at a 15-degree angle off true north to meet the existing site conditions. The long façade on the south side of the buildings utilizes an inventive combination of glazing and structure for generating and storing heat. This design successfully integrates the building envelope and structure to create a thermal mass and provide natural ventilation.

STRUCTURE The buildings' units are constructed of insulated brick bearing walls on the north façades and have full glazing with solar walls on the south façades. The internal party walls and the end walls of each building are composed of concrete, which also function as thermal masses.

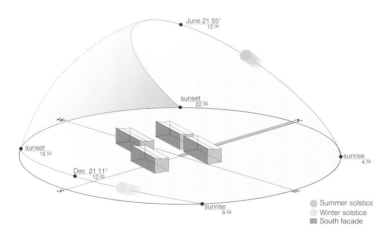

NORTH These façades receive very small amounts of direct sun during winter. The north walls are well insulated to prevent the warm interior air from escaping to the outside.

EAST The buildings' orientation of 15 degrees off true north limits the heat gain in summer months on the east walls. The east walls receive direct solar radiation in the early morning.

SOUTH In the winter months, solar radiation enters the south façades at a shallow angle for most of the day. The façades absorb significant solar energy, which is used to heat the building.

WEST The amount of solar radiation entering the west walls is also limited by the buildings' orientation. These walls receive direct solar radiation during the late afternoon.

Envelope + Mechanical

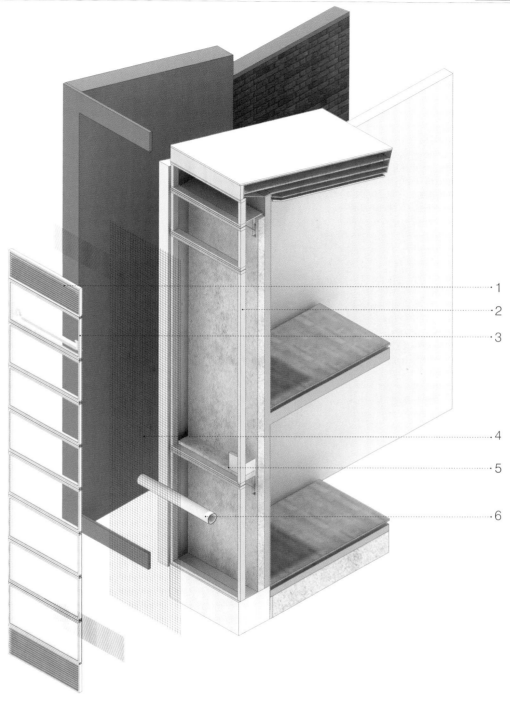
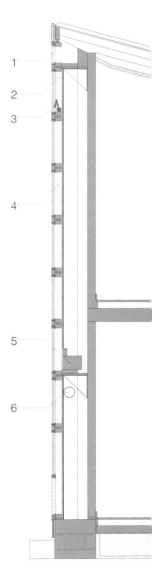

SOLAR WALL
1 ALUMINUM VENTILATION ELEMENT WITH SCREEN
2 WOOD FRAMING
3 VENTILATION FLAP
4 SOLAR WALL CONSTRUCTION:
 - DOUBLE-GLAZED SYSTEM IN ALUMINUM FRAMING
 - 2 X 4MM FLOAT GLASS
 - 12MM CAVITY
 - 3MM BLACK PERFORATED SHEET-STEEL ABSORBER
 - 125MM MINERAL WOOL
 - 100MM LIGHTWEIGHT CONCRETE WALL
5 FAN
6 180MM VENTILATION DUCT

2.4 [E+M] Housing Estate in Kolding

SOLAR FAÇADE: THE SOLAR WALL The south façades of the buildings utilize an air-based solar heating system. The solar-heated air is distributed to heat the space directly or is stored in solar energy collectors. Each unit's façade is composed of large glass panels and a vertical solar wall covered with double glazing. The solar walls are shallow and occupy a small amount of floor area. These walls are composed of a lower and an upper section. The lower section of the wall is used to preheat the fresh-air intake used for ventilation. The upper section is the solar heating system. Heat is absorbed and stored in the concrete walls located between the units. To absorb the solar radiation effectively, the solar walls use perforated-steel sheeting and a layer of insulation behind a cavity. As the steel sheet is heated by the sun, it warms the air inside the cavity. When the cavity's temperature rises above 86°F (30°C), a fan is activated to direct the heated air into the concrete party walls.[1] Due to the cold climatic conditions of Kolding, this system is utilized as an auxiliary system to the central heating plant located in the community building.

EAST AND WEST END WALLS The east and west walls at the end of each block are composed of hollow concrete with an integral layer of crushed stone. These walls perform as a thermal mass by absorbing heat during the day to warm contained air. Fresh air penetrates the lower portion of the wall and ascends through the stones. As the warm air rises, it transfers heat to the wall and cools off. The cold air returns through ducts to the base. The concrete party walls, located between the units, are equipped with heating ducts to function as thermal storage. The embedded ducts circulate the heat provided by the solar walls to warm the concrete.

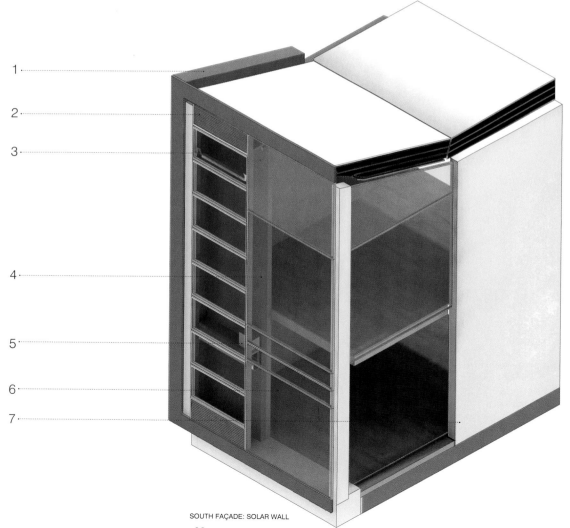

SOUTH FAÇADE: SOLAR WALL

SOUTH FAÇADE
1 CONCRETE THERMAL WALL
2 SHEET ALUMINUM VENTILATION ELEMENT WITH INSECT SCREEN
3 VENTILATION FLAP
4 LIGHTWEIGHT CONCRETE WALL
5 FAN
6 GLASS PANELS
7 INTERNAL PARTY WALL

Envelope + Mechanical

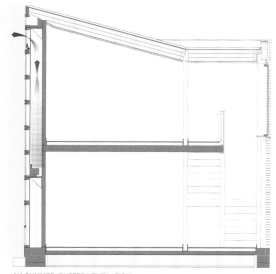

[A] SUMMER: BUFFER VENTILATION

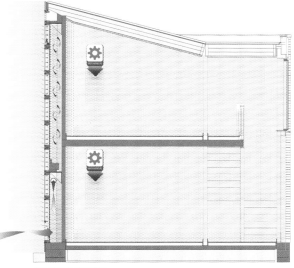

[B] WINTER: DAYTIME

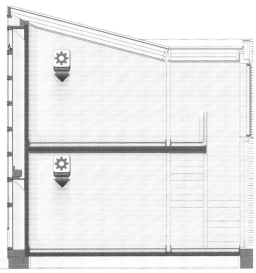

[C] WINTER: NIGHT HEAT RADIATION

VENTILATION

SUMMER:
[A] FAÇADE VENTILATION During the summer, the solar walls are not in use. Ventilation windows placed on top of the solar walls allow warm air to exit and prevent overheating of the wall.

WINTER: *[Mechanical ventilation]*
[B] / [C] DAY/NIGHT HEAT RADIATION During the winter months, heat is provided by a central heating plant and the solar walls. Solar radiation is absorbed by the solar wall elements and stored in the concrete party walls. These thermal walls radiate heat at night to warm the units.

REFERENCES

1. Christian Schittich, ed., In Detail: Solar Architecture (Boston: Birkhauser-Publishers for Architecture, 2003).

2.5 [E+M] Helicon Building

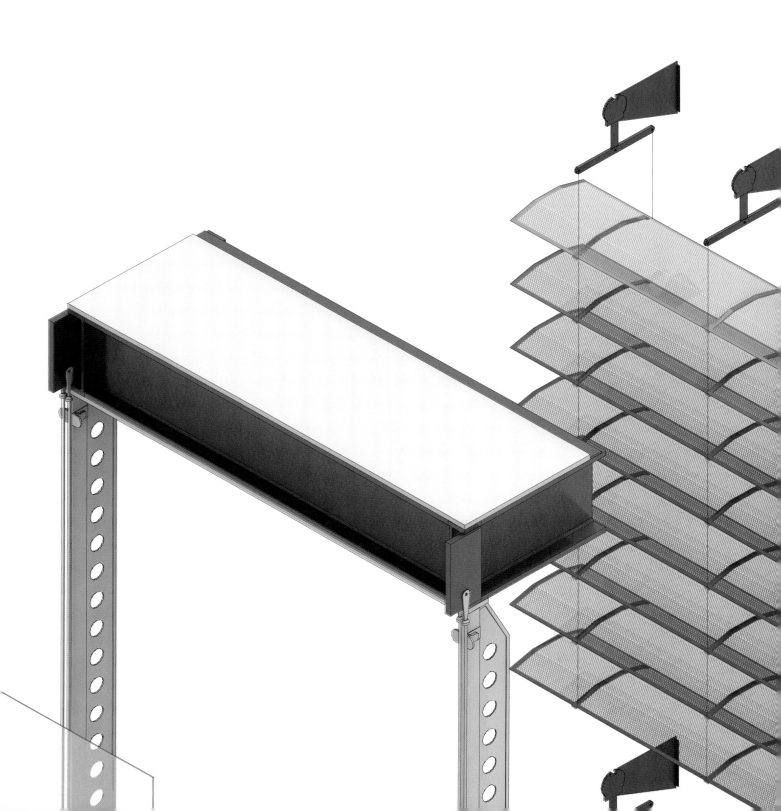

Envelope + Mechanical

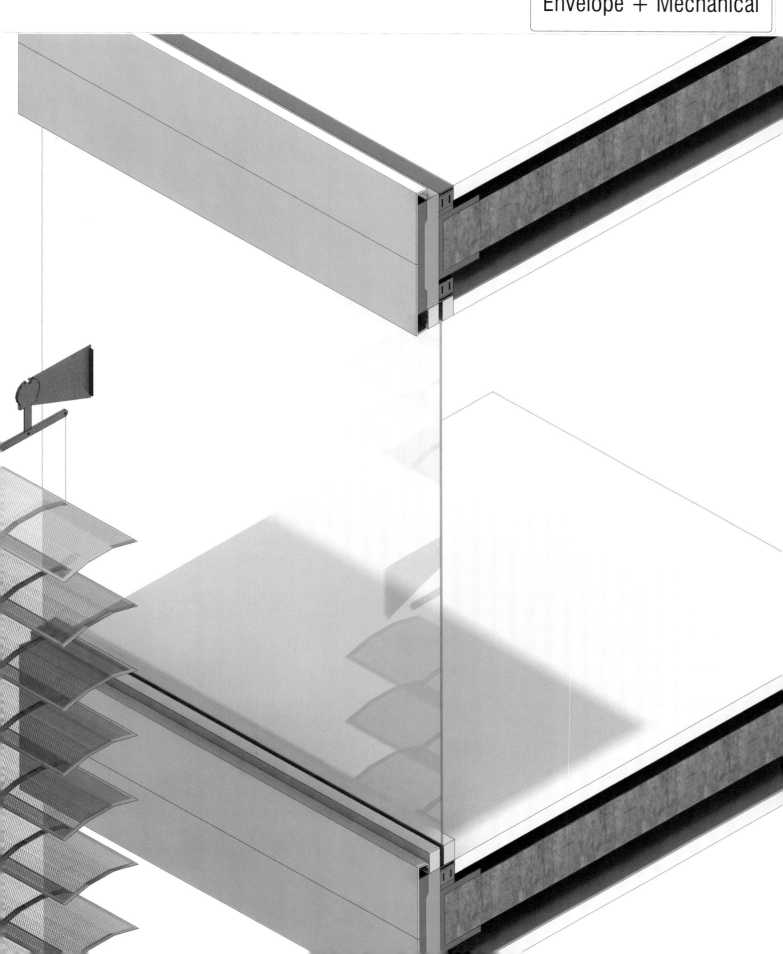

2.5 [E+M] Helicon Building

ARCHITECT	Mick Pearce + Design, Inc.
LOCATION	London, England
	51.5°N 0.5°W
DATE	1996

LOCATION CONDITIONS

BACKGROUND Surrounded by city streets on all four sides, the Helicon building occupies a city block in London's financial district. The building consists of eleven floors of mixed-use development that includes retail and office spaces. The office floors, which start on the sixth level, are arranged around an atrium with setbacks to admit light and access to outdoor spaces. The first three storeys and the two underground levels provide space for retail and storage. To respond to the occupants' desire for a comfortable space with ample connection to the outside environment, the architect has utilized a transparent envelope that provides views, natural lighting, and natural ventilation. The building envelope is designed to mediate the temperature of the interior environment by utilizing intelligent façade systems that function independently to respond to their particular building orientation and exposure.

NORTH The north façade is exposed to diffused sunlight. Sunlight entering the building is controlled by sun screening devices.

EAST During the summer, a great amount of solar radiation penetrates the east façade. The façade's cavity is kept open to remove solar heat gain.

SOUTH Shading is provided without reducing daylight entry by the metal louvers. During winter, this glazed façade allows the sun to warm the building passively.

WEST The west façade receives large amounts of solar radiation during the summer. The façade's cavity is automatically ventilated, while the metal louvers are adjusted to provide shade and allow enough daylight into the building.

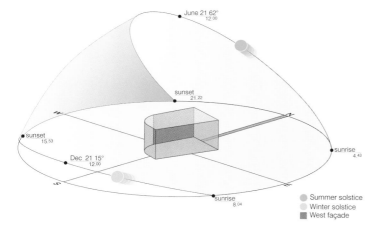

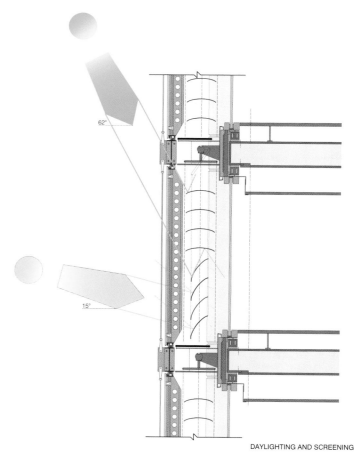

PERFORMANCE The overall energy saving strategy of the design is to reduce dependency on conventional energy sources by 50 percent by providing natural light and reducing solar heat gain.[1] In order to achieve this goal, the building responds to varying climatic conditions through integration of sophisticated glazed façades with mechanical devices. These façades are composed of active double-skin layers and are equipped with mechanically adjustable louvers to optimize transparency and daylight while minimizing heat gain. To provide additional natural light to the deep floor plates, the building includes a glass roof atrium and floor setbacks.

DAYLIGHTING AND SCREENING

Envelope + Mechanical

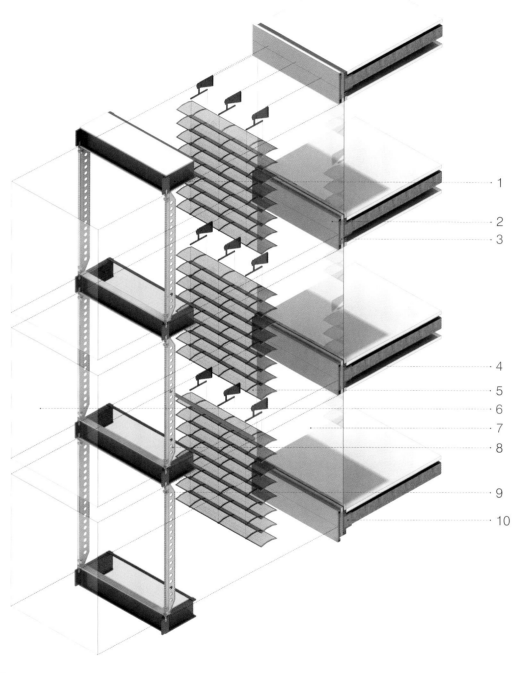
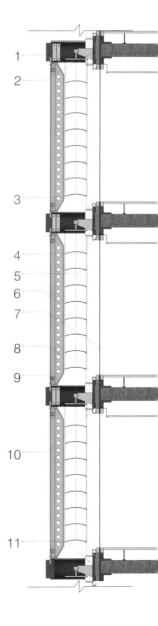

WEST FAÇADE
1. I-BEAM
2. PERFORATED ALUMINUM "SLAB CAP" 2
3. RIGID INSULATION
4. THREADED PLATES
5. PERFORATED ALUMINUM LOUVER BLINDS EXTERIOR
6. SINGLE-GLAZED LAYER
7. INTERIOR DOUBLE-GLAZED WALL
8. STEEL STRUCTURE
9. GLASS FASTENER
10. CONCRETE SLAB
11. CONCRETE COLUMN BEHIND

2.5 [E+M] Helicon Building

ENVELOPE The façades are comprised of an inner double-glazed sealed layer and an outer glazed operable layer that provides both thermal and acoustic insulation. The cavity space between the glazed walls is occupied by perforated metal louvers that reduces heat gain while allowing adequate daylight to penetrate the building. These louvers have a 14 percent perforation and have a solar reflectance of 70 percent.[2] The cavity's temperature is controlled by a centralized computer system that is programmed to open the top and bottom of the cavity to avoid overheating. The same computer system measures the amount of solar radiation entering the façade. Based on the exterior lighting conditions, the system adjusts the metal louvers to reflect heat and provide shading.

VENTILATION The cooling for the building is provided by a chilled ceiling system integrated with perforated metal ceiling panels. This system operates in conjunction with a floor-based air supply system. The chilled water is carried through the ceiling tubes and the cool air is distributed by the raised floor plenum, which supplies air at temperatures of 68°F (20°C).[3] The cool air slowly rises as it is heated by people and equipment until it reaches the ceiling where it gets cooled. Cooled air descends, initializing convection. This alternative cooling system functions by radiation and convection.

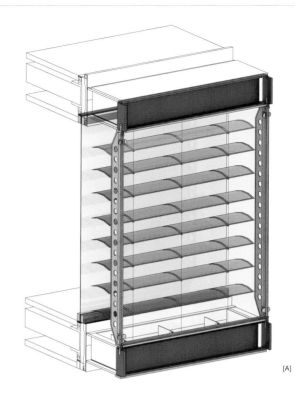

[A]

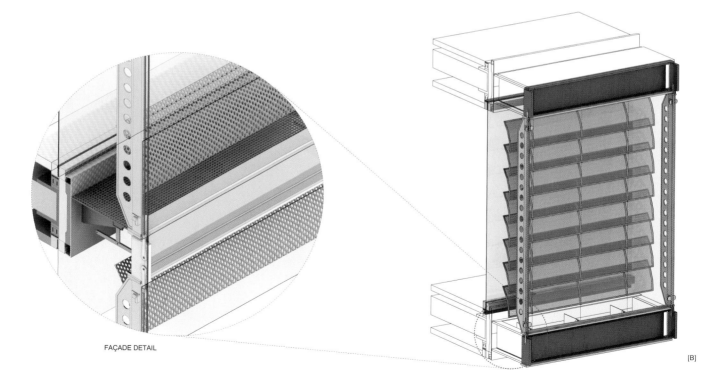

FAÇADE DETAIL

[B]

[A] OPEN LOUVERS During the early morning hours, the perforated louvers in the west façade are opened to allow daylight and reduce the need for artificial lighting.

[B] CLOSED LOUVERS When direct sunlight strikes the west façade, the building management system adjusts the perforated louvers to block direct solar radiation.

Envelope + Mechanical

VENTILATION

SUMMER: [Mechanical ventilation]
[A] FAÇADE VENTILATION In the summer months, the east and west façades' cavities are kept open to remove solar heat gain.

[B] COOLING During the summer, cooling is provided by a chilled ceiling system that works with the double-skin façade. Metal louvers are monitored and adjusted to reflect some of the sun's rays and provide shading.

WINTER: [Mechanical ventilation]
[C] THERMAL BUFFER During the colder months of the year, adequate temperatures are maintained inside the building by the insulated outer skin. During the winter, the east and west cavities are kept closed to function as a temperature buffer zone between the cold air outside and the interior air. The perforated metal louvers reflect some of the heat from the sun to preserve a comfortable environment. When interior temperatures are not adequate, mechanical heating is activated.

REFERENCES

1. Dean Hawkes and Wayne Foster. Energy Efficient Buildings: Architecture, Engineering, and Environment, first American ed. (London: W.W. Norton & Company Ltd., 2002), 146.

2. Harris Poirazis, Double Skin Façades for Office Buildings, Division of Energy and Building Design. Department of Construction and Architecture. Lund Institute of Technology. Lund University, Report EBD-R--04/3 (2004), 139.

3. Poonam Sharma, "The Helicon in Finsburry Pavement, London. A Case Study," http://www.architecture.uwaterloo.ca/faculty_projects/terri/366essaysW03/sharma_helicon.

SOURCES

David Gissen, ed., Big & Green: Toward Sustainable Architecture in the 21st Century. illustrated, National Building Museum (NY: Princeton Architectural Press, 2002).

Kate Harrison, "The Tectonics of The Environmental Skin," http://www.architecture.uwaterloo.ca/faculty_projects/terri/ds/double.pdf.

Kimberly King, "The Helicon Finsbury Pavement. London, UK," http://www.architecture.uwaterloo.ca/faculty_projects/terri/125_W03/king_helicon.pdf.

Darrell Mann and Conall Ó Catháin, "Using TRIZ in Architecture: First Steps," Systematic Innovation, Systematic Innovation Ltd, June 22, 2009, www.systematic-innovation.com.

Vijaya Yellamraju, "Evaluation and Design of Double-skin Façades for Office Buildings in Hot Climates," (May 2004).

Jerry Yudelson, Green Building Trends: Europe, illustrated ed. (Washington: Island Press, 2009).

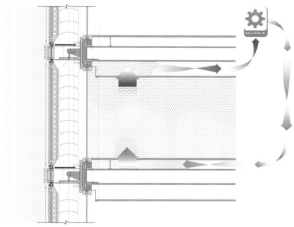

[A] SUMMER: FAÇADE VENTILATION

[B] SUMMER: COOLING

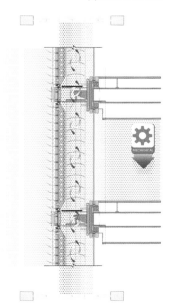

[C] WINTER: THERMAL BUFFER

DAMPERS The building management system controls the dampers at the top and bottom of the façade to ventilate the cavity and avoid overheating.

3
[S+E+M]

Structure + Envelope + Mechanical

This section is devoted to buildings that integrate structural, envelope, and mechanical systems and in doing so, these buildings become some of the most energy efficient and environmentally friendly. These buildings share a series of common features: enclosure elements that are capable of serving dual or multiple purposes, inhabitation of walls and floors, contiguous integrated cavities, and significant passive heating and cooling systems. The inhabitation of the cavities of both walls and floors allows building systems such as structural, mechanical, electrical, plumbing, and insulating systems to coexist next to one another, leading to efficient use of energy, space, and materials. In the most accomplished cases of integration, energy efficiency is further advanced by the incorporation of new systems for the production of onsite energy. These buildings serve as models of energy independence for the future.

3.1 [S+E+M] Council House 2 (CH2)

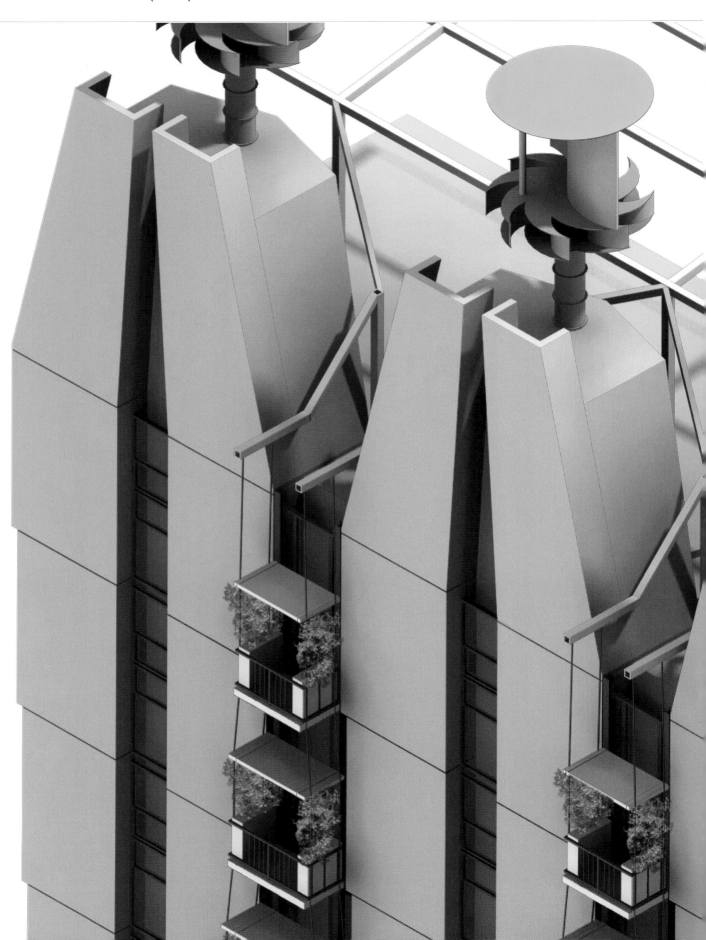

Structure + Envelope + Mechanical

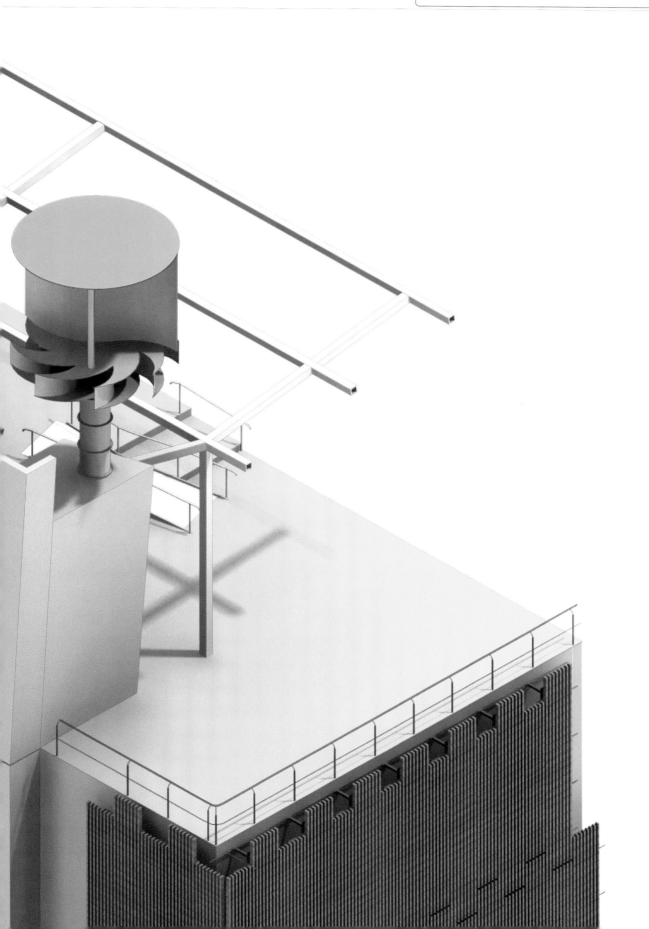

3.1 [S+E+M] Council House 2 (CH2)

ARCHITECT Jean-Claude Bertoni + DesignInc
LOCATION Melbourne, Australia
37.5° S 144.6° E
DATE 2006

LOCATION CONDITIONS

BACKGROUND The ten-storey Council House 2 (CH2) building is the new home for the City of Melbourne Council. The building has received the highest environmental ranking of any commercial building in Australia.[1] It has been described as visionary, with the potential to change the world approach to design and construction of sustainable buildings. The CH2 building utilizes a wide range of strategies to create a climate responsive building. Each façade is designed to optimize its orientation and is part of the overall integrated cooling and ventilation system of the building. The building floor structure and ceilings are also part of the cooling and heating system. The building uses both mechanical and natural air ventilation in an unprecedented way to circulate entirely filtered fresh air. The selection criteria for construction materials was based on reducing embodied energy, which led to utilizing steel and wood with high percentages of recycled content.

VEGETATION The CH2 building incorporates landscaped balconies, winter gardens, and a roof-top garden to provide occupants access to nature. Plants growing up and across the roof replicate the amount of foliage on the building's footprint. Vertical gardens covering the northern façade grow from planter boxes built into the balconies of every floor. They assist with shading, glare, and air quality. The roof garden is comprised of foliage and grass suited to the light and conditions of the roof. The gardens are used as a space for recreation for the building's occupants.

ENERGY HARVESTING Energy harvesting systems within the CH2 building are designed to minimize energy consumption by improving efficiency, recovering waste energy, and collecting energy from the environment. The building's sustainable power systems include roof-mounted solar panels for water heating, photovoltaic cells to power the west façade's timber shutters, wind turbines, and a gas-fired co-generation plant. The wind turbines integrated on the north façade assist with night cooling and generate electricity during the day.

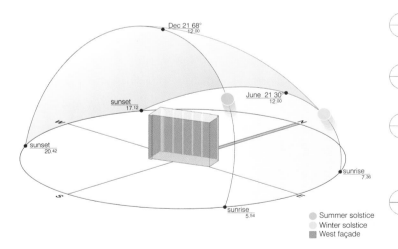

NORTH North facing balcony extensions shield direct sunlight and deflect light into the internal office space. Vertical plants on the northern façade screen low angle sun.

EAST In summer, large amounts of solar radiation enters the east façade at a shallow angle. Solar screening is provided by the perforated metal panels.

SOUTH The south façade receives smaller amounts of direct solar radiation. South facing windows admit diffused sunlight while reducing internal glare. To maximize the amount of natural light in the lower levels of the building, the concrete strips between the glass windows taper at the bottom.

WEST The west façade receives large amounts of sunlight during the summer. Solar screening is provided by the recycled timber shutters that adjust automatically based on the position of the sun.

Structure + Envelope + Mechanical

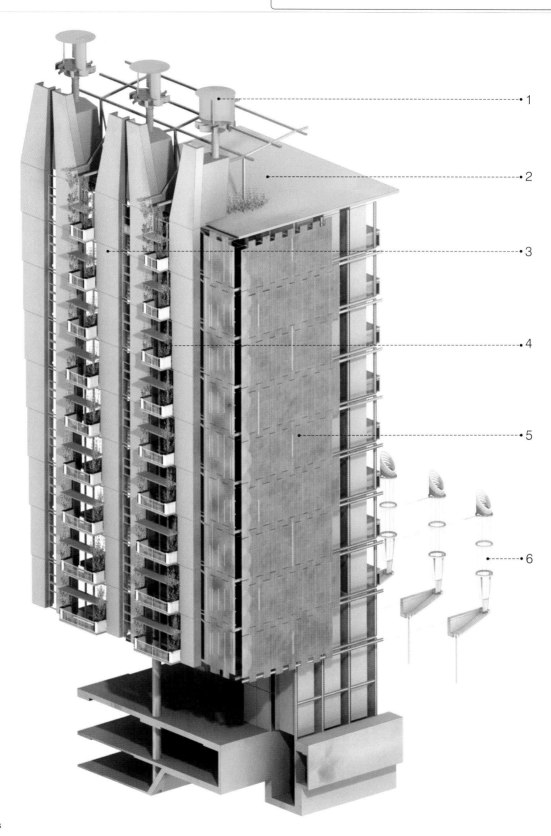

NORTH AND WEST FAÇADES
1. ENERGY-HARVESTING TURBINES
2. ROOFTOP GARDENS
3. TAPERED FAÇADE
4. VERTICAL GARDENS
5. WOOD SUN SCREEN
6. SHOWER TOWERS

3.1 [S+E+M] Council House 2 (CH2)

SOUTH FAÇADE

The south façade of the building uses down draft evaporative cooling. This passive climate control method is used in hot and dry climates to minimize reliance on mechanical cooling. The system's operating principle is based on producing a down draft of cool air by spraying fine droplets of water from the top of a tower. As the water falls and draws air, it consumes energy to evaporate, and it gradually cools. The air is then used for cooling purposes. This system has proven to be extremely effective in many buildings. The CH2's south façade has five attached shower towers composed of lightweight fabric material that are a part of a closed evaporative cooling system. The water used in the system is collected and recycled to achieve more efficiency. At the beginning of the cycle, cooled water stored in a thermal storage tank is released at the top of the shower towers. The combination of gravity force created by the dropping water and the downward flow of evaporated cool air due to increasing density sets up a down draft in the towers. The cooled air is collected and is directed to cool the ground floor retail areas. The cold exit water at the bottom of the towers is collected at night into pipes. This water passes through a storage tank containing a large number of metal balls filled with a phase change material (pcm). The pcm freezes at 59°F (15°C), which is above the temperature of the entering water.[2] The water lowers the temperature of the pcm, assisting to keep it frozen. The cooled water is used in the chilled water pipes and is also released in the shower towers in the next cycle.

[A] CHILLED CEILING ASSEMBLY

Structure + Envelope + Mechanical

The south façade also contains air circulation ducts that supply fresh air from the roof and distributes it down through the building. Fresh air is released to the workspaces by diffusers on the floor plenum that are controlled by the occupants. As the fresh air warms, it slowly rises through the gaps on the ceiling and is channeled out of the building through air ducts on the north façade. The wind turbines located on the roof are also used to help evacuate air out of the building. All air is drawn from outside, and no recycling occurs. The building performs two fresh air changes every hour.

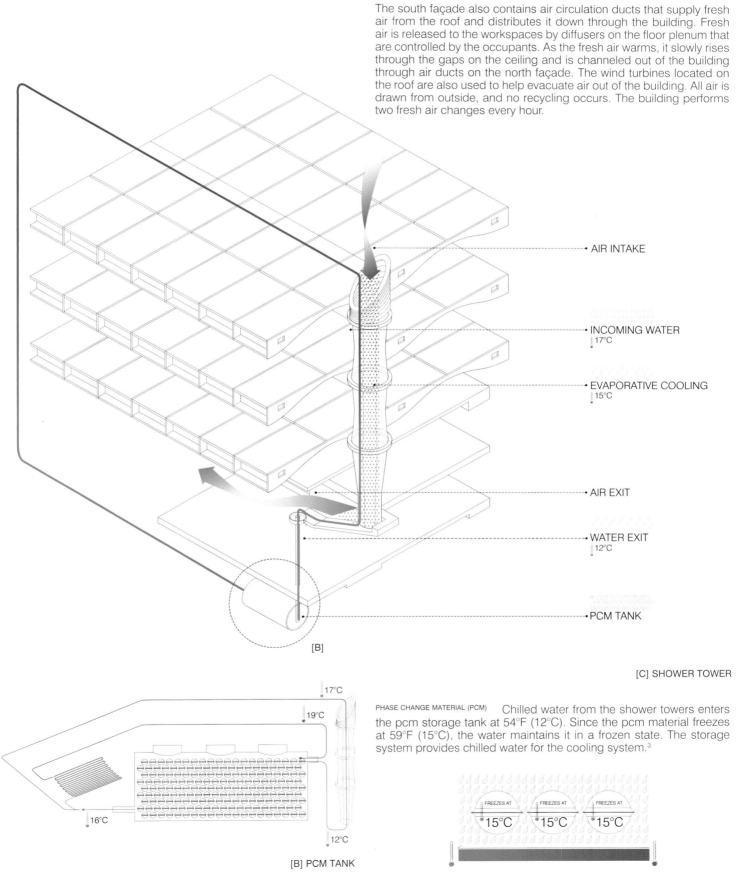

[C] SHOWER TOWER

PHASE CHANGE MATERIAL (PCM) Chilled water from the shower towers enters the pcm storage tank at 54°F (12°C). Since the pcm material freezes at 59°F (15°C), the water maintains it in a frozen state. The storage system provides chilled water for the cooling system.[3]

[B] PCM TANK

3.1 [S+E+M] Council House 2 (CH2)

WEST FAÇADE In order to keep the sun out, the west façade is wrapped with recycled timber shutters. These shutters tilt and close according to the position of the sun to protect against solar gain while allowing daylight into the interior space. The shutters' movements are powered by photovoltaic cells located on the roof.

ROTATION ANGLES BASED ON SOLAR ORIENTATION

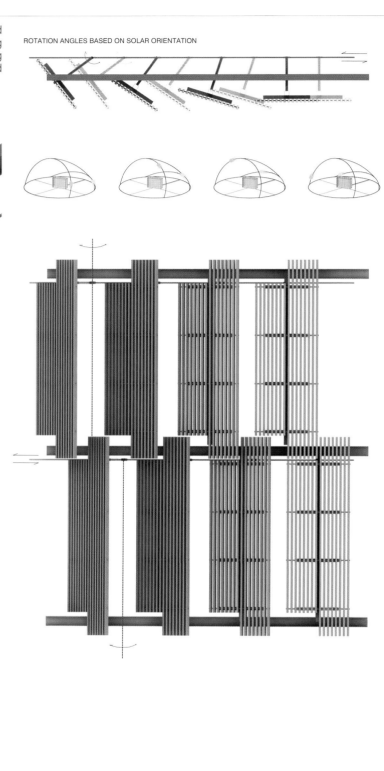

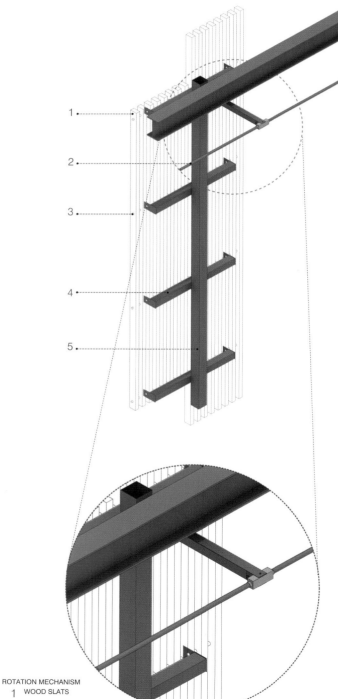

ROTATION MECHANISM
1. WOOD SLATS
2. SWING-BAR STEEL ROD
3. STEEL ROD
4. HORIZONTAL SUPPORT
5. HOLLOW ROTATING BAR

Structure + Envelope + Mechanical

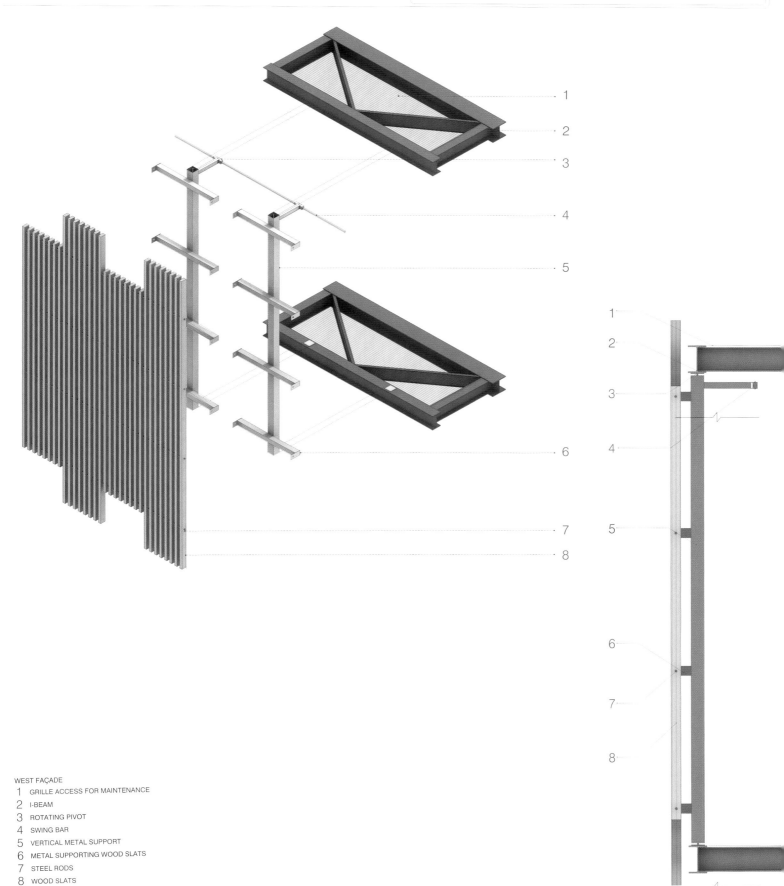

WEST FAÇADE
1. GRILLE ACCESS FOR MAINTENANCE
2. I-BEAM
3. ROTATING PIVOT
4. SWING BAR
5. VERTICAL METAL SUPPORT
6. METAL SUPPORTING WOOD SLATS
7. STEEL RODS
8. WOOD SLATS

3.1 [S+E+M] Council House 2 (CH2)

INTEGRATED FLOOR SYSTEM The building structure is composed of cast-in-place concrete beams and columns. The concrete columns are placed in three parallel rows: two rows just inside the south and north façades and one row located offset from the center of the floor. The innovative structural feature of the building is the integration of the floor beams with the ceiling panels and the floor slabs. The ceiling panels are composed of precast concrete elements formed in an undulating shape. The panels are connected to the floor beams, and the floor slab is poured to create a monolithic structure. This allows for the floor beams, slab, and the ceiling panels to act together in resisting loads, thus reducing the overall depth of the structural material used. The construction system for this building combines precast and cast-in-place concrete. The precast ceiling panels were transported to the site and placed in position. Then the concrete floor beams were cast into the spaces created between panels, followed by the installation of the deck slab. The concrete ceilings play an important role in cooling the interior of the building as they absorb the heat generated by equipment and people's activities during the day. This heat is removed through night purging.

PRECAST CONCRETE ASSEMBLY The ceiling panels consist of precast undulated elements attached to the floor beams.

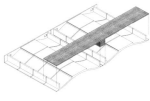

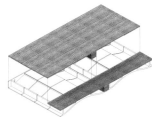

SITE-CAST CONCRETE SLABS Once the precast elements are set in place, the concrete slab is poured to create a monolithic system.

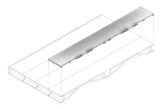

RAISED ACCESS FLOOR The raised access floor plenum integrates the HVAC system within the building's structure.

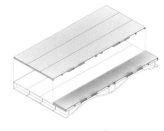

Structure + Envelope + Mechanical

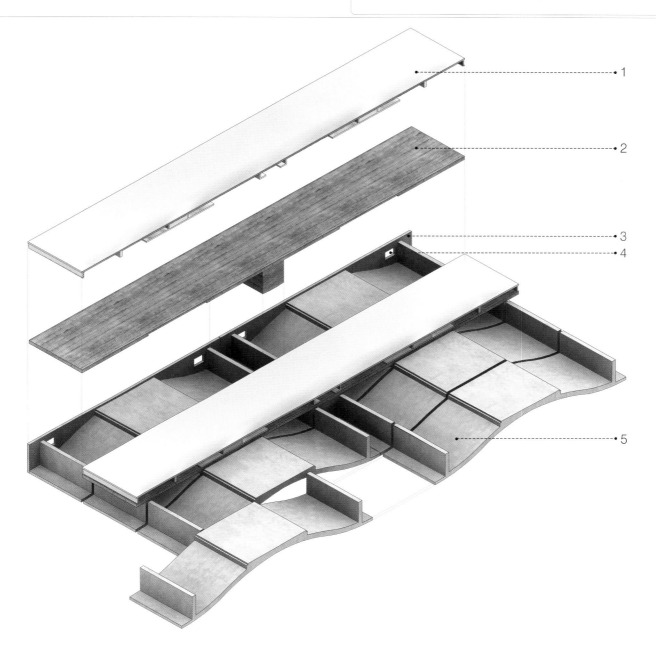

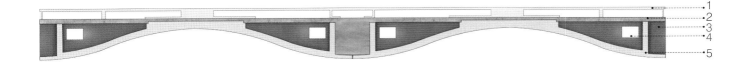

INTEGRATED FLOOR SYSTEM
1. FINISH FLOOR
2. SITE-CAST CONCRETE SLAB
3. END-CAP MOLDING PIECE
4. EXHAUST AIR OUTLET FOR END CAP
5. UNDULATING PRECAST CONCRETE PANELS

3.1 [S+E+M] Council House 2 (CH2)

NORTH FAÇADE Despite the site restrictions that led to the design of deep floor plates and the consequent challenges in utilizing daylighting, the CH2 building uses almost one-third of the artificial lighting of a standard office building. To maximize the penetration of daylight into the interior space, the façade's glass windows widen as they move down to the base of the building. This allows the lower levels of the building, where natural light is not as bright, to utilize more sunlight as the surrounding buildings cast shadows. The north façade incorporates a series of vertical gardens nine-storeys high to help filter the incoming light. This façade also integrates ten dark-colored air ducts that terminate at the roof wind turbines. As the sun heats the air in the ducts, the hot air rises and moves the absorbed heat out of the building. This air feeds into the roof turbines, assisting energy generation for the building.

EAST FAÇADE The eastern façade utilizes a protective layer to provide natural light and ventilation. This layer protects the inner skin from direct sunlight exposure by utilizing perforated metal panels. Daylight penetrates a translucent screen to provide interior lighting, while fresh air flows through a louvered opening in the ceiling. Fresh air naturally ventilates the spaces located on the eastern elevation.

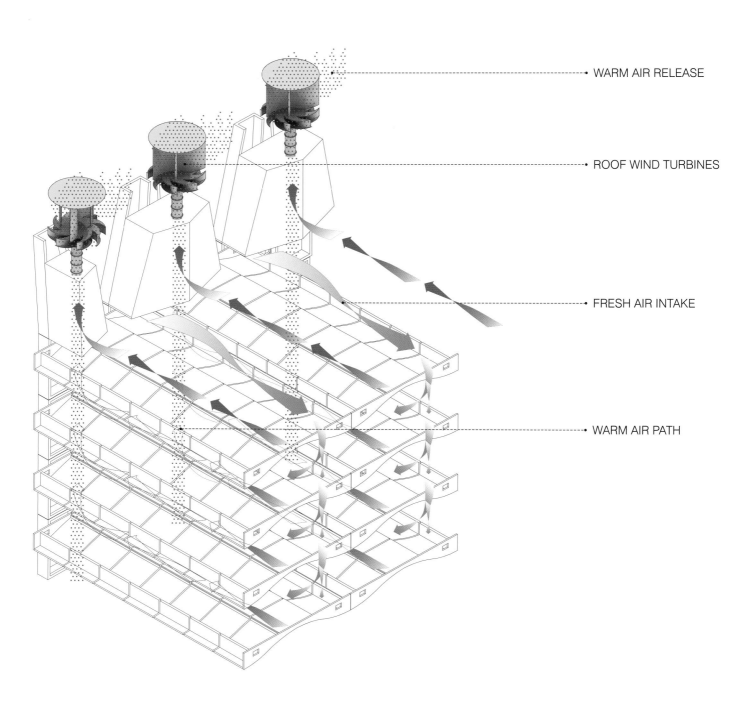

- WARM AIR RELEASE
- ROOF WIND TURBINES
- FRESH AIR INTAKE
- WARM AIR PATH

Structure + Envelope + Mechanical

VENTILATION

SUMMER:

DAYTIME The CH2 building uses down draft evaporative cooling in the form of shower towers in the south façade to cool air and water. This passive alternative cooling method is used in conjunction with chilled beams and chilled ceiling panels.

NIGHT COOLING Melbourne summer night temperatures are much cooler than daytime temperatures. The CH2 building utilizes the thermal mass of the concrete ceilings to capture and store cooling energy at night for use during the day. Windows located on the north and south façades allow cooler air into the space at night, removing the hot air from the surface of the vaulted concrete ceilings.

WINTER:

Wasted heat, from the gas-fired co-generation plant used to generate electricity, is utilized for heating during the winter months. In addition, rooftop solar water heaters supply hot water to the mechanical heating system to provide early morning heat. Heat from people's activities and equipment helps maintain thermal comfort throughout the rest of the day.

[A] WARM AIR PATH

[B] DAYTIME COOLING

REFERENCES

1. Will Jones, "Council House 2, Melbourne: Australia's Greenest Office Building," January 28, 2008, http://www.building.co.uk/story.asp?storycode=3104100.

2. Dominque Hes, "Design Snap Shot 15: Phase Change Material," CH2 Setting a New World Standard in Green Building Design, City of Melbourne, www.melbourne.vic.gov.au.

3. "Technical Research Paper 05. Heating and Cooling in the CH2 Building," City of Melbourne, May 2006, www.melbourne.vic.gov.au.

SOURCES

"CH2: Council House 2," Green Building Council Australia, City of Melbourne, www.melbourne.vic.gov.au.

"CH2 building," Greenlivingpedia, July 2008, http://www.greenlivingpedia.org/CH2_building.

Dominque Hes, "Design Snapshot 05: Energy Systems," CH2 Setting a New World Standard in Green Building Design, City of Melbourne, www.melbourne.vic.gov.au.

Dominque Hes, "Design Snap Shot 06: Shower Towers," CH2 Setting a New World Standard in Green Building Design, City of Melbourne, www.melbourne.vic.gov.au.

Dominque Hes, "Design Snap Shot 09: Water," CH2 Setting a New World Standard in Green Building Design, City of Melbourne, www.melbourne.vic.gov.au.

Dominque Hes, "Design Snap Shot 12: Western Façade," CH2 Setting a New World Standard in Green Building Design, City of Melbourne, www.melbourne.vic.gov.au.

Dominque Hes, "Design Snap Shot 13: Interface with Street," CH2 Setting a New World Standard in Green Building Design, City of Melbourne, www.melbourne.vic.gov.au.

Dominque Hes, "Design Snap Shot 14: Indoor Environmental Quality," CH2 Setting a New World Standard in Green Building Design, City of Melbourne, www.melbourne.vic.gov.au.

Dominque Hes, "Design Snap Shot 16: Chilled Panels and Beams," CH2 Setting a New World Standard in Green Building Design, City of Melbourne, www.melbourne.vic.gov.au.

Dominque Hes, "Design Snap Shot 18: Vaulted Ceilings," CH2 Setting a New World Standard in Green Building Design, City of Melbourne, www.melbourne.vic.gov.au.

Dominque Hes, "Design Snap Shot 20: Lighting," CH2 Setting a New World Standard in Green Building Design, City of Melbourne, www.melbourne.vic.gov.au.

"Technical Research Paper 01. Nature and Aesthetics in the Sustainable City," City of Melbourne, May 2006, www.melbourne.vic.gov.au.

"Technical Research Paper 04," City of Melbourne, May 2006, www.melbourne.vic.gov.au.

"Technical Research Paper 06. Energy Harvesting," City of Melbourne, May 2006, www.melbourne.vic.gov.au.

"Technical Research Paper 07. Water," City of Melbourne, May 2006, www.melbourne.vic.gov.au.

"Technical Research Paper 08. Building Structure and Construction process," City of Melbourne, May 2006, www.melbourne.vic.gov.au.

"Technical Research Paper 09. Materials Selection," City of Melbourne, May 2006, www.melbourne.vic.gov.au.

Peter W. Newton, Transitions: Pathways Towards Sustainable Urban Development in Australia, illustrated ed. (New Zealand: Springer, 2008).

3.2 [S+E+M] San Francisco Federal Building

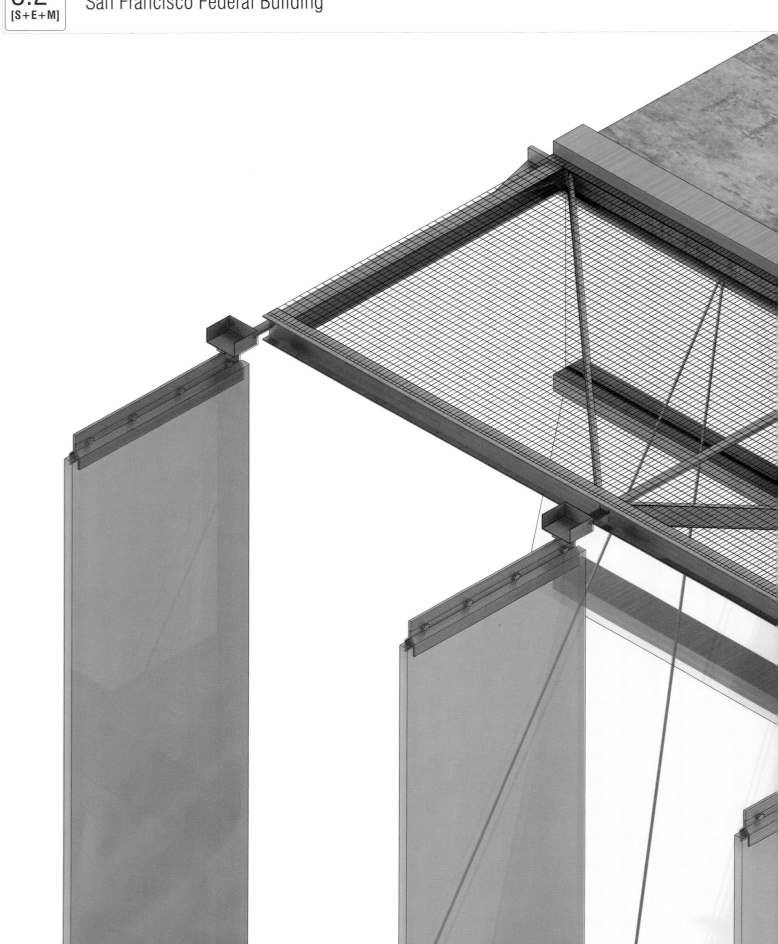

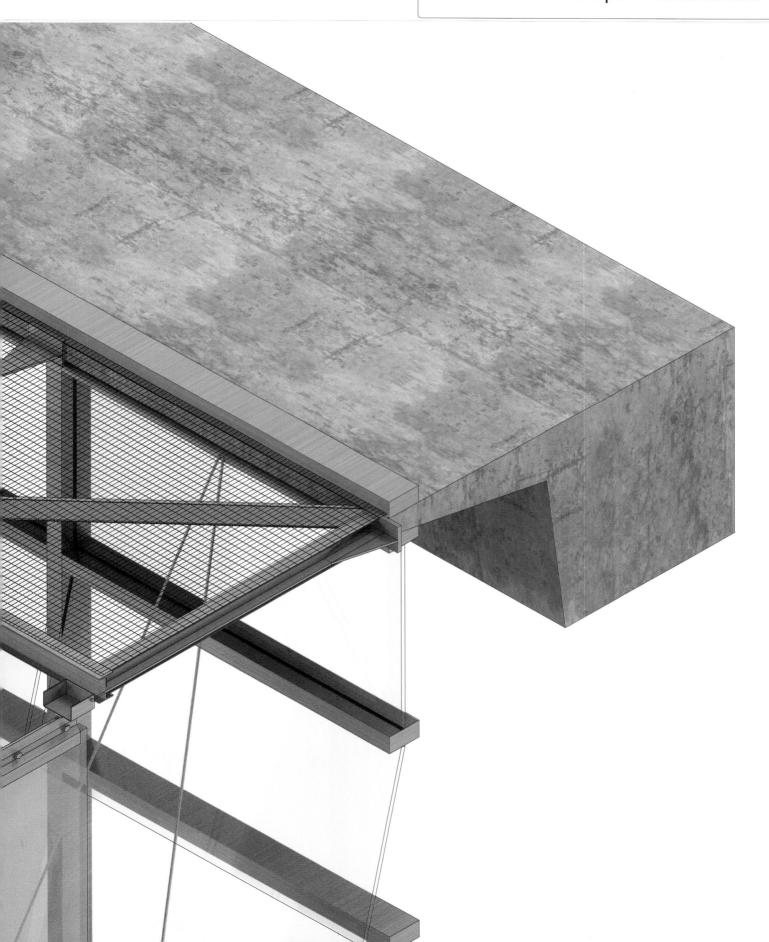

Structure + Envelope + Mechanical

3.2 [S+E+M] San Francisco Federal Building

ARCHITECT	Tom Mayne, Morphosis
LOCATION	San Francisco, California, USA
	37.8°N 122.2°W
DATE	2007

LOCATION CONDITIONS

BACKGROUND Located on a three-acre site at the northern edge of a San Francisco city block, the San Francisco Federal Building is comprised of an eighteen-storey tower and a four-storey structure with offices, day-care, a café, and a large urban plaza serving the public and several governmental agencies. The federal building is located within a ten-minute walk from downtown San Francisco and is the cornerstone of the urban renewal strategy for the struggling surrounding neighborhood.

PERFORMANCE The San Francisco Federal Building is an exemplary model of sustainability. The selection of its form, orientation, interior layout, and the building's envelope radically lower energy consumption, minimizes impact on the environment, and provides a healthy and productive work place. The design and configuration of the floor plan were influenced by daylight and ventilation concerns. The long, slender tower features narrow floor plates with individual enclosed offices along the central spine and open office spaces along the perimeter. This interior space planning strategy maximizes airflow, natural daylight, and views overlooking the city. The tower's high ceilings and glass façades also provide adequate conditions for deep penetrating daylight. The need for artificial lighting is minimized by sensors that monitor the amount of natural daylight as it increases throughout the day. These sensors automatically dim or brighten artificial lights to achieve ideal lighting levels.

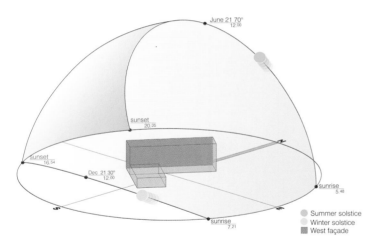

NORTHWEST In the summer, this façade receives solar radiation at a shallow angle during the late afternoon. Sunlight is controlled and diffused by the use of vertical translucent glass panels in order to achieve a comfortable room climate.

SOUTHEAST The southeast side of the building receives light at a steep angle during the summer. Solar screening is provided by the perforated metal scrim that allows ample daylight into the interior space.

NORTHEAST AND SOUTHWEST Northeast and southwest heat gain are minimized on the northeast and southwest sides of the building by solid narrow walls that contain the fire stairs on each side.

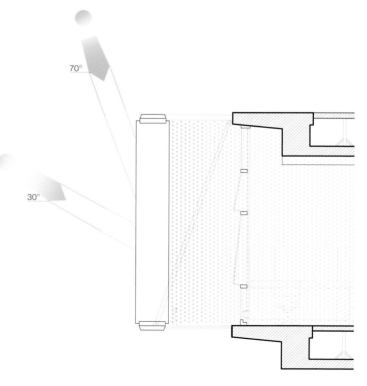

NORTHWEST FAÇADE: DAYLIGHTING AND SCREENING

Structure + Envelope + Mechanical

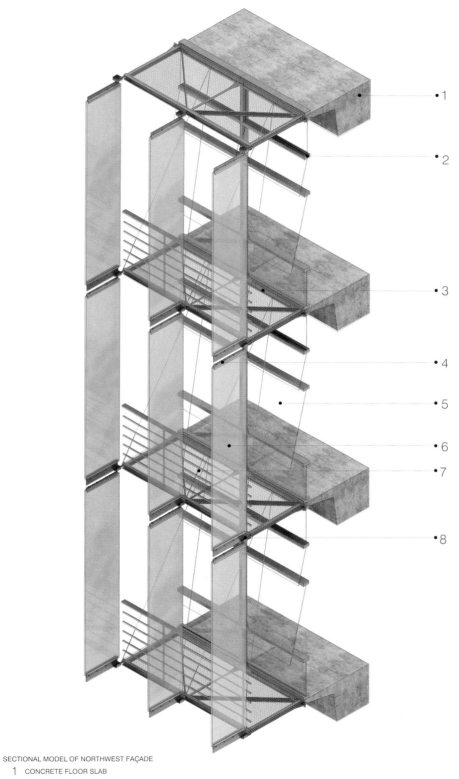

SECTIONAL MODEL OF NORTHWEST FAÇADE
1. CONCRETE FLOOR SLAB
2. EXTRUDED ALUMINUM PROFILE
3. MAINTENANCE CATWALK
4. GLASS BRACKET
5. OPERABLE WINDOW
6. LAMINATED TRANSLUCENT GLASS
7. STEEL CABLE SUPPORT
8. CLAMP

3.2 [S+E+M] San Francisco Federal Building

BUILDING FAÇADES The Federal Building is comprised of an intelligent exterior envelope that responds to lighting and other climatic conditions. The building embraces passive cooling and ventilation by utilizing a double-skin façade system on the southeast and northwest façades. The southeast façade is composed of an interior layer of floor to ceiling glass with operable windows and an exterior layer of perforated metal panels. The exterior metal skin is composed of stainless steel panels attached to a steel frame bolted to the concrete frame of the building. This scrim modulates solar radiation while allowing unobstructed views of the city and ample natural light into the interior space. During the day, the perforated panels are monitored and adjusted automatically by a computer system to respond to the changing angles of the sun. These operable façade elements help to eliminate occupant discomfort and reduce solar heat gain. During the summer, when the building heats up from the intense sun, the exterior metal scrim closes channeling the heated air between the two layers upward and out of the building.

The northwest façade consists of an exterior layer of vertical solar control panels of laminated translucent glass. The vertically oriented panels diffuse direct light and control solar radiation during the late afternoon hours. This façade also utilizes an interior layer of floor to ceiling glass with operable vents to allow the occupants to temper their environment and allow fresh air into their workspace.

INTEGRATED FLOOR SYSTEM The San Francisco Federal Building employs an innovative cast-in-place floor system. This system utilizes an up-stand beam, which is not a typical detail in construction, to integrate the underfloor distribution system within the structure. The upper portion of the floor plate has cavities that create the underfloor plenum, while the underside of the undulated deck is left exposed. The up-stand beam and undulated concrete ceilings enhance airflow through the building and maximize the pre-cooling effect during the night by allowing cool air from the automated windows to travel along the slab effectively.

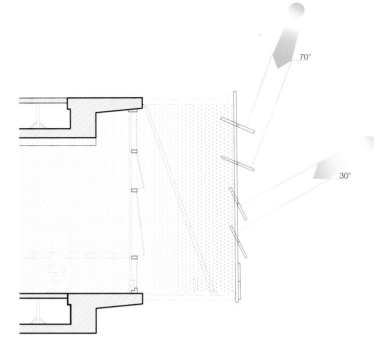

SOUTHEAST FAÇADE: DAYLIGHTING AND SCREENING

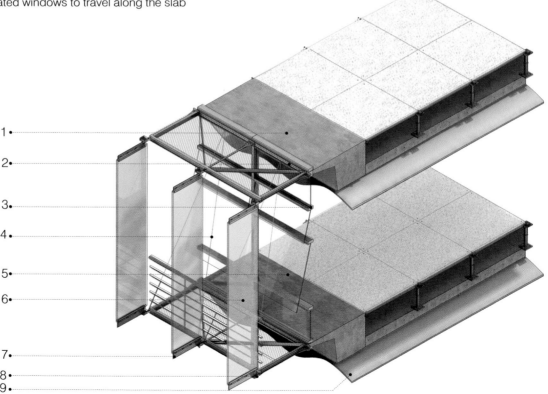

SECTIONAL MODEL OF NORTHWEST FAÇADE
1. CONCRETE FLOOR SLAB
2. MAINTENANCE CATWALK
3. EXTRUDED ALUMINUM PROFILE
4. STEEL CABLE SUPPORT
5. OPERABLE WINDOWS
6. LAMINATED TRANSLUCENT GLASS
7. GLASS BRACKET
8. CLAMP
9. UNDULATED CONCRETE CEILING

Structure + Envelope + Mechanical

NATURAL VENTILATION

SUMMER:

DAYTIME The San Francisco Federal Building takes advantage of the strong northwest winds of San Francisco. It is cooled and ventilated by controlling the upper windows on either side of the building. Above the fifth floor, windows on the northwest façade are automatically adjusted by a computerized system to admit fresh air. Air flows from one side to the other over the interior space and is vented out of the building through the southeast wall. The circulation of outside air is facilitated across the narrow floor by undulating concrete ceilings.

NIGHT COOLING The undulating concrete ceilings also perform as a thermal mass to cool the building during the summer. To take advantage of San Francisco's cool nights, the upper windows open automatically to release heat build-up and allow nighttime air to cool the building's concrete interior. The thermal mass of the undulated concrete ceilings store cooling energy at night and release it during the day to cool the circulating air.

WINTER:

ACTIVE HEATING Even though the lower levels of the building require mechanical cooling, the natural ventilation system provides cooling for most of the building from mid-April through October. The building operates with windows closed during the colder months of the year and utilizes active heating from December through February.

SOURCES

Tim Christ, "An Architectural Perspective on Natural Ventilation." Passive Cooling in Non-domestic Buildings.

Charles J. Kibert, Sustainable Construction: Green Building Design and Delivery (John Wiley and Sons, 2007).

Erin McConahey, Philip Haves, and Tim Christ, "The Integration of Engineering and Architecture: A Perspective on Natural Ventilation for the New San Francisco Federal Building," High Performance Commercial Building Systems (2002).

Kiel Moe, Integrated Design in Contemporary Architecture (New York: Princeton Architectural Press, 2008).

Scott Murray, Contemporary Curtain Wall Architect (New York: Princeton Architectural Press, 2009).

"San Francisco Federal Building GSA's Model of Sustainable Design," General Services Administration, January 23, 2007, http://www.fypower.org/pdf/SFFB_SustainableDesign.pdf.

"US General Services Administration San Francisco Federal Building," Rocky Mountain Institute, High Performance Building: Perspective and Practice, http://bet.rmi.org/files/case-studies/gsa/US_General_Services_Administration.pdf.

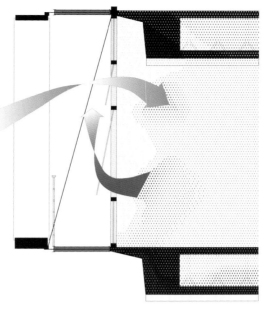

SUMMER: NIGHT COOLING

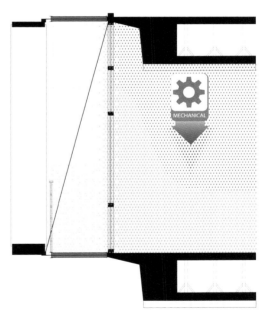

WINTER: ACTIVE HEATING

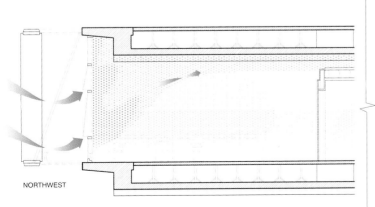

NORTHWEST

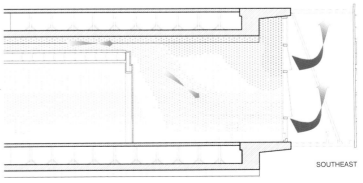

SOUTHEAST

SUMMER VENTILATION: CROSS FLOW

3.3 [S+E+M]
Loblolly House

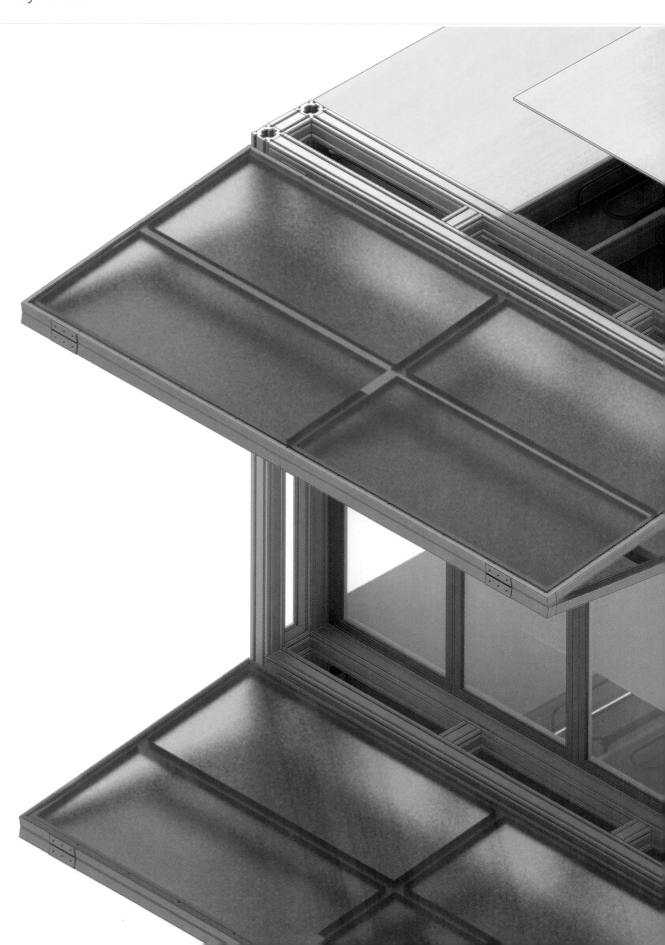

Structure + Envelope + Mechanical

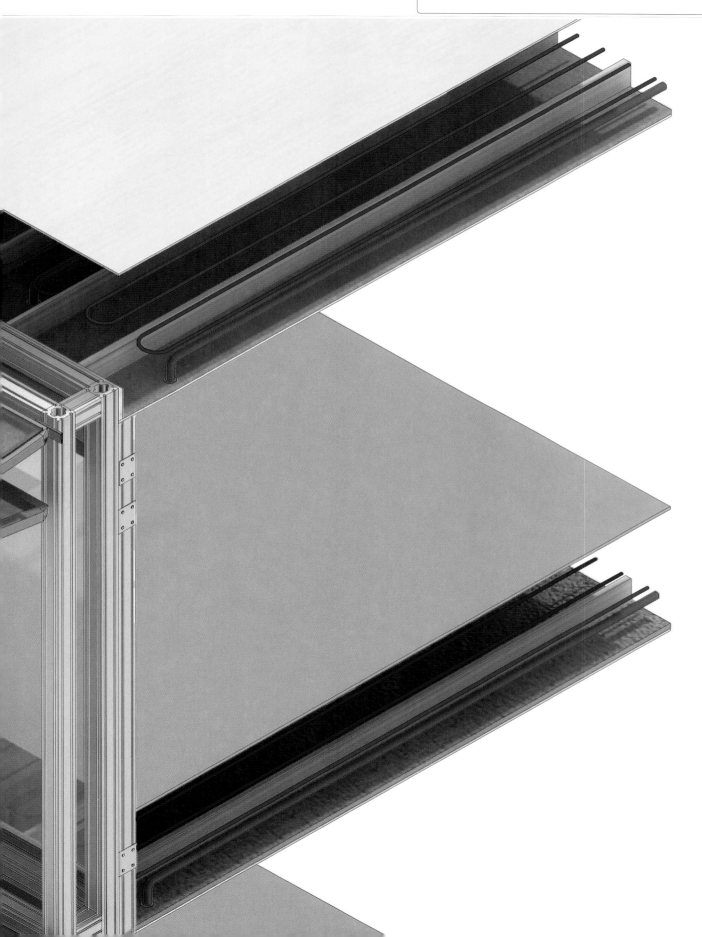

3.3 [S+E+M] Loblolly House

ARCHITECT	KieranTimberlake
LOCATION	Taylors Island, Maryland, USA
	38.3°N 76.2°W
DATE	2006

LOCATION CONDITIONS

BACKGROUND The Loblolly House is a weekend home for the architect Stephen Kieran and his family. It is located on the edge of the Chesapeake Bay within a grove of Loblolly Pines. The house is an elevated two-storey structure with three bedrooms, two bathrooms, a kitchen, dining room, living room, interior and exterior stairs, and several balconies. The majority of the house is composed of factory-made systems and elements delivered to the site for quick assembly.

Like the Eames House of 1949 by Charles and Ray Eames, this house was an occasion for the architects to research and test the possibilities of prefabrication. The architects see prefabrication as a highly controllable method of construction that allows for the integration of building systems in an efficient manner. They feel that prefabrication allows a cost-conscious home to be well built, energy efficient, and unique. The Loblolly House has the feel of a craftsperson's home with customized details built to exacting dimensions and a variety of fine finishes.

PERFORMANCE The Loblolly House employs a variety of sustainable strategies to create an energy efficient and environmentally friendly building. Efficient space planning and the use of prefabricated elements minimize material use and construction waste. The foundation system disturbs the site minimally. The façades protect the interior from unwanted solar heat gain while the adjustable western façade wall allows for passive ventilation.

STRUCTURE Twenty-one wood piles serve as the home's foundation and raise the body of the house off the ground. The piles are attached by wood collar beams, which create a platform for the prefabricated elements. The structure is composed of a prefabricated aluminum frame that is assembled onsite with a series of slotted and bolted connections. Custom connectors are required for this frame as the Bosch connectors are not sufficient to resist lateral loads. This bracing is also strengthened by diagonal rods attached at frame intersections. The resulting structural lattice is then filled with prefabricated floor and wall panels and building cores. The panels form the enclosure of the home.

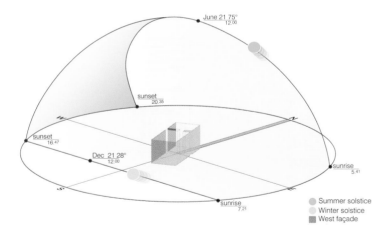

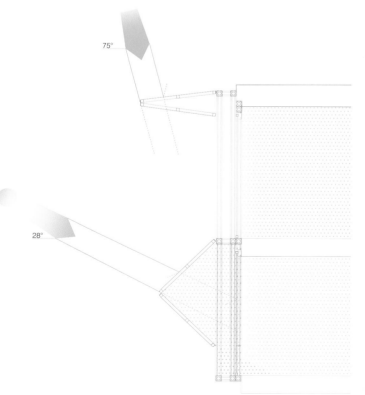

WEST During the summer, this façade receives large amounts of solar radiation. Solar screening is provided by the translucent panels that can be moved to respond to various climatic conditions.

EAST, SOUTH, NORTH These façades allow daylight to enter the house through discreet windows. Solar heat gain is reduced by the wooden screen.

WEST FAÇADE: DAYLIGHTING AND SCREENING

Structure + Envelope + Mechanical

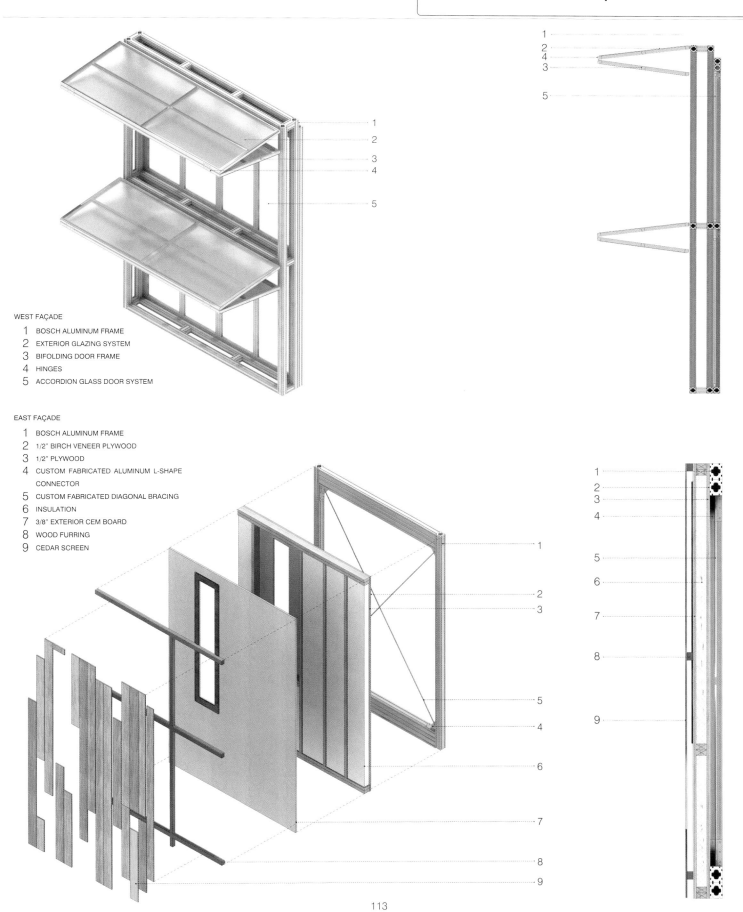

WEST FAÇADE

1. BOSCH ALUMINUM FRAME
2. EXTERIOR GLAZING SYSTEM
3. BIFOLDING DOOR FRAME
4. HINGES
5. ACCORDION GLASS DOOR SYSTEM

EAST FAÇADE

1. BOSCH ALUMINUM FRAME
2. 1/2" BIRCH VENEER PLYWOOD
3. 1/2" PLYWOOD
4. CUSTOM FABRICATED ALUMINUM L-SHAPE CONNECTOR
5. CUSTOM FABRICATED DIAGONAL BRACING
6. INSULATION
7. 3/8" EXTERIOR CEM BOARD
8. WOOD FURRING
9. CEDAR SCREEN

3.3 [S+E+M] Loblolly House

BUILDING FAÇADES There are two distinct façade types in the house: an adjustable buffer façade for the west wall and a fixed wooden screen façade for the east, north and south walls. The west façade is entirely glazed to allow views to the water. This façade proved to be the most challenging façade for the architects because the desired view faced the setting sun. In terms of sustainable planning, lining the west façade with glass exposes the home to summer heat gain and intense glare. To protect the façade, the architects developed a surface composed of two hinged systems. The first hinged system is an accordion glass door that acts as the enclosing wall for the interior. These doors can be folded against one another and pushed to the side to create an expansive opening. Outside of these doors, a second hinged system of four sets of translucent hinged panels can be adjusted to accommodate various environmental conditions. When these panels are closed, they serve as a screen and a buffer façade, creating an insulating air pocket that protects the interior from the cold. When these panels are completely open, they create an overhang that shades the glass door system from the high summer sun. As the sun sets in the afternoon, these panels can be lowered to protect from the glare of the direct western light.

The east, north and south façades are layered surfaces. The innermost layer of these façades is the prefabricated wall "cartridge" made of integrated wall panels that contain insulation, wood framing, a vapor barrier, and windows with adjustable screens. The next layer of the façade is composed of furring strips. Over this layer, a prefabricated cedar wood screen is affixed. This screen replaces typical hand-installed siding (shingles or clapboard) with prefabricated siding panels. The screen panels are composed of vertically oriented boards that are staggered and separated. The irregular placement of these boards creates the impression that the surface is spontaneously handmade onsite. The outward expression of this façade conceals the fact that the house is the product of a highly directed, computer-controlled, prefabricated building process.

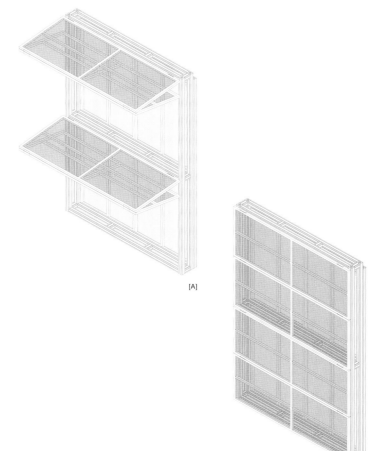

[A]

[B]

WEST FAÇADE

[A] SUMMER: Ventilation
During the summer, the west façade can be adjusted to respond to the weather. The translucent panels can be completely open to allow natural ventilation, while creating an overhang that serves as a shading device against the high summer sun.

[B], [C] WINTER: Buffer
In the winter months the west façade is heated by the sun at a shallow angle. The translucent panels in this façade are closed to create a buffer zone and protect the building's interior from the cold weather. Mechanical heating is activated to achieve a comfortable room temperature.

[C]

Structure + Envelope + Mechanical

INTEGRATION At the Loblolly House, the walls and floors are integrated with the home's building systems and are built as a series of panels that are connected to one another onsite. The architects call these panels "cartridges" as their interiors are no longer inert but composed of functioning elements. The "cartridges" of the Loblolly House are composed of integrated pre-assembled hollow panels that are occupied by structure, heating, cooling, lighting, and electrical components. The floor panels are organized in layers. At the top, bamboo flooring rests on plywood with affixed radiant heat tubing. In the middle, structural beams coexist with air ducts, insulation, and lighting. At the underside of the panel, a layer of plywood is covered with a finished wood panel. The exterior wall panels are insulated and protected with a weather barrier and contain windows.

In addition to the integrated wall and floor panels, critical instances of system integration within the plan are organized into factory-made cores. There are three cores: one bathroom and mechanical core, one master bathroom core, and one mechanical core. These cores are small in size and contain important equipment, finishes, and fixtures. One of challenges of prefabrication is the transportation of the product to the site. Whenever possible, manufacturers avoid shipping empty space. While the rest of the home was shipped to the site in a collapsed state to minimize shipping space, these cores were dense enough to justify shipping in their completed form.

SOURCES

Stephen Kieran and James Timberlake, Loblolly House, Elements of a New Architecture, (New York: Princeton Architectural Press, 2008).

Stephen Kieran and James Timberlake, Refabricating Architecture, How Manufacturing Methodologies Are Poised to Transform Building Construction (New York: McGraw Hill Companies, Inc., 2004).

"Loblolly House Building Information Model Awards 2007," (2007)

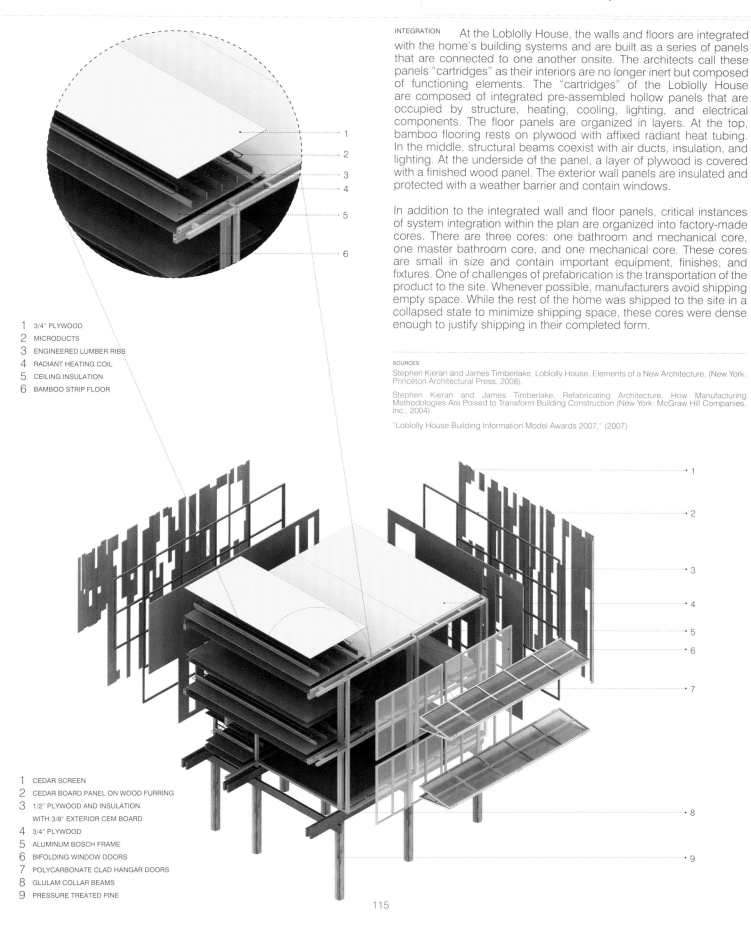

1 3/4" PLYWOOD
2 MICRODUCTS
3 ENGINEERED LUMBER RIBS
4 RADIANT HEATING COIL
5 CEILING INSULATION
6 BAMBOO STRIP FLOOR

1 CEDAR SCREEN
2 CEDAR BOARD PANEL ON WOOD FURRING
3 1/2" PLYWOOD AND INSULATION WITH 3/8" EXTERIOR CEM BOARD
4 3/4" PLYWOOD
5 ALUMINUM BOSCH FRAME
6 BIFOLDING WINDOW DOORS
7 POLYCARBONATE CLAD HANGAR DOORS
8 GLULAM COLLAR BEAMS
9 PRESSURE TREATED PINE

3.4 [S+E+M] Yale Center for British Art

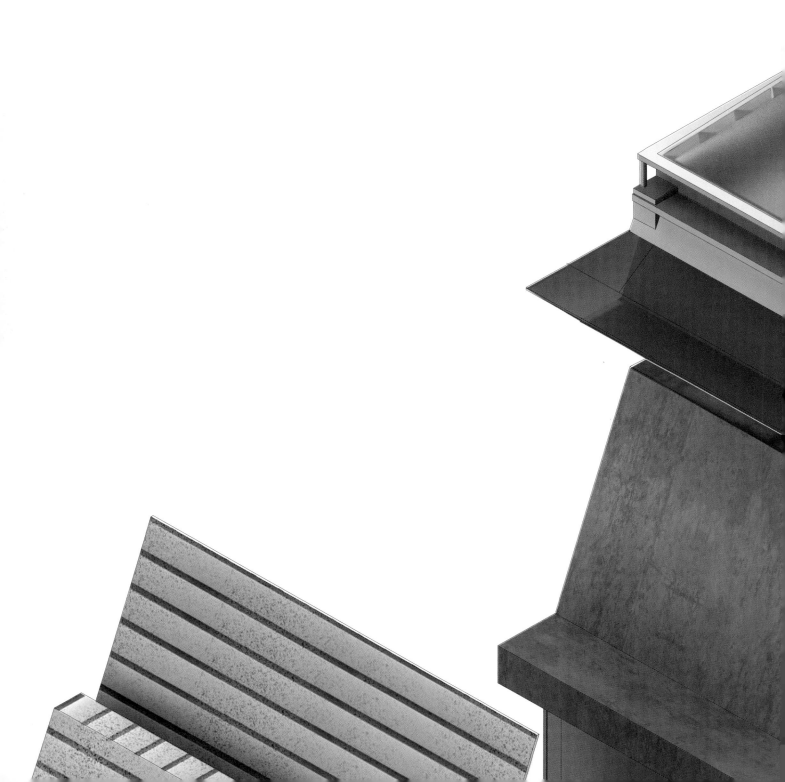

Structure + Envelope + Mechanical

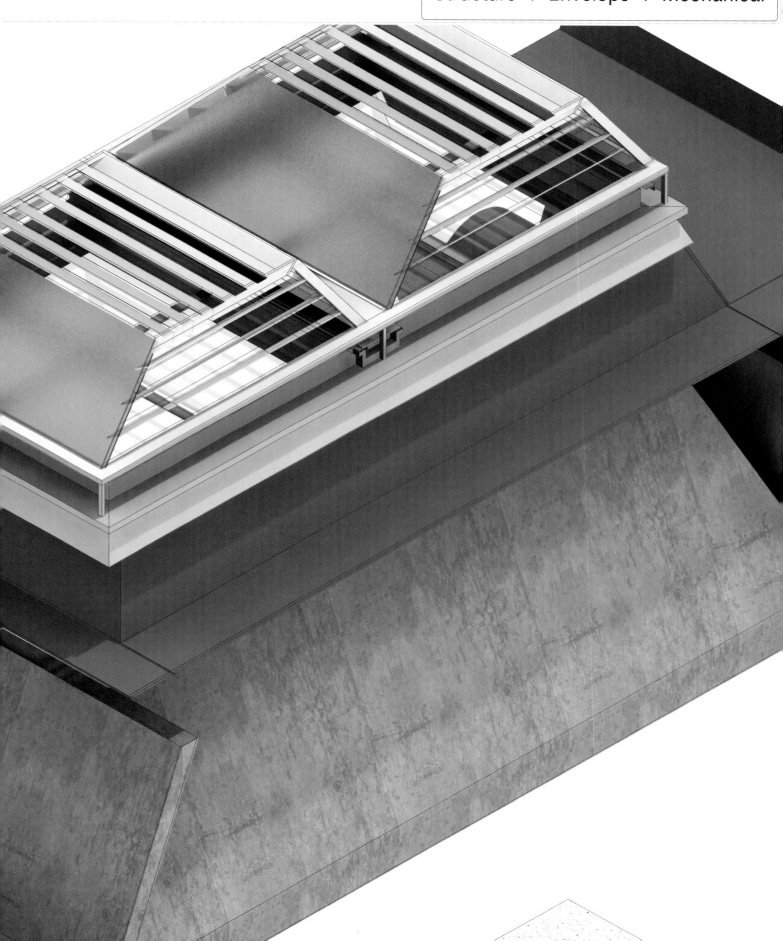

3.4 [S+E+M] Yale Center for British Art

ARCHITECT Louis I. Kahn, Pellecchia and Meyers
LOCATION New Haven, Connecticut, USA
41.3°N 72.9°W
DATE 1969-74

LOCATION CONDITIONS

BACKGROUND The Yale Center for British Art was a gift from the banker and collector, Paul Mellon. Mellon gave both the collection and funding to build and maintain a new art museum in downtown New Haven. Louis Kahn was the architect selected to design this building, making it his second for Yale University. The building is located on busy Chapel Street, across the street from Kahn's earlier Yale Art Museum of 1953. In order to maintain the street's urban life, Yale decided to incorporate a series of retail spaces on the ground floor of the building. As a result, this building is a mixed-use, four-storey structure containing gallery spaces, offices, a library, storage spaces, a museum store, a lecture hall, and leasable space for shops and restaurants. The center is a compact block organized around two courts: a four-storey entry court and a three-storey library court. The courts and the top floor galleries are all illuminated by skylights.

SKYLIGHTS The top floor galleries and the two building courts are illuminated with skylights to enrich the museum space with the changing natural light conditions during the day. To protect the artwork from harmful ultraviolet rays, the skylights in the galleries are covered with translucent panels. In addition to these interior panels, each gallery skylight is equipped with exterior louvers. This solar protection allows for an even; diffuse light for the viewing of art and minimizes solar heat gain. The entry court skylights are not covered with any solar protection as the court is not used for the display of art.

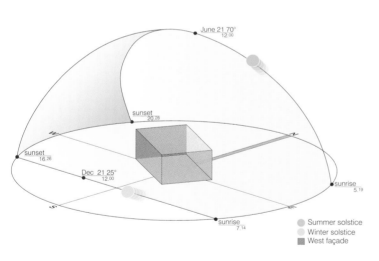

PERFORMANCE The Yale Center for British Art exists as an important culmination of the architect's efforts to organize the building program and services. Kahn developed the beaux-arts notion that primary spaces are to be served by support spaces through the organization of distinct mechanical and service zones. Traditionally, these support zones have been separated and hidden from the main spaces of the building.

The building uses a mechanical system of forced air to heat and cool the museum. The integration of a return air plenum inside the concrete floor slab allows for passive air exchange. The supply ducts mounted high inside the galleries drop cool air to the floor. Rather than have a second ceiling-mounted duct collecting air upwards, a linear diffuser pulls air into the slab plenum. The air movement efficiencies gained by this duct's placement also allows for a less cluttered ceiling.

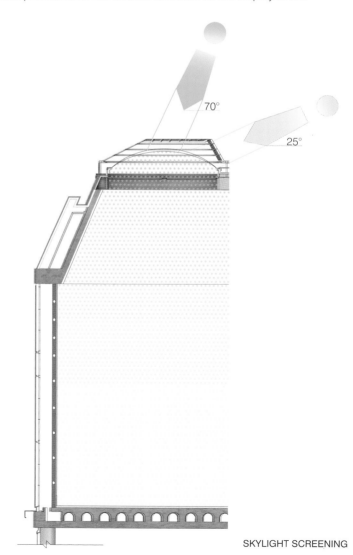

SKYLIGHT SCREENING

Structure + Envelope + Mechanical

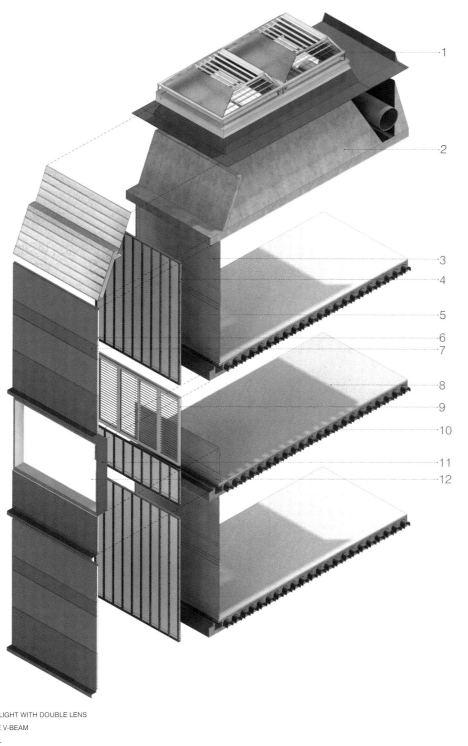
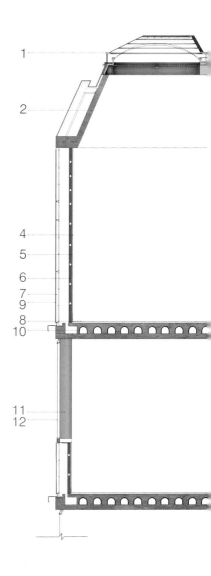

1. DOME SKYLIGHT WITH DOUBLE LENS
2. CONCRETE V-BEAM
3. OAK PANEL
4. GYPSUM BOARD
5. METAL STUDS
6. URETHANE INSULATION
7. STAINLESS STEEL PANEL
8. TRAVERTINE
9. WOOD LOUVERS
10. COPPER BARREL TILES
11. STAINLESS STEEL FRAME
12. GLAZING

3.4 [S+E+M] Yale Center for British Art

BUILDING FAÇADE The façade of the Yale Center for British Art is composed of an exposed concrete structural frame infilled with brushed stainless steel and glass panels. The columns and the floor slab edges of the concrete structure are expressed on the exterior and frame the infill panels that serve as the building's sealed enclosure. These panels are insulated and contain insulated glass windows. After the building was completed, wooden shutters were installed on the interior of these panels. The shutters allow the museum curators to open and close the gallery for exhibition purposes. These shutters are on rollers and can be opened completely to allow outside views and admit natural light into the interior space. In the closed position, their adjustable louvers can be positioned to block or diffuse daylight. While the shutters minimize direct solar exposures on artwork, they are unable to block heat gains into the building.

STRUCTURE AND MECHANICAL SYSTEMS The building utilizes a clear structural system while accommodating the spatial requirements of a forced-air mechanical system. The ventilation duct system and the building structure interact in three ways: separated, nestled, and integrated. In the separated condition, the supply ducts simply hang from the cast-in-place concrete ceiling in the gallery spaces. In the nestled condition, the supply ducts located within the roof occupy the residual space of the v-shaped roof beam section. In the integrated condition, the return-air supply plenums are located in the hollow concrete floor decks. This interaction blurs the traditional separation of structure and mechanical services. In this condition, the structure acts to support the building and house air movement.

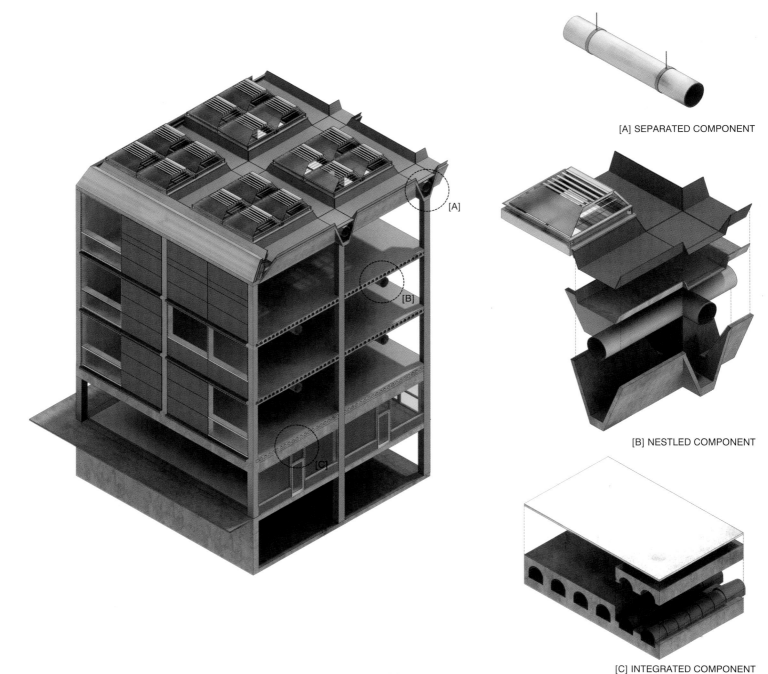

[A] SEPARATED COMPONENT

[B] NESTLED COMPONENT

[C] INTEGRATED COMPONENT

Structure + Envelope + Mechanical

STRUCTURE The structure of the Yale Center for British Art is a trabeated, cast-in-place, two-way concrete frame with precast concrete v-shaped roof beams. The square columns of the structure diminish in size as they move up the structure to reflect decreased building loads and efficient use of materials. The condition of merging the structure with the mechanical system is resolved utilizing a unique cast-in-place hollow floor slab with copper barrel tiles that were set into the slab prior to the pouring of concrete. Placed inside the slab, the plenum occupies the location of inefficient concrete and produces a lighter deck. The presence of the plenum inside the slab reveals a sophisticated understanding of structure and allows both structural and mechanical systems benefit from the use of a hollow slab. The integration of these two systems with one solution acknowledges the reality that modern buildings are composed of layered systems rather than monolithic ones.

SOURCES

Patricia Cummings Loud and Louis I. Kahn. The Art Museums of Louis I. Kahn, illustrated ed. (Durham, North Carolina: Duke University Press, 1989).

Jules Prown, The Architecture of the Yale Center for British Art, 2nd ed. (New Haven: Yale University, 1993).

Heinz Ronner, Louis I. Kahn: Complete Works 1935-1974. Enlarged 2nd ed. (Basel: Birkhäuser, 1987).

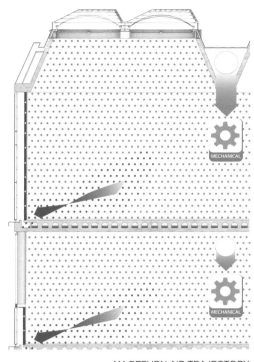

[A] RETURN AIR TRAJECTORY

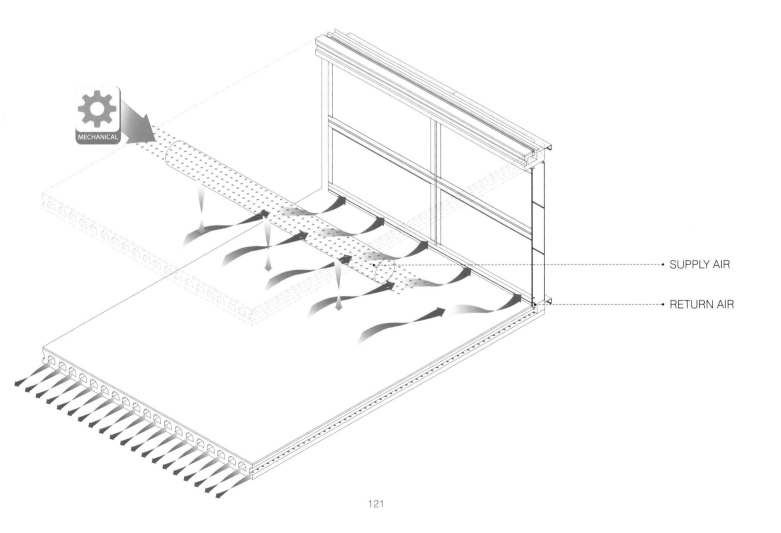

SUPPLY AIR

RETURN AIR

3.5 [S+E+M]　Manitoba Hydro Place

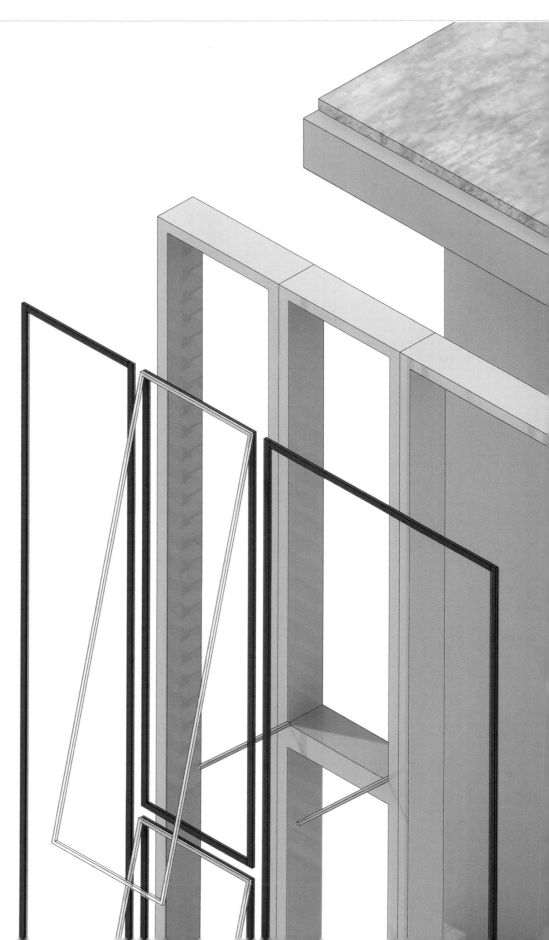

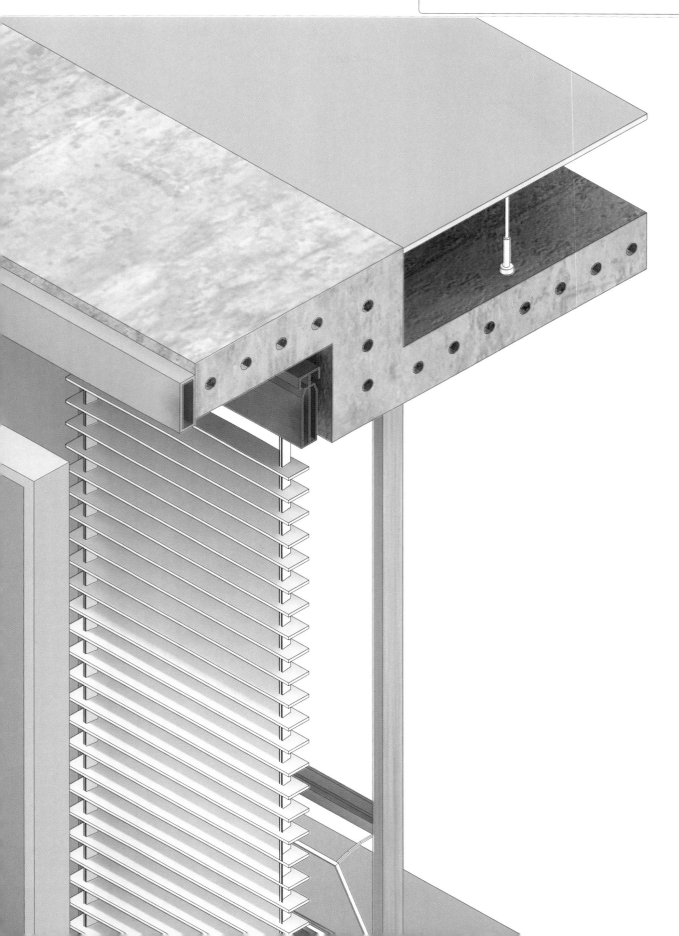

Structure + Envelope + Mechanical

3.5 [S+E+M] Manitoba Hydro Place

ARCHITECT	KPMB Architects
LOCATION	Winnipeg, Manitoba, Canada 49.5°N 97.1°W
DATE	2009

LOCATION CONDITIONS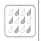

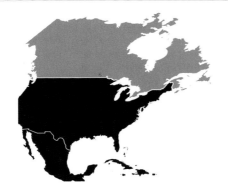

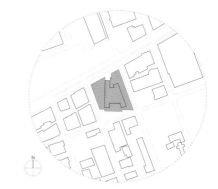

BACKGROUND The Manitoba Hydro Place occupies an entire urban block in downtown Winnipeg. The twenty-two storey office building is a 700,000 square foot (65,032 square meters) facility that accommodates 2,000 employees for one of the largest energy utilities in Canada. The tower consists of column-free office blocks separated by a service core and a series of atrium spaces. The tower sits on a three-storey podium that provides a pedestrian street, a gallery, a retail space, and lobby spaces accessible to the public. The building utilizes wind and sun energies to achieve energy savings while providing a comfortable interior environment.

PERFORMANCE The Manitoba Hydro Place building maximizes the use of passive energy to establish a model for exceptional climate responsive design. The building's north-south orientation allows Winnipeg's prevailing winds to naturally ventilate the structure while providing sunlight to the south atria. The design and configuration of the floor plate ensures ample natural light to the core of the building, reducing the need for artificial lighting. The floor plates are shallow, and the generous floor-to-ceiling heights allow light to penetrate deep into the space. To achieve maximum efficiency, the building is equipped with a high performance envelope, a borehole geothermal system, a solar chimney, and a series of winter gardens and green roofs. It features an advanced building management system (BMS) that coordinates ventilation rates, heating, lighting, and solar shades throughout the day.

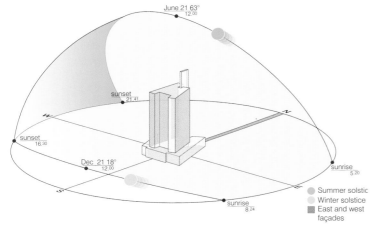

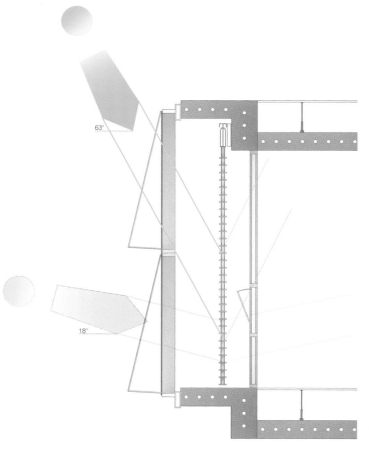

NORTH The north side of the building is minimized to reduce heat loss during the winter season. This side incorporates the solar chimney that assists the natural ventilation strategy.

EAST During the summer, the east façade receives large amounts of solar radiation in the morning. This side of the building utilizes a double-skin façade that reduces solar heat gain during the summer and performs as a thermal buffer during the winter.

SOUTH The south atriums receive light at a steep angle during the summer. This side of the building receives plenty of sunlight for daylighting during the summer and for passive heating during the winter season.

WEST In the summer months, the west façade is exposed to large amounts of solar radiation. The shading system within the double-skin façade is adjusted throughout the day to allow daylight and prevent excessive solar heat gain.

DAYLIGHTING AND SCREENING

Structure + Envelope + Mechanical

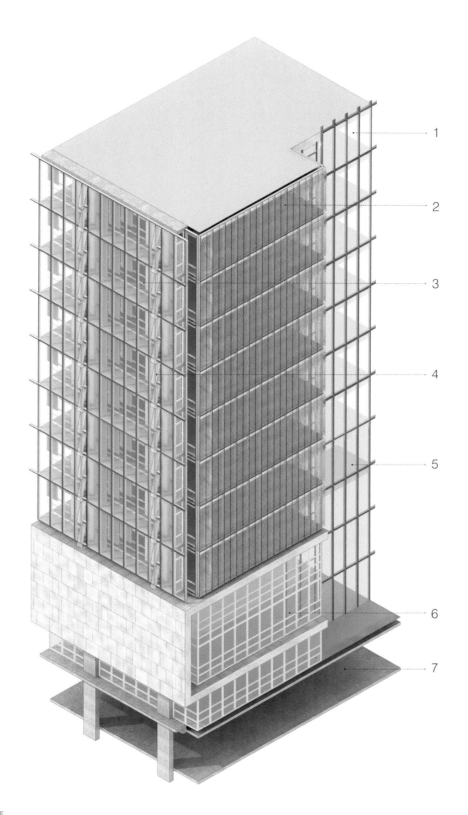

SOUTH AND WEST FAÇADES
1 SOUTH FAÇADE
2 WEST TOWER
3 WEST DOUBLE-SKIN FAÇADE
4 OPERABLE WINDOW
5 SOUTH WINTER GARDEN
6 THREE-STOREY PODIUM
7 UNDERGROUND PARKING GARAGE

3.5 [S+E+M] Manitoba Hydro Place

BUILDING ENVELOPE The building is equipped with double-skin façades on the east and west sides to respond to climatic conditions and reduce heating and cooling loads. These façades consist of low-iron glass curtain walls set apart by a three-foot-wide air cavity. The inner and outer glass walls, separated by an automatic louver shading system, incorporate operable windows. During cold weather, the double-skin façades perform as a thermal buffer that protects the building from extreme outdoor temperatures. When heat builds up inside the double skin, the building management system adjusts the shades to block direct solar radiation and opens the operable windows in the exterior wall to vent the cavity.

Located within the double façades is an automated shading system that consists of 4-inch-deep (10 centimeters) aluminum louver shades that can be adjusted to prevent excessive solar gain. Each louver is controlled automatically by the building management system to respond to the position of the sun throughout the day. The top portion of the shading device is positioned at a different angle from the lower louvers to perform as a light shelf and to reflect light off its surface onto the white ceiling. When the shading system is entirely closed, the aluminum louver blades provide views to the exterior through fine perforations on their surface. When light levels are low, the shading system is fully retracted into the ceiling.

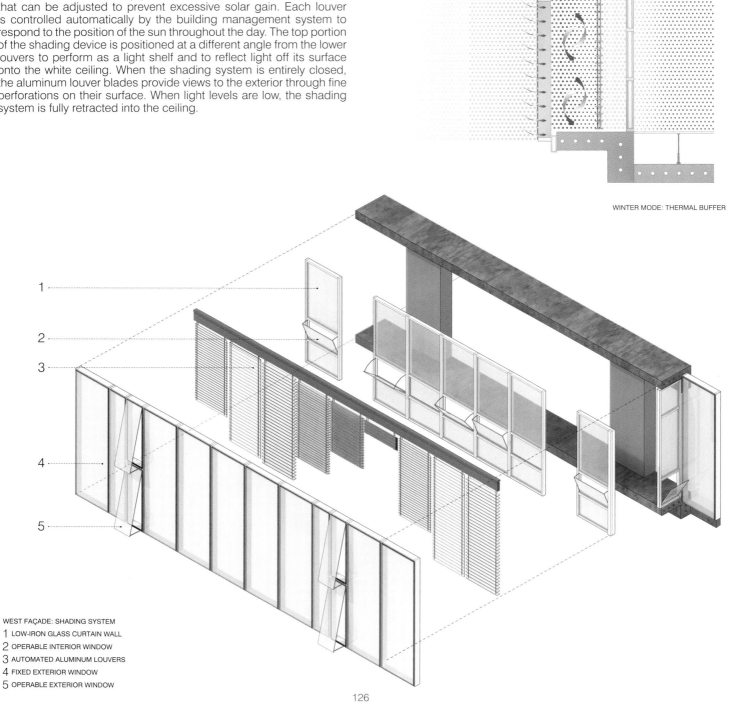

WINTER MODE: THERMAL BUFFER

WEST FAÇADE: SHADING SYSTEM
1. LOW-IRON GLASS CURTAIN WALL
2. OPERABLE INTERIOR WINDOW
3. AUTOMATED ALUMINUM LOUVERS
4. FIXED EXTERIOR WINDOW
5. OPERABLE EXTERIOR WINDOW

Structure + Envelope + Mechanical

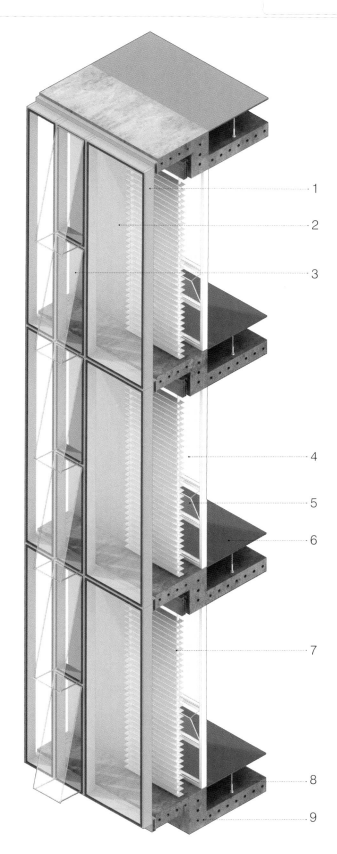

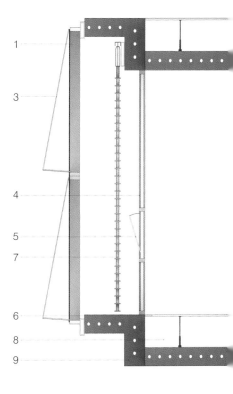

EAST AND WEST FAÇADES
1. ALUMINUM FRAME
2. FIXED EXTERIOR WINDOW
3. OPERABLE EXTERIOR WINDOW
4. LOW-IRON GLASS CURTAIN WALL
5. OPERABLE INTERIOR WINDOW
6. FINISH FLOOR
7. AUTOMATED ALUMINUM LOUVERS
8. RAISED FLOOR PLENUM
9. THERMAL MASS

3.5 [S+E+M] Manitoba Hydro Place

NATURAL VENTILATION The Manitoba Hydro Place building integrates south-facing winter gardens to achieve natural ventilation year-round regardless of exterior temperatures. These gardens are contained within three six-storey atrium spaces on the south side of the building. During the winter, fresh air enters each of the gardens through a series of automated louvers placed at strategic locations on the south façade. Incoming air is heated by the sun and humidified by water features before it enters the workspaces through adjustable vents in the raised floor plenum. Fresh air is supplied twenty-four hours a day and distributed by a displacement ventilation system. Heated air rises and is drawn north and out of the building by a solar chimney. Operable windows on the east and west façades allow occupants to individually control airflow and temperature in their own work environment.

- SOUTH ATRIUM GARDENS
- WORKING SPACES
- SOLAR CHIMNEY
- GEOTHERMAL WELL

NATURAL VENTILATION STRATEGY

Structure + Envelope + Mechanical

WATER FEATURES Each of the atrium spaces incorporates a 78-foot-tall (24 meters) water feature composed of 280 Mylar ribbons held in tension at the bottom. Recycled water flows down each ribbon to humidify or dehumidify incoming air, depending on the season. During cold temperatures, water running down the ribbons is heated, and as cool, dry air flows through, the water moisture is dispersed to temper the environment. During warm weather, water running down the ribbons is chilled to absorb moisture in the warm humid incoming air. The water temperature in the water features is regulated by a building management system.

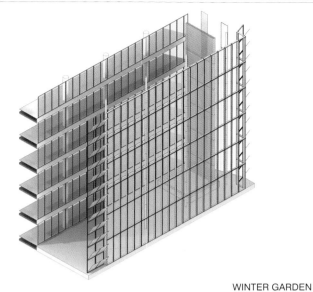

WINTER GARDEN

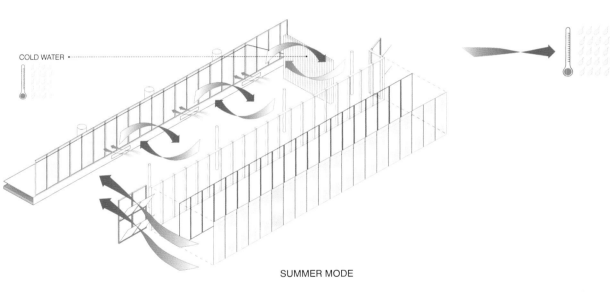

COLD WATER

SUMMER MODE

DEHUMIDIFIED AIR

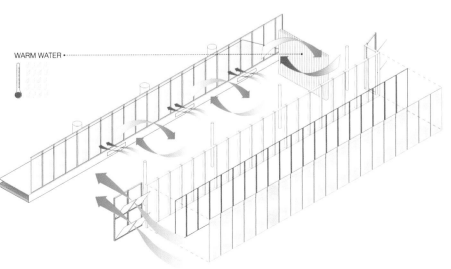

WARM WATER

HUMIDIFIED AIR

WINTER MODE

WINTER GARDEN

3.5 [S+E+M] Manitoba Hydro Place

GREEN ROOF In addition to winter gardens, the Manitoba Hydro Place building incorporates green roofs on the roof surfaces of the three-storey podium. The planted roofs contain native plant species including conifers, wildflowers, and native grasses. They offer a number of benefits that enhance the building's performance. They provide the roofs with additional insulation protecting them from solar heat gain during the summer and heat loss during the winter. They also retain rainwater for the vegetated areas and release excess water back into the city system.

DISPLACEMENT VENTILATION Preconditioned air is distributed into the office spaces by a displacement ventilation system. In this system, air is delivered through vents in the raised floor plenum to the occupied floor. The air rises as it is heated by occupants and equipment, and moves along the ceiling into an outlet. This exhaust air flows to the north atrium, where it is drawn out of the building passively by a solar chimney. The displacement ventilation system achieves a higher air quality than a conventional ventilation system. It also eliminates standard ductwork and suspended ceilings, which allows raised window heights for maximum daylight penetration.

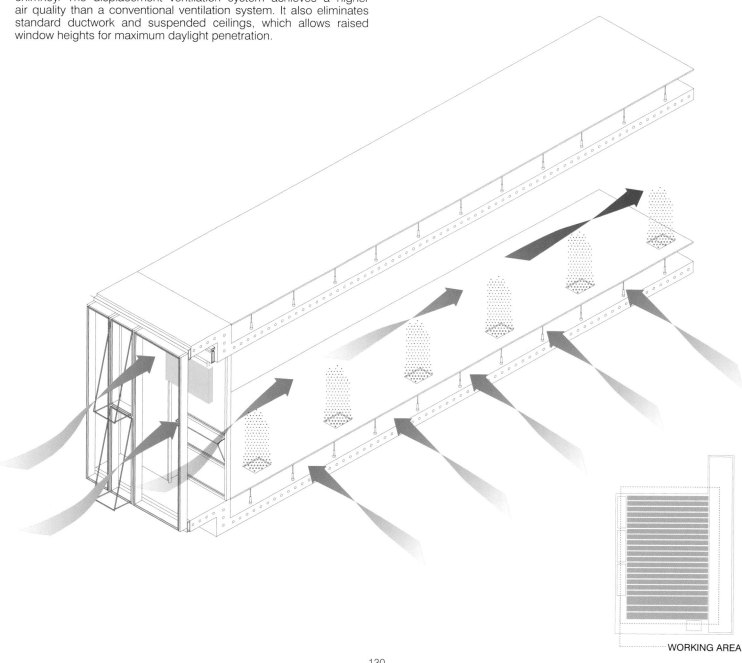

WORKING AREA

Structure + Envelope + Mechanical

SOLAR CHIMNEY The solar chimney assists the natural ventilation system by employing the stack effect to draw exhaust air out of the building. Exhaust air from the office floors is collected in the north atrium and driven into the solar chimney through vertical and horizontal dampers controlled by the building management system. During cold weather, this heated air is pulled down by fans into the underground parking garage for heat recovery. In warm weather, this air is drawn up and out of the building through automated glass louvers at the top of the chimney.

The solar chimney rises 378 feet (115 meters) above ground on the north side of the building. It is composed of steel pipes arranged vertically to optimize morning and afternoon sun. Each pipe is about 5 inches (13 centimeters) in diameter and is completely filled with sand to store solar energy in their thermal mass.[1] This strategy enhances the natural ventilation system by maintaining higher temperatures at the top of the chimney increasing the natural stack effect.

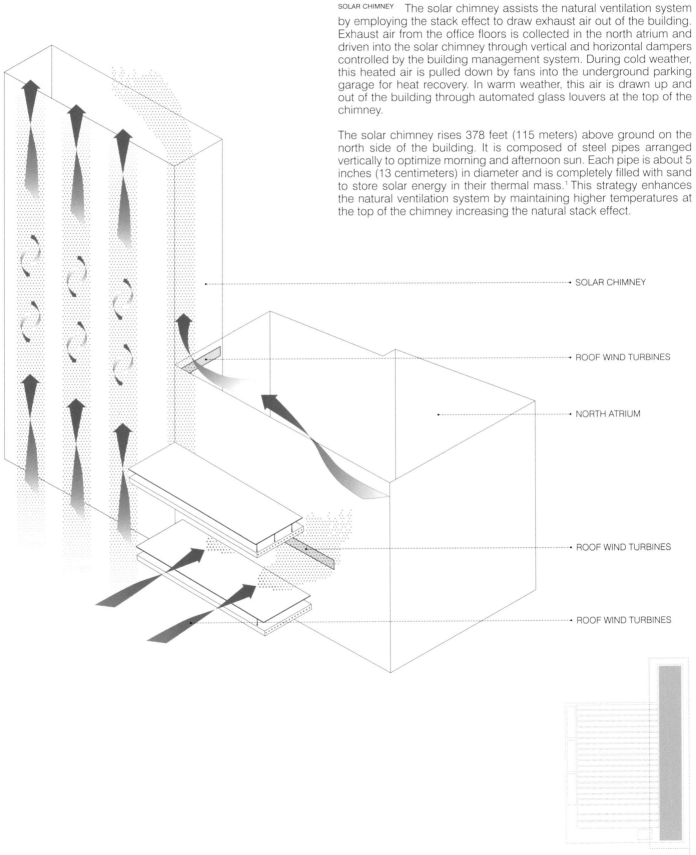

SOLAR CHIMNEY

ROOF WIND TURBINES

NORTH ATRIUM

ROOF WIND TURBINES

ROOF WIND TURBINES

SOLAR CHIMNEY

3.5 [S+E+M] Manitoba Hydro Place

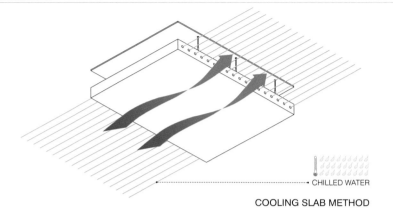

COOLING SLAB METHOD — CHILLED WATER

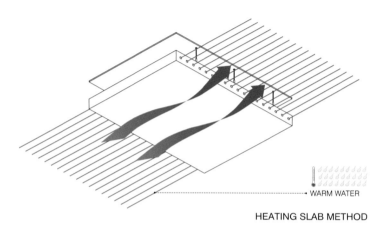

HEATING SLAB METHOD — WARM WATER

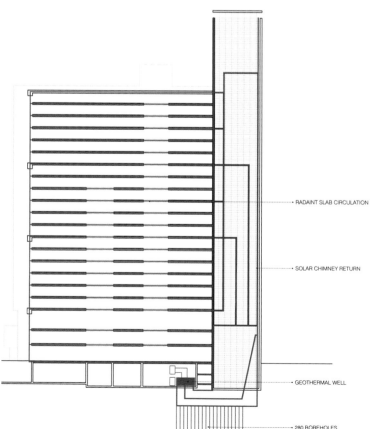

- RADIANT SLAB CIRCULATION
- SOLAR CHIMNEY RETURN
- GEOTHERMAL WELL
- 280 BOREHOLES

HEATING AND COOLING The building's concrete structure performs as thermal mass to store heat energy and moderate the impact of extreme temperatures. Radiant heating and cooling systems are located within the exposed concrete ceiling to maintain a comfortable temperature throughout the year. The heating and cooling strategy consists of circulating water through plastic pipes embedded in the concrete floor slab. This running water is warmed or chilled depending on the season to heat or cool the building by thermal radiation. Radiant heating and cooling consume less energy than standard HVAC systems. This system eliminates the use of fans to deliver heat and reduces the use of energy for fresh air heating and humidification. Radiant systems also require low water temperatures for heating compared to those of an air-heating coil because they utilize the entire underside of the slab to provide heating. The low heating temperatures allow for the efficient use of heating sources such as condensing boilers and geothermal wells.

GEOTHERMAL WELLS The Manitoba Hydro Place office building utilizes earth's natural energy storage for cooling and heating. The geothermal system consists of a closed loop system composed of 280 boreholes 400 feet deep (122 meters) beneath the building.[2] Each borehole is 6 inches (15 centimeters) in diameter, containing pipes filled with glycol, a conducting fluid that transports heat or cold. During the summer, the fluid contained in the pipes is used to extract heat from the building and return it to the ground. In the winter, the fluid extracts heat from the ground to warm the building. Heat in the fluid is transferred to water that circulates in the radiant slabs in the office towers. This fluid passes through a series of heat pumps and exchangers to maximize efficiency.

REFERENCES
1. "Manitoba Hydro Place," Manitoba Hydro, The Greening of Municipalities, www.amm.mb.ca/documents/SR-Hydrobuilding.pdf.
2. Manitoba Hydro Place Integrated Design Consortium, "Manitoba Hydro Place. Integrated Design Process Exemplar," (PLEA2009- 26th Conference on Passive and Low Energy Architecture, Quebec City, Canada, 22-24 June 2009).

SOURCES
Joann Gonchar, "More Than Skin Deep," Architectural Record, (July 2010), http://continuingeducation.construction.com/article.php?L=5&C=685&P=3.

Charles Linn, "Manitoba Hydro Place," Green Source: The Magazine of Sustainable Design (March 2010)

Kiel Moe, Integrated Design in Contemporary Architecture, illustrated ed. (New York: Princeton Architectural Press, 2008).

GEOTHERMAL WELL

Structure + Envelope + Mechanical

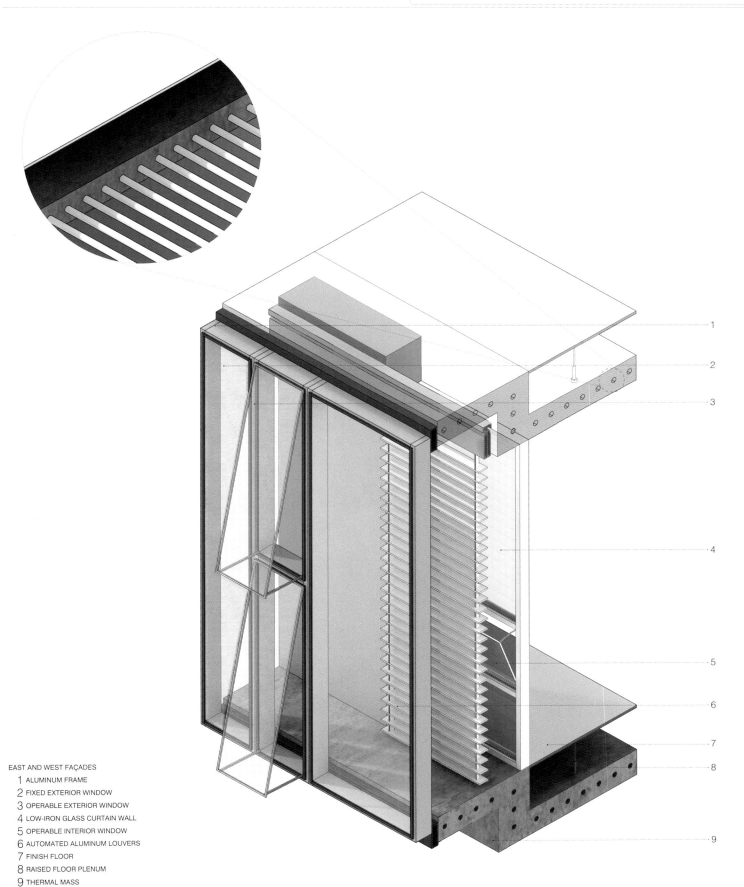

EAST AND WEST FAÇADES
1. ALUMINUM FRAME
2. FIXED EXTERIOR WINDOW
3. OPERABLE EXTERIOR WINDOW
4. LOW-IRON GLASS CURTAIN WALL
5. OPERABLE INTERIOR WINDOW
6. AUTOMATED ALUMINUM LOUVERS
7. FINISH FLOOR
8. RAISED FLOOR PLENUM
9. THERMAL MASS

3.6 [S+E+M] Braun AG Headquarters

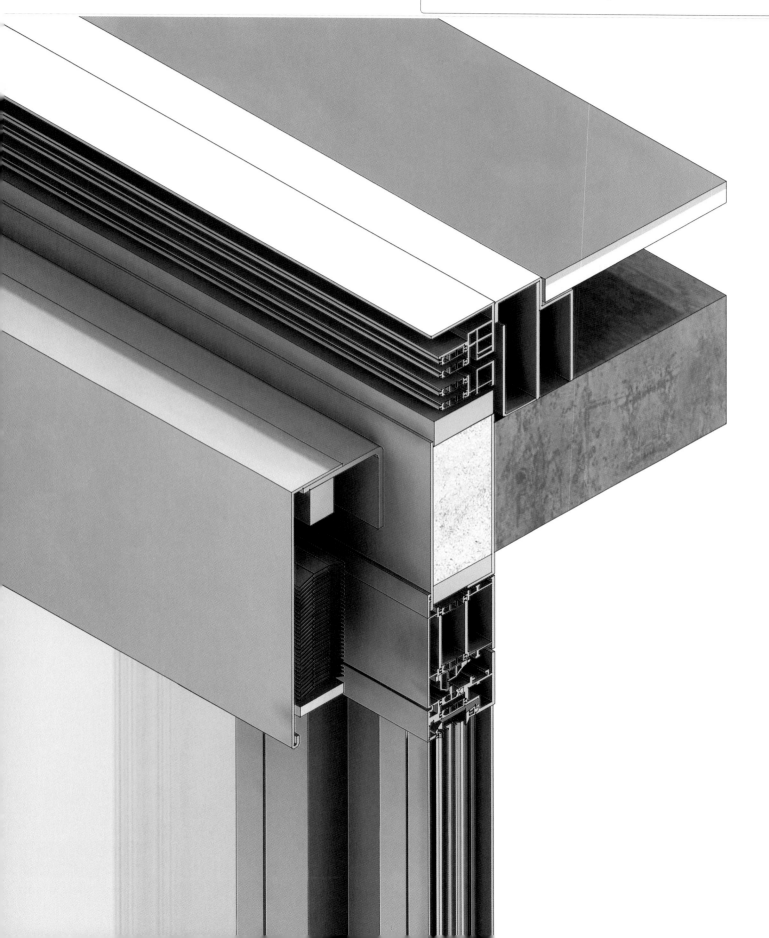

Structure + Envelope + Mechanical

3.6 [S+E+M] Braun AG Headquarters

ARCHITECT	Schneider+Schumacher
LOCATION	Kronberg, Germany 48.3°N 16.3°E
DATE	1998-2000

LOCATION CONDITIONS

BACKGROUND The Braun AG Headquarters building, located in a suburban office park, is a long three-storey atrium structure with a basement. Braun is a company known for its design conscience and innovative products. The company envisioned a new administrative building with energy efficiency and flexible office space planning. Schneider and Schumacher Architects designed a glass-lined structure that allowed abundant natural light to illuminate open floor plates that could be passively ventilated. The long axis of the building runs northwest to southeast and at the center, it has an atrium covered with a translucent, operable roof. The building program is made up of administrative offices, meeting rooms, parking, and other support spaces.

STRUCTURE The Braun AG Headquarters building is composed of a concrete structure. On the ground, second and third floors, round perimeter concrete columns support prestressed concrete floor slabs. The use of prestressed steel reinforcement allows concrete to span greater distances with less material. This structural system creates a column-free floor plate that allows for flexible office layouts. The concrete floor slabs are integrated into the building systems of this building. They function as thermal masses that are activated by a set of affixed heating and cooling tubes.

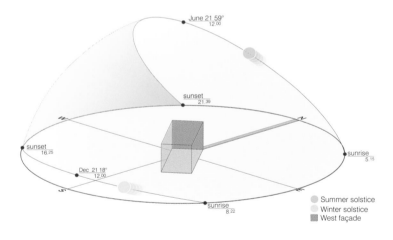

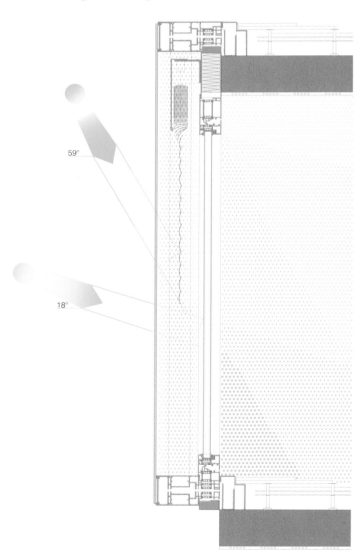

PERFORMANCE The Braun AG Headquarters is rotated off the cardinal axis leaving all façades exposed to solar heat gain. To mitigate this condition, a uniform buffer façade wraps the building to provide insulation during cold winter months and protection against thermal gain in the summer. The buffer façade and the interior atrium diminish the required work of powered mechanical systems. The thermally activated concrete floors create an even distribution of heating and cooling throughout the year. This powered system can be supplemented with the passive components of the building – the atrium roof can be opened and closed with the tall, thin, operable ventilation doors located in the building façades.

DAYLIGHTING AND SCREENING

Structure + Envelope + Mechanical

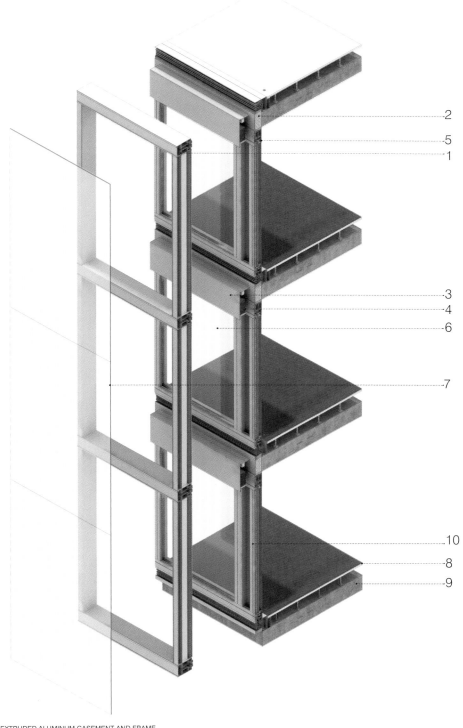
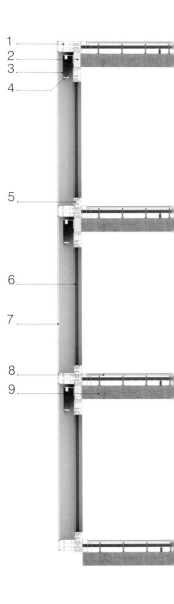

1. EXTERIOR EXTRUDED ALUMINUM CASEMENT AND FRAME
2. RIGID INSULATION
3. ALUMINUM CASING SHEET
4. BLINDS
5. INTERIOR EXTRUDED ALUMINUM CASEMENT AND FRAME
6. DOUBLE-INSULATED GLAZING SYSTEM
7. SINGLE GLAZING
8. DOUBLE-FLOOR CONSTRUCTION WITH CARPET-TILE FINISH
9. CONCRETE FLOOR
10. VENTILATION DOOR

3.6 [S+E+M] Braun AG Headquarters

ATRIUM The atrium provides abundant natural daylight into the center of this building. The offices and the atrium are laid out as long thin spaces allowing the majority of the work spaces both internal views to the courtyard and external views to the outdoors. The atrium is passively cooled with a translucent, operable roof and acts as a thermal buffer to the internal façades of the building. The roof is composed of inflated membrane panels that can pivot to allow hot air to escape on warm days. When the roof is closed, side vents are used to facilitate air movement. These two options for roof venting allow hot air to rise up and out of the atrium as cool air enters at the bottom of the courtyard. This cool air is supplied by below-basement air cavities. These cavities are connected to vents located at the outer edge of the building. Air inside these concrete cavities is passively cooled and directed into the bottom of the atrium next to a water pool. The long linear evaporative water pool assists the passive cooling for the atrium. As water from the pool evaporates, it cools the air above.

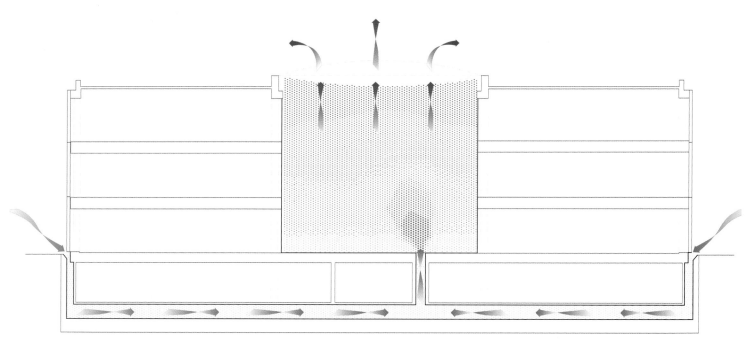

COURTYARD VENTILATION

Structure + Envelope + Mechanical

FLOOR SYSTEM The floor construction of Braun AG Headquarters contains a myriad of building systems: structural, heating, cooling, lighting, low voltage electrical, and fire suppression. These building systems are organized into four distinct layers. The top layer is a carpeted raised-floor system. The second layer is an air space that serves as an air supply plenum for the ventilation system. This air space also contains cold and hot water pipes, sprinkler pipes, and cables for data, telephone, and networking. The raised-floor system rests on the third layer, which is a prestressed concrete floor slab. Set into the slab are lights and sprinkler head modules. The concrete slab acts as a thermal mass that is activated by the fourth layer: a plaster coat with embedded heating and cooling tubes. The thermally activated concrete floors create an even distribution of heating and cooling throughout the year.

FLOOR SYSTEM
1. CARPETED RAISED FLOOR
2. FLOOR SUPPORTS
3. PRESTRESSED CONCRETE FLOOR SLAB
4. AIR SUPPLY
5. EMBEDDED HEATING AND COOLING TUBES

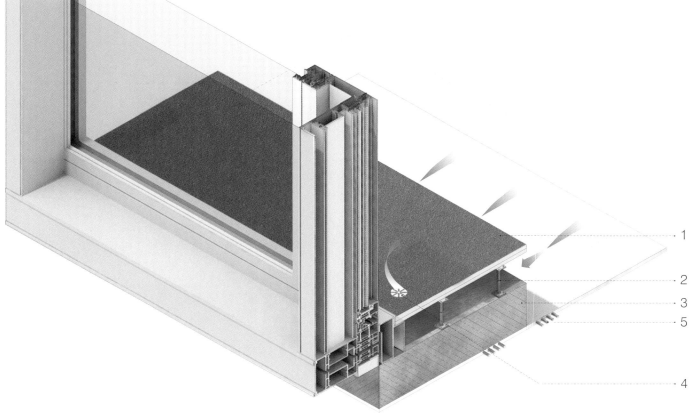

3.6 [S+E+M] Braun AG Headquarters

OUTER BUILDING FAÇADE The outer façade of the building has a dual nature. When closed, it creates a seamless glass surface. When opened, the façade becomes a permeable collection of glass plates. Seen as a vital part of the environmental control of the building, this façade serves as a buffer façade composed of two glazed surfaces. The outer surface is made of pivoting glazed panels that are adjusted with a computer controlled motorized system [A]. The inner glazed surface is made of double-glazed casement windows [B], which are separated by tall, thin, operable ventilation doors. These ventilation doors allow direct air movement between the interior and exterior [D]. Between the two surfaces is an air space, which acts as a thermal buffer. This space also contains adjustable sun louvers that mitigate solar load [C].

INTERIOR BUILDING FAÇADE The atrium façade is a variation of the outer façade. It is composed of just one of the glazed surfaces found on the exterior buffer façade. Since the atrium acts as the thermal buffer for the interior building façade, this façade is only composed of double-glazed casement windows separated by tall, thin, operable ventilation doors. The atrium is passively cooled, and its operable roof can be opened and closed to respond to climatic conditions. As on the exterior façade, the atrium façade has adjustable sun louvers that control daylighting into the workspace.

[B]

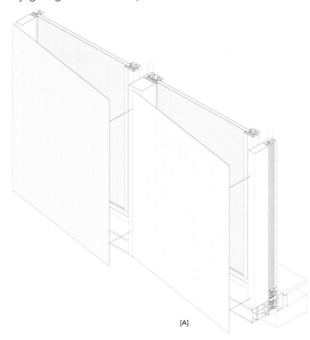

[A]

[C]

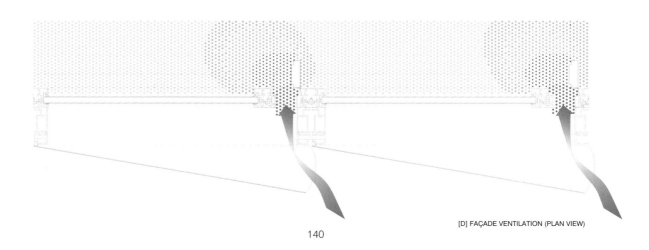

[D] FAÇADE VENTILATION (PLAN VIEW)

Structure + Envelope + Mechanical

WINTER:

HEATING During the winter months, mechanical heating is utilized to keep the interior temperature warm. The mechanical systems are supplemented by the exterior envelope, which performs as a buffer zone, protecting the building from the cold weather.

SUMMER:

COOLING In the summer, the double-skin façade protects the building's interior from solar heat gain. The use of this double-skin façade system and the three-storey courtyard reduces the amount of work by the mechanical systems required for cooling.

SOURCES
Christian Schittich, ed., In Detail: Building Skins, Concepts, Layers, Materials (Basel: Birkhauser, 2001)

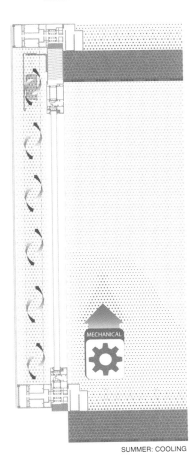

WINTER: THERMAL BUFFER AND HEATING

SUMMER: COOLING

3.7 [S+E+M]
BRE Environmental Building

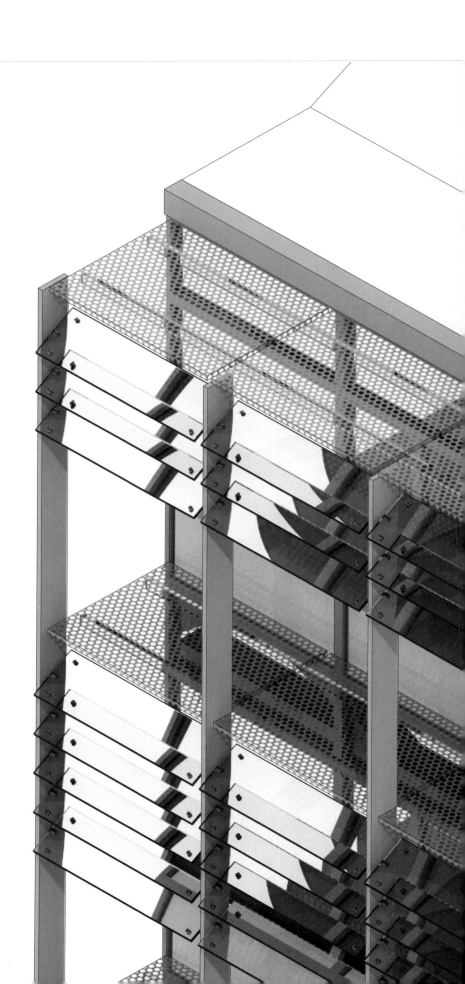

Structure + Envelope + Mechanical

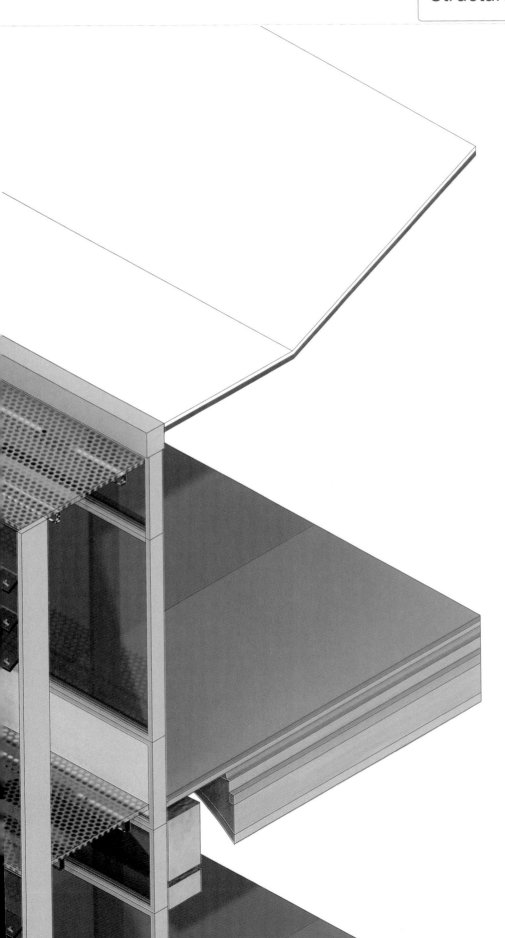

3.7 [S+E+M] BRE Environmental Building

ARCHITECT	Feilden Clegg Architects
LOCATION	Watford, England
	51.7°N 0.2°W
DATE	1996

LOCATION CONDITIONS

BACKGROUND Located on the boundaries of Watford in southern England, the BRE Environmental Building is an exemplary model of sustainability demonstrating innovative principles of design and construction. The energy-efficient office building is a three-storey structure with an L-shape plan and a floor area of about 6,500 square feet (2,000 square meters). The building consists of two components: a three-storey wing accommodating cluster offices on the north side and an open plan area on the south side. The shallow wing on the northwest side of the building incorporates three seminar facilities. The building has a narrow cross section and high ceilings that facilitate cross ventilation and daylighting. It has extensive glazing on the north and south façades and is clad in recycled timber and facing bricks. Ninety percent of the site-cast-concrete utilized in the building is composed of recycled aggregate.[1]

NORTH The north elevation incorporates an extensive use of glazing to admit diffused light into the building. The third floor incorporates clerestory windows providing light and cross ventilation.

EAST During the summer, the east façade receives large amounts of solar radiation in the morning. Glazing on this side of the building is reduced in order to prevent solar heat gain.

SOUTH The south façade receives light at a steep angle during the summer. Shading is provided by the fritted glass louvers that allow some light penetration inside the building. The photovoltaic array located on this side of the building harvests energy throughout most of the year.

WEST In the summer months, the west façade is exposed to large amounts of solar radiation during 75 percent of the period of use. Glazing is minimized in order to allow enough daylight and prevent solar heat gain.

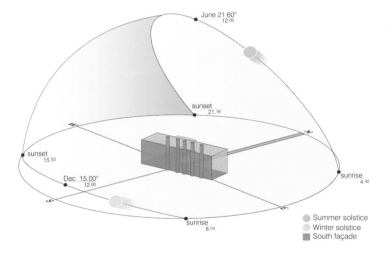

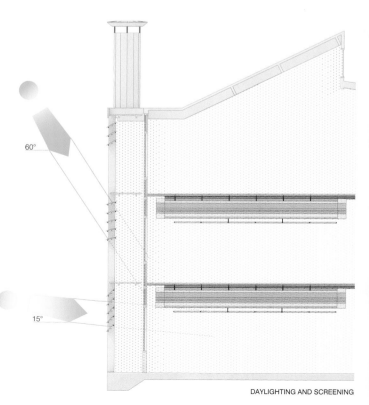

PERFORMANCE The BRE building utilizes a significant number of energy saving strategies to reduce the building's energy consumption and minimize its adverse impact on the environment. These strategies include utilizing thermal mass, natural ventilation, borehole cooling, photovoltaic panels, cooling stacks, a highly insulated roof, and resource-efficient materials.

The building utilizes one of most advanced and integrated Building Management Systems (BMS) to automatically control its operations. The BMS controls borehole cooling, photovoltaic panels, heating, window shading, and lighting levels to provide a comfortable and healthy interior environment. All control systems within the building are designed to be manually overridden by occupants to allow for additional thermal regulation.

DAYLIGHTING AND SCREENING

Structure + Envelope + Mechanical

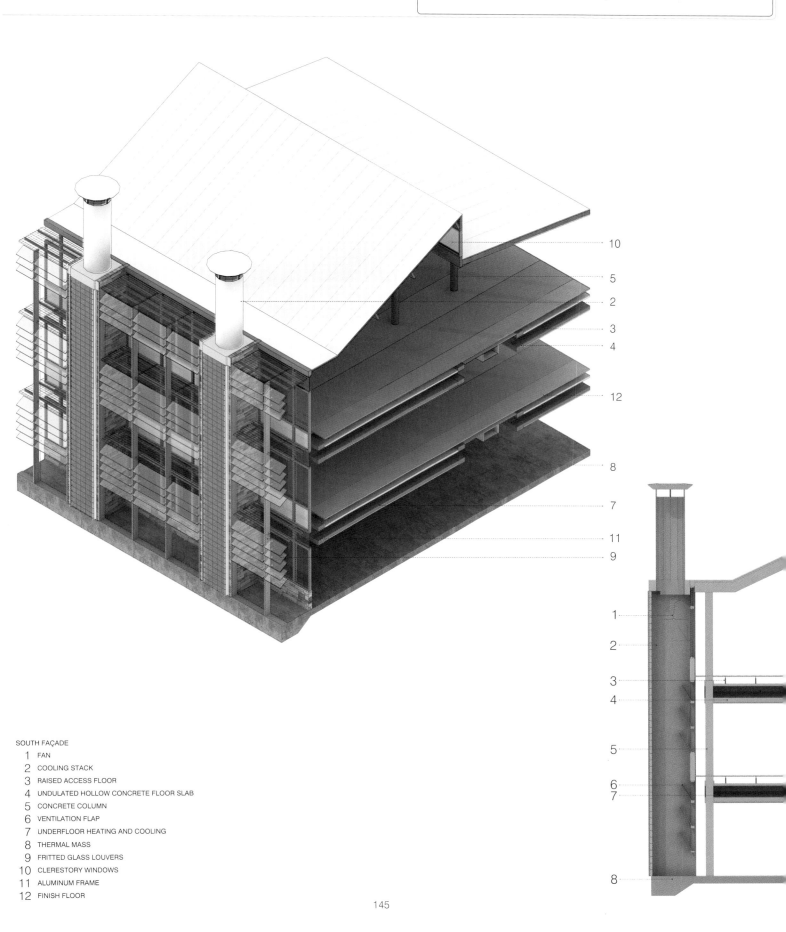

SOUTH FAÇADE
1. FAN
2. COOLING STACK
3. RAISED ACCESS FLOOR
4. UNDULATED HOLLOW CONCRETE FLOOR SLAB
5. CONCRETE COLUMN
6. VENTILATION FLAP
7. UNDERFLOOR HEATING AND COOLING
8. THERMAL MASS
9. FRITTED GLASS LOUVERS
10. CLERESTORY WINDOWS
11. ALUMINUM FRAME
12. FINISH FLOOR

3.7 [S+E+M] BRE Environmental Building

DAYLIGHT AND SHADING To maximize the use of natural daylight, the BRE building incorporates a large glass area on the south façade with an exterior layer of shading devices. The façade's glazing admits generous daylight into the interior while minimizing solar heat gain through the louvered shading system. These fritted glass louvers have a translucent ceramic coating on their undersides that screens direct sunlight. They are automatically controlled by the BMS to adjust and rotate according to the position of the sun. When exposed to diffused sunlight, the motorized louvers are positioned at an angle to reflect light off their upper surfaces onto the ceilings of the offices, thus reducing the amount of artificial lighting needed.

RENEWABLE ENERGY The BRE Environmental Building incorporates photovoltaic panels on the south façade, which contribute up to 1.5KW of the building's electricity supply.[2] The 506-square feet (47 square meters) integrated photovoltaic (PV) array utilizes thin film silicon cells incorporated into a glazed cladding. The energy harvested from these PV cells is fed into the building's main supply panel, providing additional power to the building.

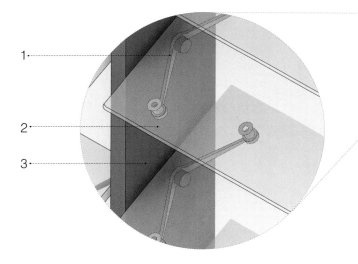

SOUTH FAÇADE DETAIL
1 GLASS CLAMPS
2 FRITTED GLASS LOUVERS
3 ALUMINUM FRAME

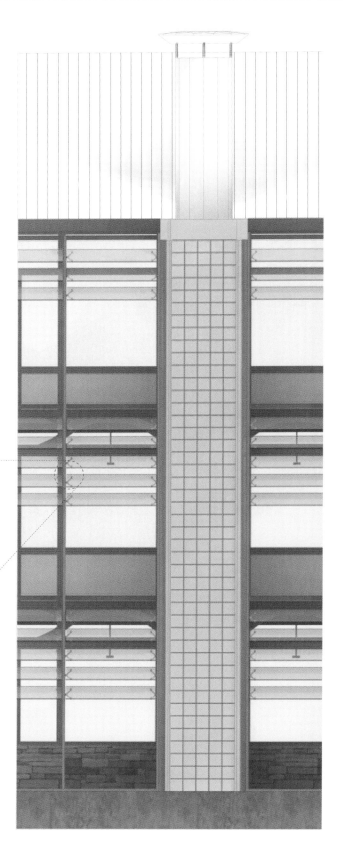

SOUTH FAÇADE: EXTERIOR SHADING DEVICES

Structure + Envelope + Mechanical

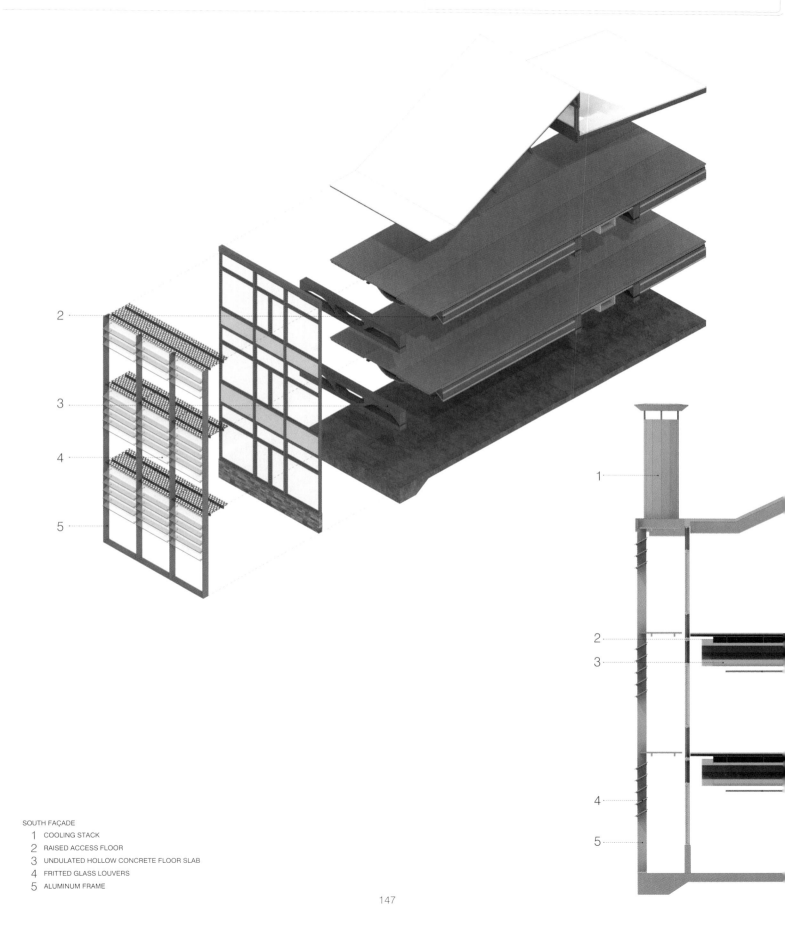

SOUTH FAÇADE
1. COOLING STACK
2. RAISED ACCESS FLOOR
3. UNDULATED HOLLOW CONCRETE FLOOR SLAB
4. FRITTED GLASS LOUVERS
5. ALUMINUM FRAME

3.7 [S+E+M] BRE Environmental Building

CONCRETE FLOOR SLABS The undulated hollow concrete floor slabs play an important role in cooling the interior of the building. The thermal mass of the concrete floors absorbs the heat generated during the day and is cooled down by cross ventilation at night. During the night, the building management system enables ventilation pathways through the hollow concrete slabs to remove accumulated heat and storing cooling for the next day. The exposed undulated ceilings provide more surface area than conventional flat ceilings and perform as cool radiators that contribute to summer cooling.

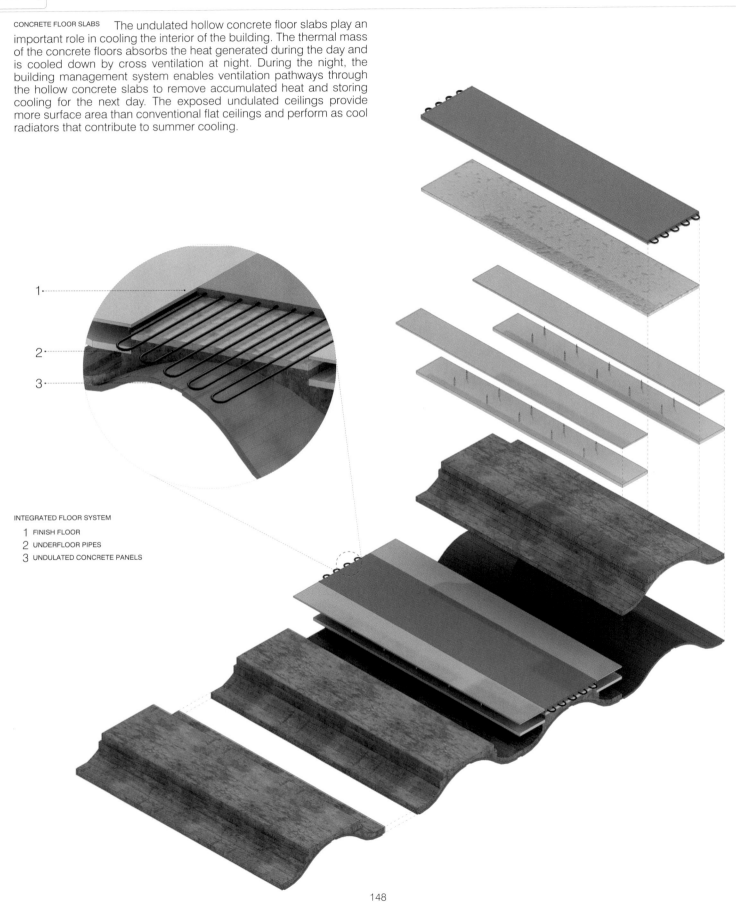

INTEGRATED FLOOR SYSTEM
1 FINISH FLOOR
2 UNDERFLOOR PIPES
3 UNDULATED CONCRETE PANELS

Structure + Envelope + Mechanical

BOREHOLE COOLING Natural ventilation is supplemented by active cooling if internal temperatures rise above 82°F (28°C).[3] Active cooling is performed by circulating cold water through a series of pipes integrated within the floor system. This cold water is supplied by a 230 foot (70 meters) deep borehole where the temperature remains constant at 50°F (10°C). Chilled water is pumped into a plant room where heat exchangers connect the borehole water to the underfloor circulatory water. Chilled water circulates through the concrete floor slabs to limit peak temperatures avoiding the use of an air-conditioning system. It is estimated that this cooling strategy will reduce daily temperatures by 1°C to 2°C. [4]

HEATING During the winter months, internal temperatures are not allowed to drop below 65°F (18°C).[5] Heating is provided by a low-pressure, hot water system that supplies the underfloor pipes and perimeter radiators. This water is heated by condensing gas boilers controlled by the building management system.

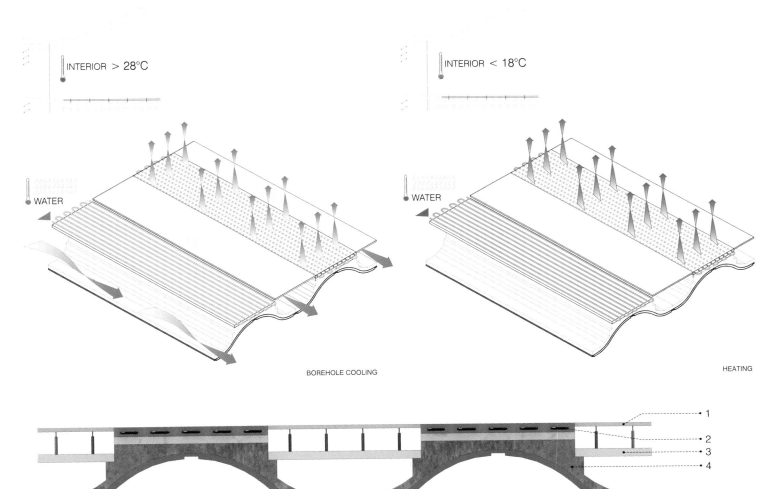

BOREHOLE COOLING

HEATING

INTEGRATED FLOOR SYSTEM
1 FINISH FLOOR
2 UNDERFLOOR PIPES
3 RECESSED FLOOR
4 UNDULATING CONCRETE PANELS
5 CEILING FINISH

3.7 [S+E+M] BRE Environmental Building

COOLING STACKS The most prominent features of the building are five cooling stacks rising over the south façade. The cooling stacks consist of round stainless steel vertical shafts that enhance airflow through the narrow building. They are an integral part of the ventilation and cooling strategy and work in conjunction with the undulated hollow concrete floor slabs. During warm, windy days, fresh air is drawn from the north side of the building through pathways in the hollow concrete slabs. Exhaust air rises thought the vertical shafts, which perform as chimneys, enhancing airflow through the building. Stack ventilation is also improved by the movement of fresh air across the top of the shafts. The cooling stacks allow the building to rely on cross ventilation during the hot summer days to achieve comfortable temperatures.

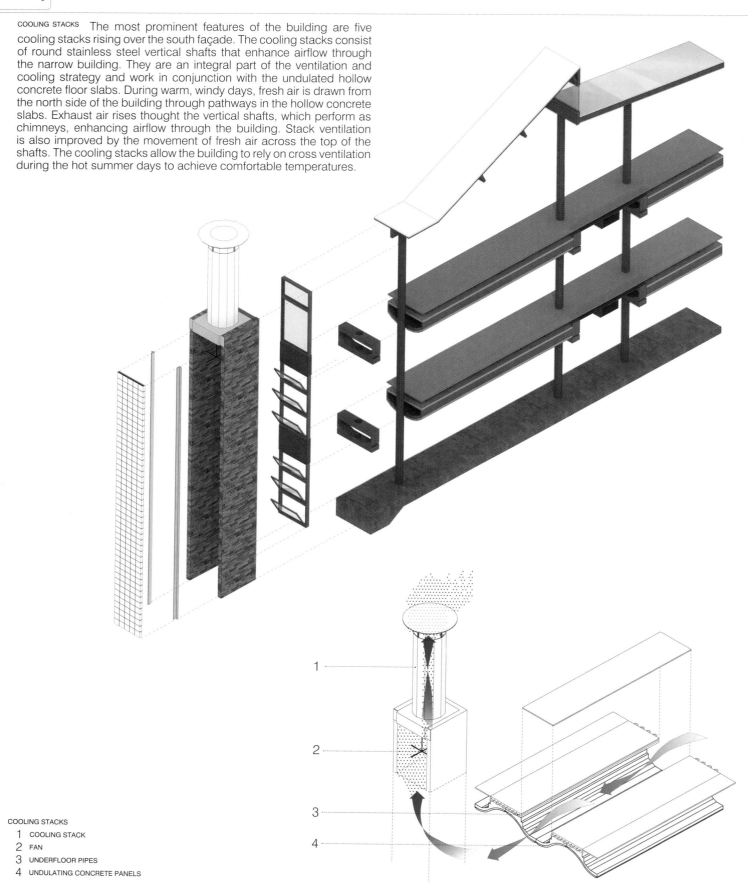

COOLING STACKS
1 COOLING STACK
2 FAN
3 UNDERFLOOR PIPES
4 UNDULATING CONCRETE PANELS

Structure + Envelope + Mechanical

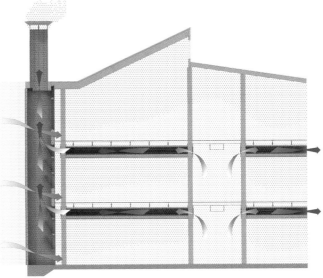

[A] SUMMER: DAY VENTILATION

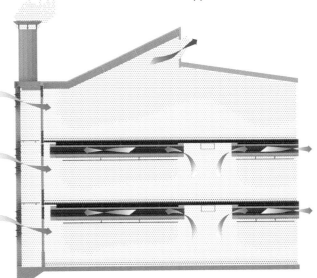

[B] SUMMER: NIGHT COOLING

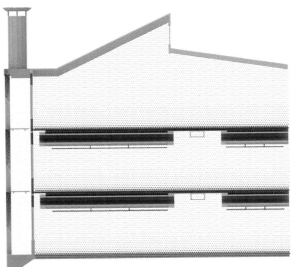

[C] WINTER: HEATING SYSTEM

VENTILATION SYSTEMS

SUMMER: [No mechanical ventilation]

[A] NATURAL VENTILATION Automatically controlled windows positioned at high levels are adjusted to allow fresh air intake. Heated air exits the building via the cooling stacks to increase ventilation. If interior temperatures rise above the summer temperature set point, active cooling is initiated.

[B] NIGHT COOLING During summer nights, the upper windows are opened automatically to remove excess heat that has accumulated during the day. This strategy allows the concrete floor slabs to stay cool and lowers the internal temperature during the next day.

WINTER:

[C] HEATING The ventilation pathways in the hollow concrete slabs are controlled to provide fresh air, allowing the slab to preheat the air. Heating is provided by the underfloor heating coils and the perimeter radiators. During winter nights, the building remains closed and no ventilation is provided to prevent frost within the building.

REFERENCES

1. W/E Consultants Sustainable Building, "BRE Environmental Building," Catalogue of Best Practice Examples. European Green Building Forum (2001).

2. Bartholomew Stevens, "Low Energy Office at the Building Research Establishment," Structural Survey 16, no. 3, (1998): 129.

3. Michael Wigginton and Jude Harris, Intelligent Skins, illustrated ed. (Burlington: Architectural Press, Elsevier, 2002), 76.

4. Clayton Harrison, "Case Study: The Environmental Building," (2006), http://www.caa.uidaho.edu/arch504ukgreenarch/CaseStudies/bre2.pdf.

5. Wigginton and Harris, Intelligent Skins, 76.

SOURCES

Pat Herbert, "The Environmental Building." Structural Survey 16, no. 2, (1998): 87-90.

Bibliography

"2006 Sustainability Report," *Agbar Group*, http://www.agbar.es/eng/docs/pdfs/2007_Informe_sostenibilidad_eng.pdf.

"Architecture 2030 Will Change the Way You Look at Buildings," Architecture 2030, http://architecture2030.org/the_problem/buildings_problem_why.

"Assessing the Assessor Breeam vs Leed," Sustain Magazine 9, no. 6: 31-33, http://www.breeam.org/filelibrary/BREEAM_v_LEED_Sustain_Magazine.pdf.

Bartholomew Stevens, "Low Energy Office at the Building Research Establishment," Structural Survey 16, no. 3, (1998): 129.

Bernard Tschumi, *Event-Cities 2* (Cambridge: The MIT Press, 2000).

Bernard Tschumi and Enrique Walker, *Tschumi on Architecture: Conversations with Enrique Walker* (New York: The Monacelli Press, 2006).

Bizley, Graham. "Civil Justice Centre, Manchester." In Detail.

Bovis Lend Lease, "Manchester Civil Justice Centre," http://www.bovislendlease.com/llweb/bll/main.nsf/images/pdf_project_uk_manchester_cjc.pdf/$file/pdf_project_uk_manchester_cjc.pdf.

"Buildings Database. Heifer International Headquarters," *U.S. Department of Energy, Energy Efficiency and Renewable Energy*, 2009, http://eere.buildinggreen.com/energy.cfm?ProjectID=781.

"Caltrans District 7 Headquarters," Morphosis Architects, *Morphopedia*, February, 2009, http://morphopedia.com/projects/caltrans-district-7-headquarters.

Cecilia Marquez and Fernando Levene, *Herzog & DeMeuron*, 1998-2002, 1st ed. (Madrid: El Croquis Editorial, 2004), 109-110.

"CH2: Council House 2," Green Building Council Australia, *City of Melbourne*, www.melbourne.vic.gov.au.

"CH2 building," *Greenlivingpedia*, July 2008, http://www.greenlivingpedia.org/CH2_building.

Charles J. Kibert, Sustainable Construction: Green Building Design and Delivery (John Wiley and Sons, 2007).

Charles Linn, *Emerald Architecture: Case Studies in Green Building* (McGraw-Hill Professional, New York, 2008).

Charles Linn, "Manitoba Hydro Place," *Green Source: The Magazine of Sustainable Design* (March 2010).

Christian Schittich, ed., *In Detail: Solar Architecture* (Boston: Birkhauser-Publishers for Architecture, 2003).

Christian Schittich, ed., In Detail: Building Skins, Concepts, Layers, Materials (Basel: Birkhauser, 2001).

Clayton Harrison, "Case Study: The Environmental Building," (2006), http://www.caa.uidaho.edu/arch504ukgreenarch/CaseStudies/bre2.pdf.

"Cooling and Heating of Buildings by Activating their Thermal Mass with Embedded Hydronic Pipe Systems," Bjarne W. Olesen, http://www.cibse.org/pdfs/Embedded%20Hydronic%20Pipe%20Sys.pdf.

Corus Group, Sustainable Steel Construction, The Design and Construction of Sustainable Buildings (UK: Corus, 2006), 16-17.

"Courtroom Appeal," *NSC*, September, 2005.

D. M. Roodman and N. Lenssen, *Worldwatch Paper 124. A Building Revolution: How Ecology and Health Concerns are Transforming Construction*, (Washington, D.C.: Worldwatch Institute, 1995), 5.

David Gissen, ed., *Big & Green: Toward Sustainable Architecture in the 21st Century*. illustrated, National Building Museum (NY: Princeton Architectural Press, 2002).

Dean Hawkes and Wayne Foster. *Energy Efficient Buildings: Architecture, Engineering, and Environment*, first American ed. (London: W.W. Norton & Company Ltd., 2002), 62.

Derek Phillips, *Daylighting: Natural Light in Architecture*, illustrated ed. (Oxford: Architectural Press, Elsevier, 2004).

"Doing Manchester Justice," *NSC*, February, 2008.

Dr Joanne Wade, Jacky Pett, and Lotte Ramsay, *Energy Efficiency in Offices: Motivating Action* (ACE The Association for the Conservation of Energy, 2003), 30-31.

Dean Hawkes and Wayne Foster. *Energy Efficient Buildings: Architecture, Engineering, and Environment*, first American ed. (London: W.W. Norton & Company Ltd., 2002), 146.

Dominique Hes, "Design Snapshot 05: Energy Systems," CH2 Setting a New World Standard in Green Building Design, *City of Melbourne*, www.melbourne.vic.gov.au.

Dominique Hes, "Design Snap Shot 06: Shower Towers," CH2 Setting a New World Standard in Green Building Design, *City of Melbourne*, www.melbourne.vic.gov.au.

Dominique Hes, "Design Snap Shot 09: Water," CH2 Setting a New World Standard in Green Building Design, *City of Melbourne*, www.melbourne.vic.gov.au.

Dominique Hes, "Design Snap Shot 12: Western Façade," CH2 Setting a New World Standard in Green Building Design, *City of Melbourne*, www.melbourne.vic.gov.au.

Dominique Hes, "Design Snap Shot 13: Interface with Street," CH2 Setting a New World Standard in Green Building Design, *City of Melbourne*, www.melbourne.vic.gov.au.

Dominique Hes, "Design Snap Shot 14: Indoor Environmental Quality," CH2 Setting a New World Standard in Green Building Design, *City of Melbourne*, www.melbourne.vic.gov.au.

Dominque Hes, "Design Snap Shot 15: Phase Change Material," CH2 Setting a New World Standard in Green Building Design, *City of Melbourne*, http://www.melbourne.vic.gov.au.

Dominique Hes, "Design Snap Shot 16: Chilled Panels and Beams," CH2 Setting a New World Standard in Green Building Design, *City of Melbourne*, www.melbourne.vic.gov.au.

Dominique Hes, "Design Snap Shot 18: Vaulted Ceilings," CH2 Setting a New World Standard in Green Building Design, *City of Melbourne*, www.melbourne.vic.gov.au.

Dominique Hes, "Design Snap Shot 20: Lighting," CH2 Setting a New World Standard in Green Building Design, *City of Melbourne*, www.melbourne.vic.gov.au.

Erin McConahey, Philip Haves, and Tim Christ, "The Integration of Engineering and Architecture: A Perspective on Natural Ventilation for the New San Francisco Federal Building," *High Performance Commercial Building Systems* (2002).

Eugene DeSouza, Andy Howard, and Teena Videriksen, "The Caltrans District 7, Los Angeles," *The Arup Journal* (February, 2005), http://goarup.com/docs/Caltrans%20District%207.pdf.

Gordon Graff, "Debis Headquarters. Berlin, Germany Renzo Piano Building Workshop," http://www.architecture.uwaterloo.ca/faculty_projects/terri/pdf/Graff.pdf.

"Green Parking Lot Case Study: Heifer International, Inc," *Industrial Economics, Incorporated* (IEC), (May 2007) http://www.epa.gov/region6/6sf/pdffiles/heiferparkingstudy.pdf.

Harris Poirazis, *Double Skin Façades for Office Buildings*, Division of Energy and Building Design Department of Construction and Architecture Lund Institute of Technology Lund University, Report EBD-R--04/3 (2004), 139.

Heinz Ronner, Louis I. Kahn: Complete Works 1935-1974. Enlarged 2nd ed. (Basel: Birkhäuser, 1987).

James Polshek, Susan Strauss, and Polshek Partnership, *Polshek Partnership Architects, 1988-2004* (New York: Princeton Architectural Press, 2004).

Jean Nouvel, *Architecture and Urbanism: Jean Nouvel 1987-2006*, special ed., (Tokyo: A+U Publishing Co, 2006).

Jerry Yudelson, *Green Building Trends: Europe*, illustrated ed. (Washington: Island Press, 2009).

Joann Gonchar, "More Than Skin Deep," *Architectural Record*, (July 2010), http://continuingeducation.construction.com/article.php?L=5&C=685&P=3.

Jules Prown, *The Architecture of the Yale Center for British Art*, 2nd ed. (New Haven: Yale University, 1993).

Kate Harrison, "The Tectonics of The Environmental Skin," http://www.architecture.uwaterloo.ca/faculty_projects/terri/ds/double.pdf.

Kennett, Stephen, "Courtroom Drama," Building Services Journal: The Magazine of CIBSE, (2007), bsjonline.co.uk.

Kiel Moe, *Integrated Design in Contemporary Architecture*, illustrated ed. (New York: Princeton Architectural Press, 2008).

Kimberly King, "The Helicon Finsbury Pavement. London, UK," http://www.architecture.uwaterloo.ca/faculty_projects/terri/125_W03/king_helicon.pdf.

"Kunsthaus Bregenz," *EcoWikiArchitecture*, February 2009, http://www.ecoarchwiki.net/pmwiki.php?n=Projects.KunsthausBregenz.

"Lighting Applications, Designing with Light in L.A.," Paramount Industries, http://www.paramount-lighting.com/caltrans-appl-sheet_3-05.pdf.

"Loblolly House Building Information Model Awards 2007," (2007)

Logan, Stephen, "Low Energy Initiatives Manchester Civil Justice Centre" (EcoLibrium, 2008), 29.

"Manchester Civil Justice Centre," *Commission for Architecture and the Built Environment (CABE)*, http://www.cabe.org.uk/case-studies/manchester-civil-justice-centre.

"Manitoba Hydro Place," Manitoba Hydro, *The Greening of Municipalities*, www.amm.mb.ca/documents/SR-Hydrobuilding.pdf.

Manitoba Hydro Place Integrated Design Consortium, "Manitoba Hydro Place. Integrated Design Process Exemplar," (PLEA2009- 26th Conference on Passive and Low Energy Architecture, Quebec City, Canada, 22-24 June 2009).

Martin L. Smith, "Green Parking Lots" (presentation, Sustainable Communities Conference, Dallas, TX, March 2009).

Matthew Wells, *Skyscrapers: Structure and Design*, illustrated ed. (Yale University Press, 2005).

Michael Cockram, "Big Ripples," *Architecture Week* (April 2007) http://www.architectureweek.com/2007/0404/environment_1-1.html.

Michael Wigginton and Jude Harris, *Intelligent Skins*, illustrated ed. (Burlington: Architectural Press, Elsevier, 2002).

National Architectural Accrediting Board, Inc., "2009 Conditions for Accreditation," Public Comment edition, (2009).

"National Library Building," Asia Business Council, http://www.asiabusinesscouncil.org/docs/BEE/GBCS/GBCS_Library.pdf.

Pat Herbert, "The Environmental Building." *Structural Survey* 16, no. 2, (1998): 87-90.

Patricia Cummings Loud and Louis I. Kahn. The Art Museums of Louis I. Kahn, illustrated ed. (Durham, North Carolina: Duke University Press, 1989).

Pekka Huovila, *Buildings and Climate Change, Status Challenges and Opportunities*, United Nations, Environment Programme, Sustainable Consumption and Reduction Branch, illustrated edition, (UNEP/Earthprint, 2007).

Peter W. Newton, Transitions: Pathways Towards Sustainable Urban Development in Australia, illustrated ed. (New Zealand: Springer, 2008).

Peter Zumthor, *Architecture and Urbanism*, extra ed. (Tokyo: A+U Publishing Co., Ltd., 1998), 172.

Peter Zumthor, *Three Concepts*, illustrated ed. (Boston: Birkhäuser Verlag, 1997).

Peter Zumthor and Hélène Binet, *Peter Zumthor Works: Buildings and Projects 1979-1997* (Switzerland: Lars Müller, 1998).

Pew Center on Global Climate Change, "Innovative Policy Solutions to Global Climate Change," In Brief, November 2006.

Philip Jodidio, *Jean Nouvel by Jean Nouvel: Complete Works 1970-2008*, limited ed., (Cologne: TASCHEN America Llc, 2008).

Polshek Partnership Architects, *William J. Clinton Presidential Library and Park, 9908* (New York: Polshek Partnership LLP, 2006).

Russell Cole, Andre Lovatt, and Mani Manivannan, "Singapore's New National Library," *Arup Journal* (2006), http://www.arup.com/_assets/_download/download626.pdf.

Sandrina Dumitrascu, "Debis Headquarters Building, Berlin, Germany, Renzo Piano Building Workshop," http://www.architecture.uwaterloo.ca/faculty_projects/terri/pdf/Dumitras.pdf.

"San Francisco Federal Building GSA's Model of Sustainable Design," *General Services Administration*, January 23, 2007, http://www.fypower.org/pdf/SFFB_SustainableDesign.pdf.

Scott Murray, *Contemporary Curtain Wall Architect*, illustrated ed. (New York: Princeton Architectural Press, 2009).

Stephen Luoni, "Little Rock's Emerging Nonprofit Corridor," *Places* (2008).

Stephen Kieran and James Timberlake, *Loblolly House, Elements of a New Architecture*, (New York: Princeton Architectural Press, 2008).

Stephen Kieran and James Timberlake, Refabricating Architecture, How Manufacturing Methodologies Are Poised to Transform Building Construction (New York: McGraw-Hill Companies, Inc., 2004).

"Technical Research Paper 01. Nature and Aesthetics in the Sustainable City," *City of Melbourne*, May 2006, www.melbourne.vic.gov.au.

"Technical Research Paper 04," *City of Melbourne*, May 2006, www.melbourne.vic.gov.au.

"Technical Research Paper 05. Heating and Cooling in the CH2 Building," *City of Melbourne*, May 2006, www.melbourne.vic.gov.au.

"Technical Research Paper 06. Energy Harvesting," *City of Melbourne*, May 2006, www.melbourne.vic.gov.au.

"Technical Research Paper 07. Water," *City of Melbourne*, May 2006, www.melbourne.vic.gov.au.

"Technical Research Paper 08. Building Structure and Construction process," *City of Melbourne*, May 2006, www.melbourne.vic.gov.au.

"Technical Research Paper 09. Materials Selection," *City of Melbourne*, May 2006, www.melbourne.vic.gov.au.

Tiffany Lee-Youngren, "Glaziers Delight: Scrim Walls, Like Those on Caltrans Headquarters, Are Multifunctional," *Glass, Your Online Industry Resource* (2005), http://www.glassmagazine.com.

Tony McLaughlin and Buro Happold, "Engineering the Library Environment," September 2007, http://library-architecture.upol.cz/2007/prezentace/Laughlin.pdf.

"TR Hamzah & Yeang International," http://www.trhamzahyeang.com/project/large-buildings/nlb01.html.

Tristan Korthals Altes, "Case Study: Heifer International Center," *GreenSource: The Magazine of Sustainable Design* (January 2007) http://greensource.construction.com/projects/0701_COL.asp.

"US General Services Administration San Francisco Federal Building," Rocky Mountain Institute, *High Performance Building: Perspective and Practice*, http://bet.rmi.org/files/case-studies/gsa/US_General_Services_Administration.pdf.

Vladyslav Kostyuk, "Debis Headquarters, Potsdamer Platz, Berlin. Renzo Piano Building Workshop," http://www.architecture.uwaterloo.ca/faculty_projects/terri/125_W03/kostyuk_debis.pdf.

W/E Consultants Sustainable Building, "BRE Environmental Building," *Catalogue of Best Practice Examples. European Green Building Forum* (2001).

"Whole Building Design Guide, National Institute of Building Sciences (NIBS)," Don Prowler, August 7, 2008, http://www.wbdg.org/wbdg_approach.php.

Wigginton and Harris, Intelligent Skins, 76.

Will Jones, "Council House 2, Melbourne: Australia's Greenest Office Building," January 28, 2008, http://www.building.co.uk/story.asp?storycode=3104100.

William J. Clinton Presidential Library and Museum, "Clinton Presidential Library Receives Highest Green Building Rating," http://www.clintonlibrary.gov/being-green.html.

William Sarni, Greening Brownfields, *Remediation through Sustainable Development*, illustrated ed. (New York: McGraw-Hill Professional, 2009).

Yoshio Futagawa ed., (Tokyo: GA International A.D.A Edita, 2003).

Index

3

3XNeilsen, Århus, 80

A

Agbar Tower, 30–35
 background, 32
 buffer façade, 34
 daylighting, 32–33
 envelope, 34
 façade ventilation, 34
 Jean Nouvel, 32
 performance, 32
 structure, 34
Arkansas, 14, 20
Arup Associates, 48
Arup Campus, 46–51
 Arup Associates, 48
 background, 48
 daylight and screening, 48
 envelope, 51
 façade, southeast, 49
 light scoop illumination, 51
 performance, 48
 section through light scoop, 50
 structure, 50
 ventilation, 51
Australia, 94
Austria, 68

B

Barcelona, 32
Basel, 38
Berlin, 74
Bernard Tschumi, 26
Braun AG Headquarters, 134–141
 atrium, 138
 background, 136
 cooling, summer, 141
 façades, interior/outer, 140
 floor system, 139
 heating and thermal buffer, 141
 performance, 136
 Schneider+Schumacher, 136
 structure, 136–137
 ventilation
 courtyard, 138
 façade (plan view), 140
BRE Environmental Building, 142–151
 background, 144
 cooling
 borehole, 149
 night time, 151
 stacks, 150
 daylighting
 screening and, 144
 shading and, 146
 Feilden Clegg Architects, 144
 floor slabs, concrete, 148
 floor system, integrated, 148, 149
 heating, 149, 151
 performance, 144
 renewable energy, 146
 south façade, 145, 146, 147
 detail, 146
 exterior shading devices, 146
 ventilation systems, 151
Bregenz, 68
 Bregenz Art Museum, 66–71
 air exchange, 71
 background, 68
 building envelope, 70
 climate control, 71
 cooling, summer, 71
 daylighting and screening, 68–69
 façade diagram/detail, 70
 Peter Zumthor, 68
 performance, 68
 radiant floor system design, 71
 structure, 68

C

California, 62, 106
Caltrans District 7 Headquarters Building, 60–65
 background, 62
 building façades, 63, 64
 daylighting and screening, 62
 east and west façades, 63
 perforated aluminum panels, 64
 ventilation, natural, 65
 lightwell/diagram, 65
 performance, 62
 south façade, 64
 photovoltaic panels, integrated, 64
 Tom Mayne, Morphosis, 62
Canada, 124
Connecticut, 118
Council House 2 (CH2), 92–103
 background, 94
 ceiling panels/assembly, chilled, 96
 cooling, daytime/night, 103
 energy harvesting, 94
 façades
 east, 102
 north, 95, 102
 south, 96, 97
 west, 95, 98, 99
 floor system, integrated, 100–101
 Jean-Claude Bertoni + DesignInc, 94
 PCM tank, 97
 rotation mechanism/angles, 98
 shower tower, 97
 vegetation, 94
 ventilation, 102–103
 daytime cooling, 103
 warm air path, 103

D

Debis Headquarters Building, 72–77
 background, 74
 building façades, 75, 76
 cooling/thermal buffer, 77
 daylighting and screening, 74
 open louvers/closed blinds, 76
 performance, 74
 Renzo Piano, 74
 ventilation, natural, 77
 west façade, 75, 76
Denmark, 80
Denton Corker Marshall, 54

E

England, 48, 54, 86, 144

F

Feilden Clegg Architects, 144
Florida, 26

G

Germany, 74, 136
Greater Manchester, 54

H

Heifer International Headquarters, 18–23
 background, 20
 cooling diagram, 23
 daylighting, 21
 façades
 north, 23
 south, 21
 floor system, 23
 performance, 20
 Polk Stanley Rowland Curzon Porter Architects, 20
 structure, 20
Helicon Building, 84–89
 background, 86
 cooling/thermal buffer, 89
 dampers, 89
 daylighting and screening, 86
 envelope, 88
 façade
 detail, 88
 west, 87
 Mick Pearce + Design, Inc., 86
 open louvers/closed louvers, 88
 performance, 86
 ventilation, 88, 89
Herzog & deMeuron, 38
Housing Estate in Kolding, 78–83
 3XNeilsen, Århus, 80
 background, 80
 end walls, east and west, 82
 heating/cooling, 83
 performance, 80
 solar façade, 82
 solar wall, 81, 82
 south façade
 solar wall, 82
 structure, 80
 ventilation, 83

J

Jean Nouvel, 32
Jean-Claude Bertoni + DesignInc, 94

K
Kieran Timberlake, 112
Kolding, 80
KPMB Architects, 124
Kronberg, 136

L
Little Rock, 14, 20
Loblolly House, 110–115
 background, 112
 building façades, 112–113, 114
 east façade, 113
 integration, 115
 Kieran Timberlake, 112
 performance, 112
 structure, 112
 west façade
 daylighting and screening, 112–113
 ventilation/buffer, 114
London, 86
Los Angeles, 62
Louis I. Kahn, Pellecchia and Meyers, 118

M
Manchester Civil Justice Centre, 52–57
 background, 54
 building envelope, 57
 Denton Corker Marshall, 54
 façades, north and south, 55
 heating/cooling, 56
 morning/afternoon sunlight, 54
 performance, 54
 structure, 57
 tension and compression forces on steel truss, 57
 ventilation, 56
Manitoba, 124
Manitoba Hydro Place, 122–133
 background, 124
 building envelope, 126
 daylighting and screening, 124–125
 east façade, 127, 133
 geothermal wells, 132
 green roof, 130
 heating and cooling, 132
 cooling slab method, 132
 heating slab method, 132
 KPMB Architects, 124
 performance, 124
 solar chimney, 131
 south and west façades, 125
 ventilation
 displacement, 130
 natural, 128
 water features, 129
 summer mode/winter mode, 129
 winter garden, 129
 west façade, 127, 133
 shading system, 126
 winter mode
 thermal buffer, 126
Maryland, 112
Melbourne, 94
Miami, 26
Mick Pearce + Design, Inc., 86

N
New Haven, 118

P
Paul L. Cejas School of Architecture, 24–29
 background, 26
 Bernard Tschumi, 26
 building façades, 27, 28, 29
 north façade, 27, 28
 performance, 26
 shadow analysis, winter and summer, 29
 structure, 28
 studio wing section, 28, 29
Peter Zumthor, 44, 68
Polk Stanley Rowland Curzon Porter Architects, 20
Polshek Partners, 14

R
Rehab Basel, 36–41
 background, 38
 building envelope, 40
 daylight and screening, 38
 façade sectional model, 39, 41
 Herzog & deMeuron, 38
 performance, 38
 skylights, 38
 structure, 38
 verandas, 40
Renzo Piano, 74

S
San Francisco, 106
San Francisco Federal Building, 104–109
 background, 106
 building façades, 106, 107, 108
 floor system, integrated, 108
 heating/cooling, 109
 northwest façade
 daylighting and screening, 106
 sectional model of, 107, 108
 performance, 106
 southeast façade
 daylighting and screening, 108
 Tom Mayne, Morphosis, 106
 ventilation, 109
Schneider+Schumacher, 136
Singapore, 8
Singapore National Library, 8–11
 background, 8
 building façades, 9, 10
 climate buffers, 10
 daylight and screening, 8
 façade
 east, 9
 west, 9, 10
 performance, 8
 planted terraces, 8
 T.R. Hamzah & Ken Yeang, 8
 ventilation strategy, 11
 atrium stack effect, 11
Solihull, 48
Spain, 32
Switzerland, 38, 44

T
Taylors Island, 112

Thermal Baths, 42–45
 background, 44
 façade sectional model, 45
 green roof, 44
 performance, 44
 Peter Zumthor, 44
 structure and envelope, 44
T.R. Hamzah & Ken Yeang, 8
Tom Mayne, Morphosis, 62, 106

U
USA, 14, 20, 26, 62, 106, 112, 118

V
Vals, 44

W
Watford, 144
William J. Clinton Presidential Center, 12–17
 background, 14
 building façades, 15, 16
 performance, 14
 Polshek Partners, 14
 structure, 17
 steel pier and transfer beam, 17
 steel truss frame, 17
 west façade, 15
 daylight and screening, 14
 elevation, 16
 laminated glass panels with printed dots, 16
 passive air flow, 16
Winnipeg, 124

Y
Yale Center for British Art, 116–121
 background, 118
 building façade, 120
 Louis I. Kahn, Pellecchia and Meyers, 118
 performance, 118
 skylights/skylight screening, 118–119
 structure, 121
 return air trajectory, 121
 structure and mechanical systems, 120
 components of, 120